Photoshop for Photography

the art
of
pixel processing

Tom Ang

Amphoto Books
an imprint of Watson-Guptill Publications/New York

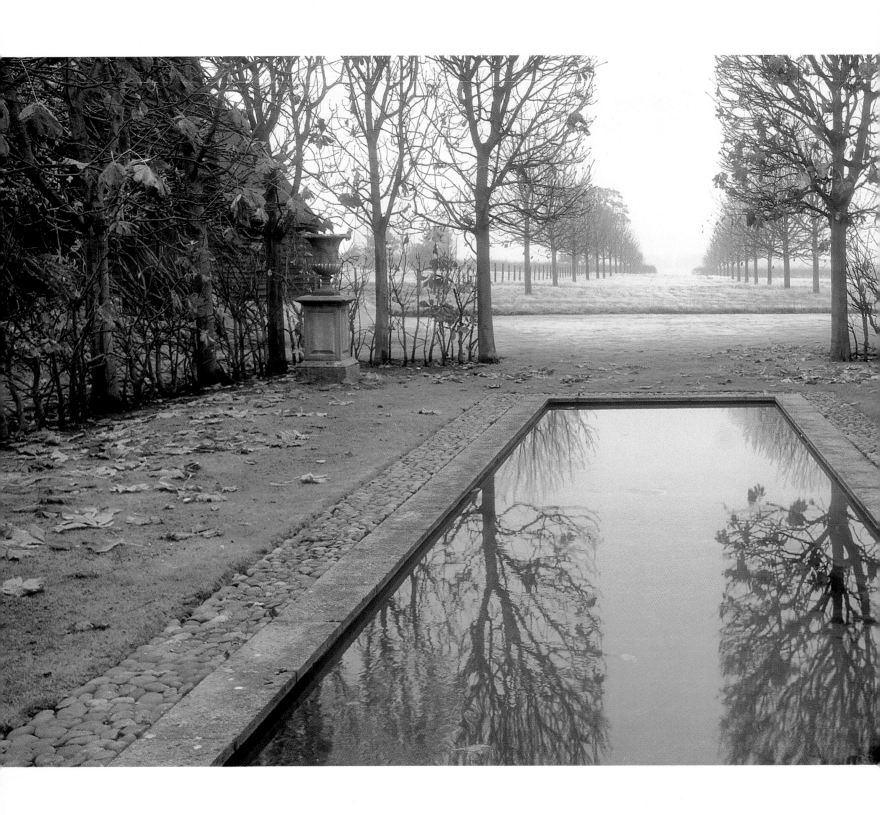

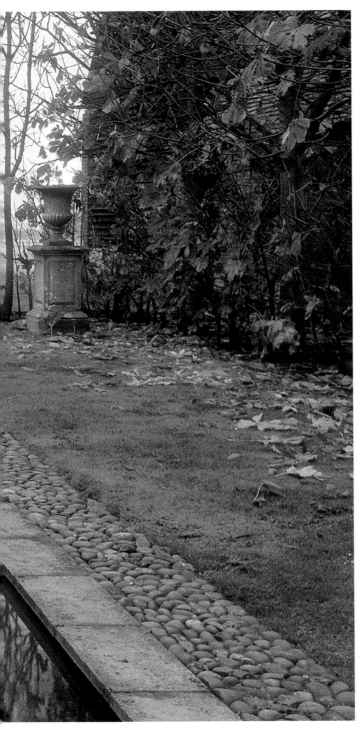

Photoshop for Photography

the art of pixel processing

Tom Ang

**This book is dedicated to those
students who teach me**

First published in 2003 by Amphoto Books
an imprint of Watson-Guptill Publications
a division of VNU Business Media, Inc.
770 Broadway, New York, NY 10003
www.watsonguptill.com

First published in Great Britian in 2003 by Argentum
an imprint of Aurum Press
25 Bedford Avenue, London WC1B 3AT

Design: Tom Ang

Library of Congress Card Number: 2002114985
ISBN: 0-8174-5373-3

Printed in Singapore

1 2 3 4 5 6 7 8 / 10 09 08 07 06 05 04 03

Contents

ONE The background

TWO Pixel processing

THREE Reference section

ONE

The background

Introduction

Pixel processing is the most exciting development in photography since the invention of photography itself. It may not have changed the world. But it has overturned the working patterns of numerous photographers. It has not simply rewritten the rules. It has transformed them into a vast and ever-expanding recipe book. And is there a photographer alive who has not felt the electronic digit tapping their shoulder? Whether you embrace digital photography or not, the simple fact is that no part of photography remains wholly untouched by pixel processing.

And why should we not avail ourselves of it? Pixel processing is the computer-based working on images to improve a photograph without substantially altering its content. In this book we only occasionally touch on image manipulation – which substantially and drastically alters an image's content or appearance.

And for this work, the instrument of choice is Adobe Photoshop. While it is neither perfect nor is it capable of doing everything, its wide acceptance is due to its reliability, ease of use and depth of potential. Nonetheless, you should not feel left out if you cannot afford Photoshop. Excellent and powerful software such as Photo-Paint, Paint Shop Pro and many others less well endowed are entirely capable of achieving exactly the same effects.

For the beauty of pixel processing is that it uses basic tools: most of them are available in even elementary software.

Incidentally, it is not worth arguing whether digital photography means that the images must originate from a digital camera. If you do digital photography it simply means you work with a photograph in its digital form at some time in its life. Its provenance – whether from film, electronic sensor or Internet – is of no importance (either for this book or for any right-thinking person).

In this book I share with you all that I know about the art of pixel processing: how to take command of Photoshop for the use of your own visual sensibilities in order to make your fine photographs even better.

no part of photography remains wholly untouched by pixel processing

Therefore those who are put off by garish filter effects and clumsy juxtapositions – and there are many — may take heart. Those who are confused by the thousands of different effects available – be comforted. This book is for you. I concentrate on the essentials, working on the basis that digital image manipulation is at its best work when it remains quite transparent.

Indeed, perhaps the best compliment you can pay a pixel processor is the same as to a make-up artist or hairdresser: you do not realize they have been at work. All you experience is the joy in the vision: stunning to look at, a visual treat.

Paradoxical though it sounds, then, I hope this book will help you to work invisibly. You will then be creating on a higher plane than other image manipulators on this planet … long may you do so.

Tom Ang
London 2003

How to use this book

All the techniques shown in this book can be used directly or be easily adapted for use with most software. I used Adobe Photoshop 6 (and now use version 7) because it is convenient and powerful. But this book relies on perhaps less than 20% of its capabilities. Corel Photo-Paint 11 is also very powerful (better in some ways) and an excellent value alternative.

Nonetheless, if you have earlier versions of Photoshop, Photoshop Elements, Photo-Paint or use Picture Window Pro, Paint Shop Pro, Painter, PhotoFix, Soap, PhotoSuite, Photo Impact, etc. then every technique discussed here is applicable. And everything here applies equally with Apple Macs as to PC machines running Windows.

Instructions such as Image > Mode > Grayscale means: navigate to the Image menu, choose the Mode option, then choose the Grayscale option within the Mode option. Command (Control) + P means: press P while holding down the Command key if Mac or hold down the Control key with a PC running Windows.

We start from the very basics so if you have no experience of digital photography, you won't be left behind. However, I assume that you know basic photography. Some topics are tricky: there is no alternative to working on your own images. You may find my 'Dictionary of Digital Imaging and Photography' to be a useful resource. For further picture ideas, techniques and discussion, try my 'Silver Pixels'; both are published by Argentum.

1
Pixel processing essentials

The art of pixel processing is the visual equivalent of text editing in word processing. Its aim is to improve clarity by correcting visual 'grammar' and eliminating visible defects equivalent to visual misspellings and poor punctuation. The central aim is to improve the effectiveness of your images, to enhance their powers of communication. Now that even entry-level machines are capable of handling enormous files, pixel processing is as indispensable to photography as word processing is to writing.

In addition, digital technology is sweeping aside the tedious inconvenience of dark-room paraphernalia and its medieval needs for perfect darkness and – if you please – cool running water. Instead, grey boxes, purring fans and a Medusa's head of trailing leads are taking over your desk. The rewards of this unsightly invasion are, nonetheless, a considerable load of advantages: amazing immediacy of response, an infinity of opportunities visually to modify and experiment freely, coupled with a greatly reduced impact on the environment.

Pixel processing

Now, text editing improves the written word by shuffling word-order around, polishing word endings and refining punctuation. Pixel processing works in exact analogy with the digital image. It improves legibility, clarity of form and the readability of an image in order to improve – even to optimize – its ability to communicate, its ability to do its job. At the same time pixel processing will concern itself with reproducibility and suitability for a given mode or form of output – which is rather like making sure that the number of words written will fit neatly into the space available.

Pixel processing is therefore very different in intent from image manipulation. Whereas one stresses improvement, the other majors on

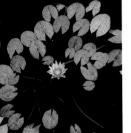

After a little exposure to image manipulation it can become hard to be sure what is real and what is not.

change; while one stresses preservation and enhancement, the other exploits invention and elaboration. And as one aims at reserve in action, the other is not afraid of being boringly in-your-face.

Functionally, pixel processing distinguishes itself from image manipulation by leaving the content – hence the meaning and significance – of the image substantially intact (although one may not wish to proscribe the occasional excursion beyond these limits). One test is that a statement about the subject matter of the image would remain true after pixel processing, whereas it may not be true subsequent to image manipulation. In other words, one could say that pixel processing changes certain qualities of the image – its contrast, local and global brightness or darkness, colour qualities and sharpness while leaving its content – what it shows or what it appears to refer to – largely unchanged.

The imaging chain

As a concept it is more descriptive than illuminatingly analytical, but that of the imaging chain helps us to keep in mind that working an image has a natural flow from one step to the next. Furthermore, the metaphor reminds us that the quality of our final image is only as high as the steps preceding it are carefully done: the chain is strong only as its weakest link.

Technically speaking, the imaging chain starts with the acquisition or capture of the image – this could be from a digital camera, scanner or onto film – so that what you capture is fixed into a more or less permanent and ultimately viewable form. In practice, however, image acquisition must be preceded by a number of preparatory steps and certain conditions must be met before acquisition is possible. It is well to keep this in mind. And indeed, we can start there: with the human mind: what are the intentions, the hopes and aims – are they purely mechanical or technical, or is the photographer hoping for acclaim and great riches? What are the emotions which drive the image

Toning effects are one of the triumphs of pixel processing: it is easy, flexible and powerful. Not to mention the convenience, yet you can still be surprised.

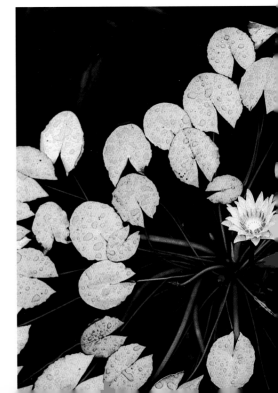

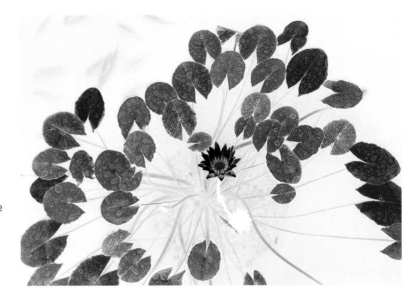

Its aim is to improve clarity, to correct visual grammar

acquisition? Are they fear, excitement, or boredom from performing a repetitive task? The answers can tell you much about the images that are captured. They may prosaically determine the technical quality, but are likely also to mould the power of the images to communicate effectively. This must be relevant because if, after all, the image does not communicate then why proceed with the rest of the imaging chain; why process the pixels? Far better to put them out of their misery; hit the 'Delete' button.

It's all processing

In a simple scenario, pixel processing follows from image acquisition. However it is being increasingly realized even by inexpert digital photographers that the process of acquiring the image – whether it is via the chip of a digital camera or working up the data from a scanner – itself puts the pixel data through considerable processing. Unfortunately nearly all of that is beyond the user's control but it is important to keep in mind that the pixels you work with have already been worked at by hidden circuits within camera or scanner.

Where you have a choice – and some digital cameras allow you to save a raw file – i.e. with minimum processing – while others allow you to pre-set characteristics such as contrast, saturation and sharpness – it is worth experimenting (and experimenting endlessly) with different settings to see which results cause you the least trouble and give the most satisfaction.

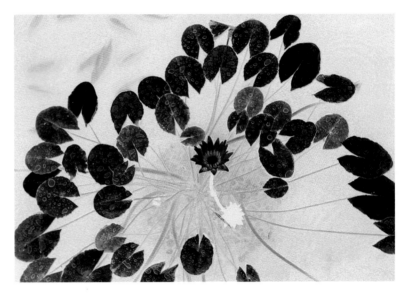

It is clear from the preceding that pixel processing itself can be done automatically – enough is known about human vision to be able to get very good images from the vast majority of image files. Indeed, that is how you can print directly from the camera to a printer: all you need to do is to tell the printer which camera you are using and the print automatically applies the corrections needed.

Of course, that is to miss out on all the fun. Pixel processing is the heart of digital photography: it is what distinguishes your images from the millions of images captured by identical cameras owned by thousands of others.

Now, the skill is not in what you do to your image, but what you do not do. The basic power of today's applications is awesome enough, but add the plug-in filters and the result is a bewildering infinity

of effects. It possible to use every different filter on each image but of course you will, mostly, likely, use three or at most four effects on any single image. It could be said that the exercise of skill and judgement in working with digital images is shown by the effects you do not use.

Finally, the imaging chain leads to the output. If image acquisition is creatively rewarding and pixel processing is fun, then image output is – unfortunately – often frustrating hard work. The reason is that for all the combined power of the computing, electronics and camera industry, no-one has brought colour under control. Although great advances have been made to ensure colour consistency and accuracy, our eyes are just too discriminating and accurate to tolerate what are, to machines, invisible differences in hue or luminance. However, it helps to understand something of what is going on and, in particular, to appreciate the limitations of machines and paper compared to the human eye and real objects in the world – see also pp. 24–29.

Seemingly simple effects like inversion of tones and colours show themselves to be highly complicated actions – to understand needs some command of its underlying technology. But pixel processing keeps to the simplest changes.

11

Anatomy of the digital image

To describe a digital image as a large collection of ones and zeros is accurate enough. But it is also deeply dull: it makes an image file indistinguishable from any other. The magic of the visual collapses into gas bills and spreadsheets. Worse, it hides the fact that a huge amount of applied science is crammed into every image you view. This is a condensed summary of the basics of the digital image: skip it if you find it difficult; but it could be worth returning to from time to time.

Essential digital

The fundamental method of visual recording in systems ranging from animal eyes to film-based cameras, digital cameras and video is to locate and respond to variations in brightness in a scene i.e. only monochrome tones are recorded. A digital image is ultimately distinguished from an analogue or film-based image in that variations in scene luminance (brightness) are represented by an arbitrary set of signs such as numbers and letters. This contrasts with exposed and developed film which directly and proportionately represents variation of scene luminance as variations in the density of silver or the quantity of dyes. As a grain in your film represents a part of the scene, so a picture element in a digital image stands for a part of the scene. However, you don't actually see the digital data – it must be output into a form which can be seen, and that step is itself essentially analogue in character.

All black & white

As all visual recording is basically monochrome, colour must be analysed into a number of monochrome components (called separation colours or channels). In theory any three or more colours – and even certain pairs of colours – can do the work. But the crucial point is that each component is recording only brightness variation. We say that each channel is greyscale – i.e. it codes a range of brightness from white to black. In one scheme, colours are represented by proportions of red, green and blue: each channel of red, green or blue records the brightness limited to its own band of colour.

Colour is played back or reproduced by reconstituting or synthesizing the components in the same proportions as originally analyzed. The accuracy of the reconstituted colour depends on how carefully and fully the original colour was originally analyzed into its constituents. With film-based materials, the design of the separation colours is something of an arcane art – modern colour films may have over 20 different layers to ensure the recording accuracy of the basic triad of separation colours. With digital files, one measure of accuracy (strictly, of resolution) is the bit depth: this tells you how finely or detailed the information is. A bit depth of one allows two states representing e.g. black or

The original image turned into a mosaic of squares measuring 200 x 200 pixels

The original image turned into a mosaic of 100 x 100 pixels square

all visual
recording is
basically
monochrome

With a 20 pixel-square mosaic, we can finally see enough to be fairly confident about identifying the picture. But is it easy to see what it is really about? We can identify a picture of a beach – but does it follow that the other images are of the same scene?

With mosaic of squares measuring 50x50 pixels square, we might be able to see what the image is about. Note the way that image contrast appear to increase, as averaging effects lessen.

white. A bit depth of two allows four states to be coded (2 raised to the power of 2), and so on – to a bit depth of eight allowing 256 different states or levels (2 raised to the power of 8) to be coded or named. Higher bit depth therefore translates into smoother, more accurate representations of transitions in tone, which may lead in turn to a greater range of reproducible colour.

Virtual in space

It should be clear that your digital image does not exist in space. You might be able to locate your digital file as being in so-and-so region of a hard-disk or lying in this or that part of a CD. But that is not the image, only where it is temporarily stored. Therefore the pixels of your image have no size either – not until they are output onto paper or displayed on a screen: this is fundamental to understanding how resolution applies through the imaging chain. (See 'Pixels on a pinhead' on p.113.) Nonetheless, the size of your digital file does tell you something important about your image: how much information you have. However, not all information is created equal: having a huge file is no guarantee that the image is of high quality.

To understand why, we need to consider the concept of the transfer function. This measures how well details in an original are transferred to the copy or other representation. A sharp image with useable contrast has a higher transfer function than does a blurred image – it records subject details at nearly the same contrast as present in the original. In the digital image, the details which can be recorded are very sharply limited by the number of sensors available to make the record. The basic image file cannot have more pixels than the number of sensors (or photo-sites) used to capture the image; therefore its capacity to record detail is also sharply limited. But this assumes that the image is well focused, that contrast of fine detail in the image is sufficient to be detected i.e. that the lens itself is able to project well enough; and that faults such as noise in the electronics, inadvertent shake of the camera, etc. do not degrade image quality.

Extracting colour

In order to obtain colour information, as we have seen, we have to analyse colours into primaries. Each sensor in the capture device must be assigned to a separation primary. In digital cameras the Bayer pattern is most often used. Sets of four sensors contain one each of red and blue, but two of green arranged so the red and blue are diagonally opposite each other, leaving the greens to occupy the other corners and out-numbering the others by two to one.

Now, each sensor represents a pixel in the image. But an image showing spots of various brightnesses of red, blue and green would look pretty poor (in fact it would look like a monitor image). Instead, each pixel is given a colour based on the colours of the neighbouring sensors. That is, the RGB values for each pixel are calculated by comparing the values of neighbouring pixels and applying a rule e.g. the G value for a R sensor is that of the lowest of the G values of the nearest four G sensors, and so on. This is called de-mosaicking: it smooths out the Bayer pattern. The net result can be, as we know, images of very acceptable appearance.

The number of pixels of a captured image is therefore a very optimistic measure of image quality. The population of pixels in an image can easily be increased but the actual detail captured by the system cannot. However, the effective appearance of detail can be improved. There are few reasons to have more pixels than necessary, but it does pay to make the most effective use of the pixels you possess … and that is what this book is about.

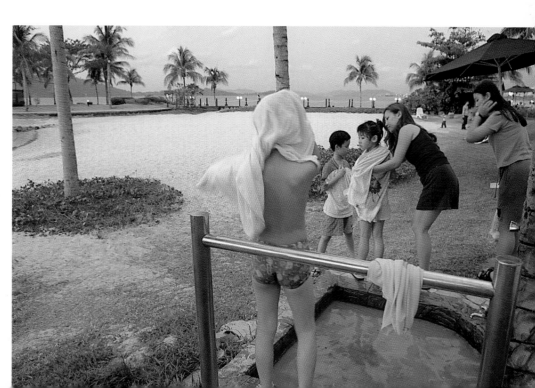

Technology and new choices

Today's changes are sweeping away the cobwebs of practice so quickly, you may find yourself changing even as you deny it. As digital photography becomes more and more part of your life, more or less subtle changes creep into the way you look and the very way you photograph. Change the tool, and you surely change the way you work. And if you think that you are unaffected, consider that virtually every image you see has been through the digital mill. Nearly every single image you see outside your own darkroom went through a digital metamorphosis at least once in its life. So, not only is no-one immune, the issue is turned on its head: if you want your pictures seen by anyone today, you need to keep in mind the requirements of that digital transformation. We consider now some changes and the new choices they offer you.

Slow responses

The majority of digital cameras take a relatively long time to wake up for work and may even take a relatively long time to take the picture once you've pressed the shutter button. There are thus two possible sources of delay: the start-up time and the shutter lag. The latter can be the greatest problem as it intrudes into the smoothness and flow of photography: you can never be quite confident that the image was taken when you wanted it, even if you try to compensate.

An associated problem is that, because the camera uses up the batteries while it's on – even if only on standby i.e. partially activated – you have to balance its slow start-up time against battery consumption caused by leaving it on all the time. Life is too short to enjoy the burden of yet another necessary balancing act.

Steady goes it

Perhaps more serious is the limitation on what is known as the 'burst rate': how many images can be taken in quick succession before the camera must pause to take a breather – the burst rate is determined by what is appropriately called the refresh time: how it long takes to clear one image from the data-stream before another can be shot. Modern cameras improve the

burst rate by using many different techniques to reduce the effect of bottle-necks caused by the need to process data, to write data, and so on. With film cameras you can of course expose film as fast as the camera can wind it on – right until the roll is finished. To be able to take 36 exposures without stopping is something only the very most expensive digital cameras are capable of doing. Even the Canon EOS-1D, for example, which costs nearly four times more than the top-of-the-range EOS-1V camera, can manage only 21 shots in succession (however, that is achieved in under 3 seconds).

Changing habits

As a result, you may find your shooting habits will adapt – you may have to pace yourself; you will have to look ahead and anticipate a little more. And you could find yourself worrying about batteries all the time.

When you expect your negative – whether it is black & white or colour – to be used digitally i.e. that it will be scanned, you can relax a little. Although it is as true now as always that the better the exposure and processing, the better will be the resulting scan, it is also true that you can do more with inaccurately exposed film and slightly under-par processing when you scan it than when you print from it. For example, it is easy for scanner software to correct for flatter-than-normal film – no recourse to special paper grades or developer: contrast Nirvana is just one mouse-click away.

Likewise, image manipulation software can usefully improve the sensation of sharpness even if, of course, no software is able to increase the amount of information actually captured by the film. And as for grain, image manipulation software can increase or decrease the graininess of film at will. The key, now just as it was at the dawn of photography, is to avoid over-processing. With all film, over-processing is a waste of time: any highly dense film is difficult to scan with

No software is able to increase the amount of information that is actually captured by the film

first things they were invented to do. Even large colour imbalances e.g. a scene lit by domestic lights shot on daylight-balanced film can be corrected, provided exposure is ample and that blue and green colours are not major components of the image. This limitation is caused by metamerism, the phenomenon of an object appearing to change in colour according to the illuminant hue. For example, suppose a vase that is deep blue in daylight is illuminated only by a household bulb. As this illumination is very deficient in blue light, the vase will appear nearly black and that is what will be registered by any film or light sensors recording the scene. Nothing can extract colours out of black which is, by definition and in actuality, lacking in colours.

Distractions done

With digital photography the tyranny of the telephone wire is coming to an end. No longer will you be forced to change your vantage point or to recompose a picture because wires criss-cross the view. You know that some careful work on the computer can make them disappear entirely. Indeed, as you gain in experience and confidence, other unwanted objects in a picture will hold no terrors for you. You will then note a corresponding shift in your photography: you will simply frame and compose for best effect, making a mental note to deal with the unwanted object later. This practice brings its own dangers – playing God with insufficient experience and training is never safe – so you need constantly to retain both a respect for the subject and preserve a healthy scepticism of your motives.

With the sun below the ridge, the glacier was in the blue shadows of evening. The resulting transparency was heavily blue cast and lacked contrast. But you make the shot anyway, knowing that convincing colours and healthy contrasts are a few mouse-clicks away.

When working to small enlargements it is only a few seconds' work to remove the wires – you do not have to work precisely.

success. With negative film you build up excessive density which loses tonal subtleties as well as definition – although a slight extra development can be beneficial. With positive colour films, you lose colour as well as fine details – and these are also difficult to scan.

Relaxed lighting

In parallel with a relaxation regarding processing – and for similar reasons – you can relax about lighting. It is easier to deal with lighting that is slightly out of control in the computer than in the darkroom. You will find that, instead of feeling discouraged from photographing a scene because of the tricky lighting, you will go ahead anyway. You will be able thereby to enjoy the moment and proceed with the confidence that in trying to balance the tones in the computer you are not going to waste countless sheets of paper.

A different relaxation applies to the colour temperature of the illuminating light. Small imbalances are easily corrected in image manipulation software – indeed that is one of the

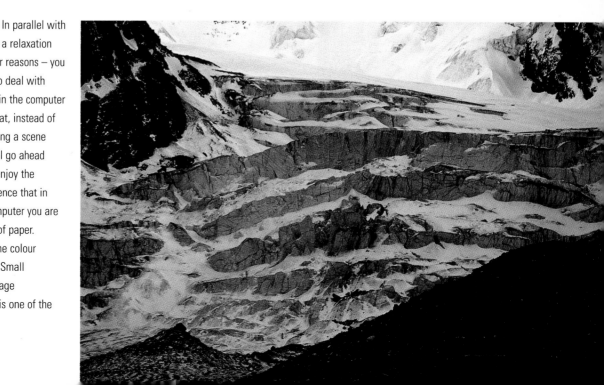

Software directives

The beauty of pixel processing is that nearly all of it can be done by nearly any software application designed for image manipulation. That is because pixel processing does not rely on plug-in filters producing improbable effects, nor on sophisticated layering and compositing techniques. The fact is that all imaging software – even camera and scanner drivers – offer tonal controls, dodge and burn tools, some sort of sharpening filter as well as more or less control over colour channels. Now, if you find you are having to improvise non-standard methods and developing work-arounds to obtain the effects you want from your software, or you're throwing the instruction manual across the room then it is probably time you considered upgrading to more capable software such as Adobe Photoshop or Corel Photo-Paint.

Compare this orderly arrangement of images – which can be easily reclassified – to a box full of prints. The latest software, such as iPhoto for Macs makes picture management even easier

Overdose on RAM

Whatever you use, there are some habits and approaches which long experience has shown to be worth their weight in saved sweat and tears. The first is have as much physical RAM (Random Access Memory) installed on your computer as possible – irrespective of whether you are a Mac or a PC user. Now, if you are a Mac user (with operating systems prior to Mac OS X) you should allocate as much RAM to the image manipulation software as possible. At the time of writing, RAM prices are so low there is little excuse for not installing as much as the computer will hold – as much as 1GB or more – and certainly as much as you can afford. A related tip is to quit all applications you do not really need to be running – let your pixel processing hog all the memory. Do not as I do – run six applications at once – but then I'm writing, designing and processing images all at the same time.

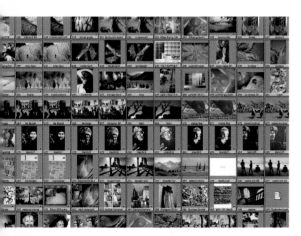

While Photoshop is the engine at the heart of image manipulation, it does not do everything. Locating images was difficult until verson 7, which can display thumbnails of folder contents. And while Photoshop can take the drudgery out of some repetitive tasks, it is inflexible for those working with large numbers of pictures. Furthermore, for some simple tasks such as changing the format of a file, using Photoshop is like taking a hammer to a nut. For these tasks shareware Graphic Converter is fine or the fast and powerful Equilibrium DeBabelizer is the tool of choice.

Manage thyself

An essential utility for the digital photographer is a picture manager, also called digital asset or portfolio manager. With such an application, you can view all contents of a folder on screen in small thumbnail pictures – usually you can decide whether you want small thumbnails, so you can see perhaps twenty to forty or more images at once or you can view larger thumbnails. You will be able to perform useful jobs such as change file names, rotate images, move an image from one folder to another. Perhaps the most useful and impressive of their abilities is being able to print out a 'contact' sheet of all the thumbnails, complete with file names.

One of the best known is Extensis Portfolio. In the same semi-professional league is Canto Cumulus. These applications are good if you have large libraries and want to be able to search images by keywords. This feature always appears a good idea at the time, but don't forget that some poor mutt will have to input all the keywords – and as no-one knows your pictures better than you … If you take this route, it is advisable to start while your collection is small – which is when you don't really need the indexing but the task is then manageable.

The fastest working application that I know for image management is FotoStation: it is inexpensive, but may be found bundled e.g. with Nikon scanners. It is not very customizable but it is easy to use, works very rapidly indeed and is stable provided it has lots of memory. I unreservedly recommend the more powerful Pro version.

Software which create proof-sheets are often given away with printers and cameras. It is one of the most useful things to come out of pixel processing.

Some poor mutt will have to input all the keywords

Working practices

The advice given here is not an unrealistic attempt to make you work with perfect tidiness – every sheet of paper in place, disks in neat order, cappuccino out of easy reach. But there are aspects of your workings which impact on your health, and others on the quality of work you produce. It's worth trying to maintain high standards.

Work-safe place

Your first priorities with the workspace are to work safely and to maintain good health. Safety in this context largely concerns electrical matters: see the side-bar. Good health is assured by working comfortably: it is futile to insist on a clear and tidy desk (I certainly can't keep mine tidy) but at least ensure you sit square onto the computer and keyboard, that you can reach the mouse comfortably and move it without obstruction. Your chair should be comfortable, able to tilt slightly forward and be at a height so that your arms can lie horizontally on the desk and you can see the monitor screen with your head held level.

> Disks in neat order, cappuccino out of easy reach

Next you should attend to lighting. The overall light in the room, including the colour of its walls can affect your experience of the image on the monitor as well as literally colouring your perception of any print-outs. For professional work, the room should be in semi-darkness with neutral-coloured walls and any light used to view a print or transparency should conform to industry standards. For the rest of us, ensure that desk-lamps do not shine onto the monitor screen and also place the monitor so that it does not pick up reflections from any bright objects such as a window or lamp.

Virtual tidiness

Creating and maintaining a tidy, efficient workspace is just as important in the computer – your virtual desk-top – as it is on your real desk. And it is equally advantageous to work neatly in the computer as in your real room. The truth is that if we are untidy in the real world, we are usually even more untidy in the virtual one. The result? Chaotic file management which causes you to lose time looking for images or the unintended deletion of work or, even worse, not even realizing you have lost work until you need it again.

A common error is to save your working files in the first folder which is offered by the system – usually that which holds the application and its helper files. If you do that, your work will be mixed up with the application. Now if you move your work to other folders or delete unwanted work, you risk misplacing or deleting essential software components.

You will find it easier to locate your files if you first create a folder for each project or subject – e.g. 'Granada' for digital images captured on a trip to Spain. The folder 'For print-out' holds images you have cleaned and corrected, ready for printing. You will find that you open some folders far more often than others: create a shortcut (Windows) or a favourite (Mac) so you can find these quickly.

The same applies to software – you could even have some software open automatically when you start the computer up: consult the system software help for details.

Sensible names

You will also find it helpful to name your images in such a way that you can understand in years to come and which others can interpret easily. 'Becky in Canaries' may mean much to you right now, but in three years' time will you remember it's a silhouette of a girl against a volcano? And a stranger would be forgiven for expecting to find a girl on a beach. A name like 'grl silhtte vlcan GnCanaria 03' contains description, location and date all in abbreviated form but is not too difficult to decipher. In fact, as all current computer operating systems allow long names – Mac OS X allows what amounts to a short document – your file name can be effectively a brief or abbreviated caption. It takes longer to work out a suitable name at the outset, but clearly it will save you much searching later.

The desk-lamp is a great enemy of pixel processing: its sprawling yellow light confuses your colour perception and reflects in the monitor. Keep it clear if you cannot keep it off.

2 The Photoshop workspace

Even experienced workers seldom use all the tools – and for the beginner, the sheer variety can be a bewildering inhibition to doing anything at all. Here are the most important commands for the digital photographer. Learn these as a basis for mastering pixel processing.

Open

Command (Control) + O

Open files not by sending the mouse to the File menu (takes too long), but by hitting the Command (Control) key and O: in no time at all a list of folders and files appears for you. If you know the name of your file, type the first letter and you will get near or click on 'Find' to search for it.

Save

Command (Control) + S

Type this with your thumb on the Command (Control) key and you can reach S with the first finger: soon you will do it without looking, almost without thinking. Check that you know to which location your file is being saved: never save in the application's folder.

Save as

Shift + Command (Control) + S

Type this with your thumb on the Command (Control) key and little finger on the Shift key, so the first finger reaches the S easily. This too will be something you can do in your sleep. Use this so you never save on top of – and replace – an original image or scan.

Escape

Esc

Use this key – usually in the top left corner of the keyboard for your third or little finger – to dismiss dialogue boxes when you decide you do not wish to apply an effect. It is easier than pointing the mouse at the 'Cancel' button.

Undo last step

Command (Control) + Z

The busy thumb and first finger combination is responsible for this one too: it is useful for comparing subtle changes in an image, enabling you to flick rapidly between one or the other – what hi-fi buffs call 'a/b-ing' – to switch between sources a and b.

Page setup

Shift + Command (Control) + P

Get into the habit of invoking this command before you print, particularly if you print to a variety of sizes or if you have to share a printer. It enables you to confirm that the size you want is indeed what the printer is instructed to print. At the same time, of course, it reminds you to check the kind of paper loaded. A quick way to check is to click on the bar in the lower-left corner of the image window: a page preview is presented – lack of a margin and diagonals that do not reach the corners (see right) show the image is larger than the page size.

Print

Command (Control) + P

A typist will use any finger for the Command (Control) key and the third finger of the right hand for P. You need never send the mouse pointer all the way to the top left-hand corner of the screen and navigate down the File menu to Print.

Moving around

Space-bar

When you're viewing an enlarged image and want to move to another part of it, hold down the space-bar and drag with the mouse i.e. place the cursor on the picture, hold down the mouse button and move it. This key-and-mouse combination is by far the easiest way to move around the picture.

Zoom in

Space-bar + command (control)

Press this combination and the cursor changes to a magnifying glass (with + sign): click and you zoom in. Or you can click and drag an area: this then is enlarged to fill the window. Thus if you drag only a small area you get a big enlargement. Also, you can use:

Command + +

Hold down the Command (Control) key and hit the plus key will also zoom into the image: a good option when your hands need a rest from using the mouse (an anti-repetitive strain injury measure).

Zoom out

Space-bar + option (alt)

Press this combination and the cursor changes to a reducing glass: click and you zoom out. This is so much easier – even infinitely easier – than using the magnifying glass tool plus key. Also you can use:

Command + –

Hold down the Command (Control) key and hit the minus key will also zoom out of the image: a good option when your hands need a rest from using the mouse (an anti-repetitive strain injury measure).

Full size image

Command + 0

The combination of Command (Control) + 0 i.e. with the zero key – not capital 'O' – takes the image to full screen whether it starts from small or is enlarged. Photoshop is slightly bugged here: the picture may take up only the free space left by palettes, sometimes the picture is partially hidden by palettes. If you move the palettes out of the way the image can be larger. Take care: the image is likely to be heavily interpolated as the magnification will probably not be an simple ratio like 50% or 100%.

Reset or re-apply

Option (Alt)

You have been working in a dialogue and decided it is best to return to the original settings. Hold the Option (Alt) key down, whereupon the 'Cancel' button turns into a 'Reset' button: click on that and the settings return to their default values. This shortcut works with all dialogue boxes. To apply the previously used settings, hold the Option (Alt) key when you open a dialogue box e.g Option (Alt) + Command (Control) + M to re-apply a curve. To re-apply the last filter used with the same settings, type Command (Control) + F.

Jump numeric entry boxes

Tab

Ordinarily the Tab key sends the cursor to pre-set stop points in word processor documents or to successive cells in a database. In dialogue boxes, Tab does the same: it sends the cursor to one numeric entry box after the other. You will find it so much easier to hit the Tab key a few times than to point the mouse pointer to the right box especially when, as above, the boxes are tiny.

Changing numeric values

Arrow up and down

In menus, pressing the arrow keys increases or decreases the figures in a selected numeric entry box. This is preferable to using the numeric keypad or, worse, the numbers at the top of the keyboard. Hold down the Shift key for changes in steps ten times the basic unit i.e. either whole units or tens, according to the units used in the dialogue box.

Viewing modes

F

Jump between viewing the image in a window – as normal – or to a plain mid-grey background or to a plain black background. The mid-grey is most useful e.g. for checking colour reproduction (see Preview CMYK, p.23). Black is useful largely for cheering yourself up – colours look great. If you're desperate for screen space, hit Shift+F (after hitting F) to clear the top menu bar as well.

Quick little digits

A useful trick for reducing fatigue of finger and hand is to enter double digit values e.g. for the strength of a filter or the opacity of a layer by hitting the same number twice. For example, instead of typing 20 for a value of 20, try typing '2' and '2': your fingers only have to find the '2', not two different keys and how much difference is there between 20 and 22? Equally, if you want a value of 80, you will find that 77 will do just as well. It takes a little while to get used to this trick, but in the end anything that saves time and effort is worth a little application beforehand.

The tools of Photoshop

Tools in Photoshop's Toolbox are best accessed by typing a letter. English users complain about the correspondence between letter and name of tool but to forget think about the poor non-English user. Some tools are accessed by typing the same letter a few times e.g. typing E cycles through different Eraser tools – normal, magic and background (you can set in Preferences whether you need to hold the Shift key down or not). Only a selection of tools from the Toolbox are featured here. Some, like the Zoom or Move tool should always be accessed through the keyboard combined with mouse action.

Crop
C

One of the first keys you should hit after you open a scan: it enables you to remove excess edges of the image which might have been caught on the scan. Note that if you have set to snap in View > Snap i.e. if a line gets close to a guide or edge it will jump to it – then fine crops are difficult to achieve. Turn off snap by typing Command (Control) + ; (semi-colon). You can override snap-to temporarily by clicking and holding the mouse button down on the crop handle then depressing Control (or right-clicking in Windows).

If you have a number of pictures to set to a fixed size, you can put the figures, including resolution, into the options. In fact this is a quick way of changing image resolution .

Burn/Dodge and Sponge
O

The 'O' key of your keyboard will wear down with the number of times you hit it to access the tools for burn, dodge and saturate. The latter is also known as the sponge tool, in a quaint reference to a water-colour

technique. Pressing O successively cycles through the three tools. To choose between saturate and desaturate, you have first to select Sponge, then, while pressing Shift + Alt (Option) press S for saturate and D for desaturate. If you find this is illogical and long-winded, don't ask what previous versions of Photoshop demanded.

The Shift + Alt (Option) key combination is worth remembering because with it you can choose to burn-in or dodge different tonal ranges: the quarter tones of shadows or highlights or the midtones. And the keys are logical: pressing Shift + Alt (Option) add M for midtones, S for shadows and H for highlights. While this is easy to remember unfortunately it's a two-handed operation unless you have the manual dexterity of a concert pianist.

Clone
S

Also known as the Rubber Stamp tool: you will reach for it in the hunt for unwanted dust-specks and scratches and watermarks. Pressing S a second

time gives you the Pattern stamp which crudely paints a pattern onto your image. In version 7, pressing J will give you the powerful Healing Brush or Patch tools – these adapt the source image to the destination, which makes repairing some faults easier than straight cloning.

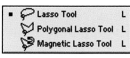

Lasso
L

This tool, pronounced 'lassoo', selects or separates off pixels from the rest of the image. You use it like a pencil: draw a line around the area you want to select and when you completely surround it, the area is defined. You can decide how finely or precisely the area is defined using the Feather setting: 0 makes a clean cut, whereas higher figures makes for a fuzzy selection.

Press L again to gain the Polygonal version: this cuts out irregular shapes with straight-line sides. Press L again to obtain the wonderful Magnetic version: this can detect if you hand is wandering and keep the line to the boundary between different areas. Using these tools takes practice.

History brush
Y

This is a marvel of a tool: it lets you paint back from the current state in the History Palette to any previously stored state. It means you can apply an overall filter and paint back selected areas to reduce or remove the filter effect – useful when trying to deal with dust specks: apply a blur overall, then paint back the areas you want sharp. If you

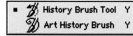

want to be creative, you can set up a number of different states and jump from one to another as you apply the brush. The Art History is fun as it adds painterly textures, but its usefulness to pixel processing is limited. Besides, Corel Painter does a much better job.

Gradient

G

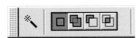

You will reach for this when dealing with broad areas of uneven tone. You can set to run from colour to white or from colour to transparency, with the colour applied in different modes. It is a powerful tool but you have to learn to work with accumulated results. That is, if you don't get the result you want with one gradient, it will be easier to create new layers with different gradients which overlap in a shape that cannot be created with a single gradient. Type G again to fill a layer with colour with the Bucket tool.

In later versions of Photoshop, the Gradient palette is a kaleidoscope of different colour schemes and effects – most pixel processing will steer well clear of these garish variants.

Magic Wand

W

You can set the selections to intersect, add, substract, exclude etc. by clicking on the appropriate icon.

A tool eagerly reached for by beginners because, well, it seems to work like magic. With it you can instantly select a plain background and consign the troublesome pixels to the scrap-heap. It looks at the pixels you click on and rounds up all the pixels which are similar, within the tolerances which you specify. If you specified too wide a tolerance, you will select more pixels than you intend. It is often better to specify a narrower tolerance than would do the job in one go, then add to the selection by clicking on a new area while holding down the Shift key. In later versions of Photoshop you can decide whether pixels selected are next to each other i.e. contiguous or whether they can be separated by other, unselected, pixels i.e. the selections are non-contiguous.

Marquee

M

It may seem at first sight that the pixel processor will have little need of this tool as it selects large areas for compositing purposes. But it has uses for the quick repair of large areas of even tone. Further, there are two little-known features: these enable you to select a single row of pixels either vertically or horizontally oriented. Why would you ever want to do that? If a single CCDs sensor on a scanner is faulty, it can

leave a line all the way down your image that does not match that of the rest of the image. The single pixel row or column marquee makes it easier to mend such damage. Note that these tools must be accessed by mouse action.

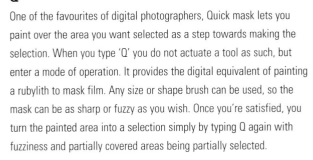

Quick mask

Q

One of the favourites of digital photographers, Quick mask lets you paint over the area you want selected as a step towards making the selection. When you type 'Q' you do not actuate a tool as such, but enter a mode of operation. It provides the digital equivalent of painting a rubylith to mask film. Any size or shape brush can be used, so the mask can be as sharp or fuzzy as you wish. Once you're satisfied, you turn the painted area into a selection simply by typing Q again with fuzziness and partially covered areas being partially selected.

Quick Mask paints a red 'rubylith' which changes into a selection when you exit Quick Mask.

The key shortcuts of Photoshop

An exhaustive list of all the shortcuts available would be exhausting. Instead, here are some of the more useful, constituting the foundation set you should know. Some, such as cut and paste, are system-wide. Others are specific to Photoshop but may apply to other software.

Copy
Command (Control) + C

Select a group of pixels, then copy them with this command – leaving the original in place. The copied data is held in the clipboard until you replace it. If you copied a large chunk of image, it can slow your machine down. You can purge – i.e. empty – the clipboard from the Edit menu > Purge > Clipboard.

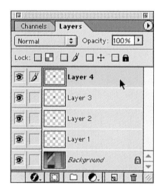

Paste
Command (Control) + V

Yet another task for the busy thumb and first finger: this places the pixels you copied onto the image. By default in later versions of Photoshop, a new transparent layer is automatically created to hold the pasted-in image. This can can be a nuisance for multiple pastes (left).

Cut
Command (Control) + X

A cousin to copy and paste is Cut: this removes selected pixels and stores them in the clipboard. I use this to delete items as it is a single-handed action.

Levels
Command (Control) + L

Another command you should be able to do in your sleep. Add the Shift key to apply Auto Levels – the automatic version which helps in a minority of cases. In version 7, if you add to that another key, Alt, you obtain Auto Contrast which corrects exposure without shifting colours and generally works more successfully than Auto Levels. To apply Levels control to individual channels you hit Command (Control) + 1, 2 or 3 in the order red, green, blue – i.e. RGB.

Image size
Image > Image Size...

Everyone accesses this so often, it is surprising it has no shortcut. I recommend you create one straightaway by creating a new action. It is vital you are comfortable with every detail of this box. See also pp.110-111.

Unsharp mask
Filter > Sharpen > Unsharp Mask

This is another menu option you reach for so often, it should be given its own standard programme shortcut. In the absence of any, make your own through the Actions palette.

Curves
Command (Control) + M

Obviously Command (Control) + C cannot be used to invoke Curves because that key combination is reserved for the system-wide Copy command. As with Levels, Command (Control) + 1, 2 or 3 cycles through the channels. In CMYK mode, the channels appear in the order you would expect, with Command (Control) + 4 for the K channel.

Hue/Saturation
Command (Control) + U

Another key (excuse the pun) command for your lexicon: most often you will use this to improve colour saturation especially when accessing poorly scanned or Photo CD images. For this it is easiest to use the Tab key: opening the box and hitting the Tab key once takes you straight to the Saturation control.

Fade
Command (control) + Shift + F

Suppose you applied a filter or tonal change but find the effect too strong. This command reduces the effect without have to return to the original command: you simply pull the slider down or enter a figure and the effect is reduced. Furthermore, the reduced effect acts like a layer so you can change the layer mode – this gives you scope for a good deal of subtle manipulation. It is worth experimenting with both opacity and mode after you apply any filter or tonal effect.

Open dialogue with previous settings

Option + command for dialogue

This little trick is useful when you are applying very similar settings to a series of images but don't wish to set up the batch or automatic processing feature, or if you simply wish to see the effect of a setting on a different image.

Duotone mode

Image > Mode > Duotone

A modestly named command, this: not only does it take you into duotones – the world of printing with two coloured inks – it takes you into printing with three and even four colours. In this control you can select the colour of the inks and apply different transfer curves to each. You also set whether a colour overprints – i.e. completely obscures – another. A fascinating and powerfully interactive tool for the pixel processor: we will look at this in loving deal of detail on pp. 68–73.

Moving selections

Arrow keys

You can throw your selections around with the mouse, but when you need to work to niggling pixel-accuracy, you need the arrow keys. In this mode, they are accurately referred to as 'nudge' keys. Your selection will be nudged one pixel at a time by pressing the arrow keys or, with the Shift key down, by ten pixels at a time.

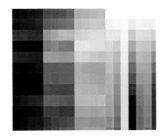

Color balance

B

The Color Balance command may be used for toning black & white images in RGB mode as well as correcting colour balance of colour images. Like many slider-based controls, it may be easier to use the keyboard than to use a mouse. Ensure you have the Preview box checked so you can watch changes as you set them.

Jumping channels

Command (Control) + ~, 1, 2, 3, etc.

When you have any dialogue box where separation channels are

relevant, you can cycle through them using these key combinations. In the Hue/Saturation dialogue, you can choose the waveband in the same way. It is quick and easy and the principle also applies to other dialogue boxes such as for Preferences.

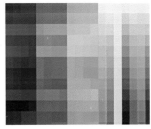

Preview CMYK

Command (Control) + Y

This is a vitally important command to use but its effect you may find so depressing you will not like to use it at all. The decrease in vibrancy and liveliness of the image on previewing CMYK is a reality check on what happens when your image lands onto paper i.e. it soft-proofs the image – and is a salutary reminder of the facts of life. The precise effect of the preview depends on the colour settings you have made (see pp.24–7) and assumes a calibrated monitor. Make a habit of using this before you pronounce an image ready for the world of print.

This pair of pictures simulates the difference between the brilliant RGB image on screen with its inevitably less lusty image on print – CMYK preview helps you accept this fact.

Do it yourself

Turn yourself into a keyboard wizard by creating your own shortcuts. Most professional-grade software allows this. Photoshop allows as many as 15 function keys (keyboards usually offer at least 12) to be defined; which, multiplies to 45 when used with Shift or Command (Control) keys. A dozen commands is plenty, unless you have great memory.

To create one, ask for New Action in the Actions palette (click on the right-hand arrowhead and drag down). Give your new action a name including the key e.g. "Rotate 90 CW Cm+F2". Choose the F2 function key from the dropdown list and choose Shift or Command (Control) if needed. Click on 'Record'. Return to the Actions palette and click to obtain 'Insert Menu item': you can then select the menu option as normal e.g. go to Image > Rotate > 90º CW and it will be allocated to your key. Click on the red spot on the bottom of the Actions palette to stop recording.

If you use different software, try to ensure that the keystrokes are as similar as possible across them all e.g. I use F12 to mean "Save As" in Photoshop, Word, Excel as well as Painter.

How to calibrate your system

Almost everything in photography – cameras, lenses, exposure meters and film – has been carefully calibrated so that they all work together. In these, the early days of digital photography, you have to calibrate the system yourself – just like in the first days of photography.

What is calibration?

Calibration is the matching of the response of an instrument with a standard. In scientific work, standards are stable and reliable. But in digital photography, the final standards we work to are our own visual perceptions of correctness of colour and density – neither stable nor reliable, yet highly critical. But independent standards exist, and if you do your best to adhere to them, your reward will be fewer unpredictable results. Now, if everyone were to do their best to adhere to the standards, everyone would suffer fewer unpredictable results.

The strategy for calibrating colour is to define a standard colour space, one which includes all the colours which can be perceived by the human eye. The range of colours or colour gamut which can be recorded or reproduced by an instrument is then defined in terms of how it differs from the standard: from this can be created the instrument's colour profile.

In theory, every component system producing an image file should be calibrated: digital camera, scanner, monitor and printer. In general practice, only the monitor is calibrated, if you calibrate only one thing, let it be the monitor. The work will prove itself when you pass an image file to someone else and they produce output that produces no nasty surprises – that is very satisfying indeed.

Check that your monitor is displaying millions of colours – the only choice for serious pixel processing.

Checking monitors

So, if anything is worth an hour's steady attention and work in digital photography, it is the calibration of your monitor. This is where you meet your scan or digital image face-to-face, for the first and indeed last time. It is at the centre of all you do. How can you possibly take the probity of your monitor's image for granted?

Using the screen-based metric tools for calibrating your monitor is not the most reliable or precise, but it is infinitely superior to ignoring the whole issue until you have to do something critically important. And it is really quite easy. But first to dispose of a common error: monitor calibration is not a process of making the screen image look really great. Actually quite the opposite: it's to make the screen image look as if you had the image on a piece of paper – which is, of course, dull and low contrast compared to what monitors are capable of.

First, turn on the monitor and let it warm up for at least 30 minutes. While you are waiting, ensure the room lighting is in its most usual state – e.g. if you usually work at night, dark with desk-lamps and not bathed in morning light. Remove any source of magnetism e.g large loudspeakers or transformers as far away as possible and do not move the monitor – all can change colours.

This panel helps set contrast to a standard.

Now turn on the Adobe Gamma (Windows) or the monitor calibration in the control panel for Monitor > Colour > Calibrate (Mac OS 8–9; or the Displays option in System Preferences in Mac OS X). Follow its instructions which take you step by step through the process. You should be able to alter the monitor's contrast or brightness directly. The other controls can be effected through software. But if you can make the adjustments through buttons on the monitor, then that is technically preferable.

This panel balances the three 'guns' which aim at different phosphors to produce the colours.

A choice of gamma

Now, all would be easy if you simply had to follow on-screen guides but unfortunately you have to make some decisions from choices offered. First tricky bit is deciding on the gamma. Actually that's easy: you select a gamma of 1.8. This is the Mac OS standard and that of the printing and repro world. It produces an image which appears brighter and with weaker colours than a monitor set to a higher gamma e.g. 2.2 – in short the screen appears less attractive at a gamma of 1.8 than at 2.2 but then the screen image will better match your print-outs.

This panel sets monitor gamma – higher figures make the screen darker .

White point choice

Next there is the question of the white point to use. Here the correct answer depends on what you want to do. But note that if your monitor has button-based controls for choosing the white point, then set it using the buttons before starting the calibration

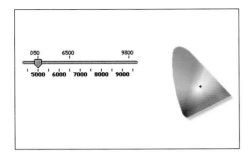

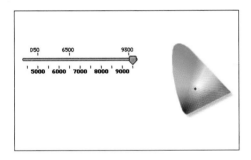

Choose the white point – between D50 for repro (top) to 9300 (above) for a bright, blue monitor image. Note the cross pointer (indicating the white point) changes position.

steps. If you set them after you begin the calibration process you'll need to start all over again.

For general, non-critical purposes, choose the D65 (or 6500 K) white point: this is midday white, relatively blue: it is visually at a half-way house between the print repro and the PC standard. It provides a good screen image usable for word-processing as well as one passable for image processing. While D65 is useful for assessing images for the typical Web surfer's screen, it is arguably not so accurate for print-based work – either ink-jet or off-set.

For the latter, the standard white point is D50 (or 5000 K): called 'warm white'. When you first switch to this white point the screen image looks quite horrible. But after a minute, it does not look so bad. And once you get used to it, most screens will look much too blue and brilliant to you. D50 is in fact the standard used by the repro and graphic arts industry for it delivers a white that is close to paper seen under a strong domestic tungsten light i.e. a warm white. However, D65 may be used for output on bright-white glossy paper.

Colour spaces

At the end of this setting-up process, you will have given the software enough information to generate a colour profile for the monitor. You will be invited to give it a name, which will then be

placed into the system. Two separate things have occurred, which are often conflated into one. Firstly the process of matching targets and such has set up your monitor to approach a known standard – this is calibration. At the same time, you need to tell the system that you've done all this work and provide the data it needs i.e. the settings needed to match your monitor or printer's colour space to that of the standard colour space - this is characterization.

The nature of colour spaces is described on pp.28–29 but here we consider only what you need

to set. In deciding on which RGB space to work in, you are defining the source space – that from which you will print. This can be defined by the monitor's RGB or that of your ink-jet printer. I used the ColorPerfexion RGB space which is designed to reduce mismatch with the CMYK space without making the space as small as that as CMYK – this is important as most of my work is destined for CMYK printing. A popular space, touted as a new standard, is sRGB. It is, however, a pig's ear of a standard having been defined so that most monitors fall within it i.e. it has all the miserable limitations you'd expect of a lowest-common denominator solution. In contrast, a good all-rounder space – recommended if you have no other clear choice – is Adobe RGB 1998. These matters are discussed in greater depth on pages 26–27.

The CMYK space is the space in which your output will appear. If you do not produce images for printing in books or magazines, you need not trouble yourself with this. The rest of us do, however: I use the ColorPerfexion Offset B space as that is a space statistically generated from numerous colorimetric measurements of the actual output from a number of printing presses around Europe. As it is not possible to predict where your work will be printed, a real-world space based on actual printing press performance is comforting.

In the absence of this solution – which is not inexpensive –– you can use a standard such as Euroscale coated, which will cover much magazine work or else use the generic CMYK profile, which is designed to play on the safe side of reproducibility.

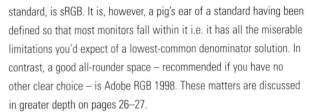

The space for monitors (above) is defined by straight lines joining the three phosphor colours. The space of four-colour printing (below left) looks like this: note the lack of deep colours like dark blue.

Living with monitors

- Ensure the monitor is displaying millions of colours.
- Remove colourful, jazzy background patterns from your monitor desktop – replace with boring grey. Bright patterns mess up accurate colour perception.
- Monitor performance changes and declines over time so re-calibrate and re-characterize your monitor every couple of months. If you find it difficult to calibrate your monitor, it's probably reached retirement age. Use it on a print server, for the Internet – or give it to a school.

Setting up for great print-outs

For almost all digital photographers in the world, the question of good colour reproduction boils down to whether you can obtain good-looking, accurate and consistent results from the ink-jet printer sitting at your desk. Yet this can be more troublesome than obtaining excellent results when your images are printed by a large-scale printing operation on the other side of the globe. The reason for this can be found in the printshop's steady adherence to industry standards whereas your system is, by comparison, a wild cannon. We look at the ways you can work like a professional printer and obtain similarly reliable results.

Print control

Of the principal factors which affect reproduction accuracy, perhaps the easiest to control yet the most often neglected is the paper. You know, of course, that if you want consistent colour you should stay with the manufacturer's own inks — however painful that is on your credit card. And controls built into the printer's software or driver also contribute hugely to image reproduction. But the paper itself — how easy it is to change and how unpredictable results can be!

Firstly, be aware that humidity greatly influences the character of a paper. Do not keep your papers next to a radiator or window where they will dry to a crisp nor keep next to a damp wall where they may become saturated: paper that is too damp

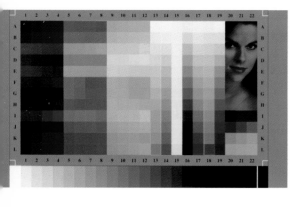

A scan from an IT8.7/1 transparency is a good real-world standard for test prints.

may crinkle and refuse to lie flat. Nor should paper feel crisply dry.

Next, beware that many ink-jet papers have two sides — one gives good results, but print on the other and you waste ink, time and the sheet. Manufacturers are careful to give you clues — either a corner nicked from the sheet, a light imprint of their name on the non-printing side or packing the printing side so it faces the front of the package. Thirdly, beware it is not safe to assume that papers from the same

manufacturer will produce matching colours and density. You could predict, just from first principles that, for example, a print on high-gloss film will offer a higher contrast and saturation than the same image on a matte-surface paper, even after correction for the different surfaces. At the same time, different colours can interact differently with the paper, which leads — just as with silver-based materials — to a shift in colour balance.

Finally, on the no-free-lunches principle, while papers that dry smudge-free very rapidly are very practical, you may find that colours are neither as intense nor contrast as snappy.

Being systematic

Let us assume you have a sample of paper and wish to test it. You will already have calibrated your monitor at least by using a subjective screen utility such as Adobe Gamma. Also ensure that you have a nice dull but neutral desk-top picture of 70% grey.

The ideal file is a standard which you use again and again. This way you can build up a library of test prints which will serve as a useful reference. A useful standard is a scan made from an IT8 target alternatively use the IT8/7.3 file which offers a good range of CMYK colours. This file, as well as the neutral desk-top, is installed as an accessory in the Mac OS in the Targets/Tools folder. Windows users can use the Olé No Moire file which Photoshop keeps in the Goodies folder. Avoid images with delicate tones and pastels: you are here evaluating only the accuracy of colour reproduction not their subtlety. Wait until you are satisfied with the accuracy before throwing difficult images at the printer.
Open the file

Olé no Moiré supplies basic cyan, magenta and yellow with grey patches and a colourful picture. But too many prints of this could drive you crazy.

A full colour target such as the IT8.7/3 can be confusing. Squinting or look at comparison with half-closed eyes may be easier.

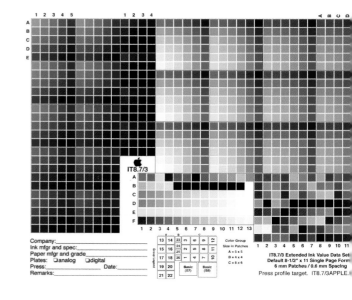

Print your image at !00%; do not allow the printer to re-size the image or colour accuracy will not be reliable.

up in Photoshop and take a good look at it. Remember that you want the print to match the monitor image; you must not look at either the screen or the print image to judge one on its own merits. You must evaluate both images relative to each other.

Now open up the print dialogue and make a note of all the relevant settings – particularly print quality, paper used and colour control. If you invoke any special colour controls beyond the default values, make a note of these too.

Next print off and compare it to the screen image. A good light-source is a low-voltage tungsten halogen lamp: easily recognized by their large base for a transformer and a very small, extremely hot-running bulb kept under a glass cover. Turn this on to full power. This gives an approximation to D50 or 5000 K illumination. If you use a different light e.g. that from a light-box for transparencies, the white point is closer to D65 or 6500 K. If the print is not to your liking, you may need to make changes to the printer driver settings. Do not change the image file: remember that is your standard. If you change the image then the next image you make will need its own set of changes, and so on.

Manual adjustments can fine-tune for your images e.g. balance red bias and make tonal corrections.

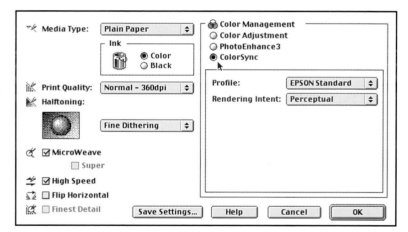

Setting the changes

Printer drivers take a variety of approaches to the extent to which they allow you to control their operation. Ideally you want drivers that allow you to set, for example, saturation or density by typing figures (see above) rather than push a slider which may not always stop where you wish it to. The best software will allow you make a whole set of changes, then save them as a specific set. Once you have found your ideal settings for a particular paper, you can save the set to re-apply the next time you use the paper.

These processes are not only time-consuming but of course consuming of paper and ink. And you'll have to repeat them every few months. Your reward will come quickly however: after this palaver, rest assured your prints will come out superbly and reliably.

Pastel tones and subtle gradations are testing for a printer but not for checking colour reproduction. This image is best printed once you have established a reliable colour set-up.

Colour management through ColorSync has been selected (top right) but look at the paper and resolution selected: with only plain paper and low output resolution results are no reliable.

Camera calibration

Professional digital cameras provide colour profiles, but the vast majority of digital cameras do not. One technique costs nothing. You open an image from your camera in Photoshop without converting any tags (Color management policies: RGB: Off or discard embedded profile). Now, in Colour Settings, with Preview ticked, choose a Working Space RGB profile that makes the image look good. Fine-tune this by choosing Custom RGB from the RGB menu and changing various settings to get the best-looking result. Save this setting as a new profile. This is the profile for your camera. To use it, you simply apply it to an image when you open it in Photoshop: ensure that the Color Settings are set to 'Ask when opening' when a profile mismatch is encountered. Some software allow profiles to be attached to any files.

Understanding colour

Colour, like light, appears to change its nature depending on what you do to it. Light behaves like a tiny bullet in some environments but acts like a wave in others. Now

colour, considered in one way, is a single entity whose character – its frequency – varies infinitely through space and time. But in order to capture and use it, colour splits into lumps of greyness – of little character in themselves but which create the magic of hue when correctly assembled. Whether we are working with film or with sensors in a digital camera, colour can be recorded only by separating the single entity into components. It has been realized since the eigtheenth century that there is fundamentally triple nature to colour.

Forced separation

Broadly speaking, when you want to record or reproduce colour the physics of the process forces you to represent them with

varying amounts of other colours – the so-called separation colours: primaries of red, green and blue or the secondaries of cyan, magenta and yellow. Where you want to describe or represent colour, you can use other, more abstract properties such as angle on a colour wheel. As these models of colour are all three-dimensional, they define a space or volume – from which arises the notion of colour space. Different colour models can define the same or different colour spaces.

One system uses hue, saturation and brightness (the HSB or HSV model, now increasingly obsolete but useful as an intuitive model). Another uses lightness, red-green and yellow-blue (the CIE Lab model, widely used but is intuitively less easy to grasp). And within the most widely used space – RGB – you will encounter small variations as attempts are made to define the space according to what a monitor or printer or system can reproduce. This is to limit the colour space to what is within an instrument's grasp, as it were

Top: the colour picker from Painter. Above: a colour picker for limited choices.

Colour gamut

It is easy to confuse colour model with colour gamut. A gamut is the range of values recordable or attainable by a specific instrument or device. So the colour gamut of a specific printer is the range of colours which can be printed by that device. The colour gamut of a monitor is the range of colours reproducible by a computer monitor. Naturally, a suitable colour model is needed with which to define the gamut.

Gamuts of different devices are often compared and one said to be larger or smaller than another: so the gamut of an ink-jet printer with 3 inks is smaller than that of an ink-jet printer using 6 inks which in turn is smaller than a monitor's gamut. But it is not so simple. While the range of colours that a printer can reach may be smaller than that of a monitor, there are printable colours which a monitor cannot show.

From this simple little fact arises a hornet's nest of problems. If a printer can print colours that cannot be seen on a monitor, the only thing you can be sure is that your expensive monitor cannot fully represent your output. It is commonly said that the problems arise because printers and monitors use different (and indeed they are diametrically opposed) methods of synthesizing colour. While that is true enough, even two printers from the same manufacturer cannot be totally relied on to produce precisely the same gamut in all circumstances. What we need is a way of translating the colour characteristics of one device to that of another, so that what you see in one is what (or very close to what) you will get from the other.

Black point

The 'Use Black Point Compensation' option controls whether to adjust for differences in black points when converting colours between colour spaces. When this option is selected, the full dynamic range of the source space is mapped into the full dynamic range of the destination space. When not selected, the dynamic range of the source space is simulated in the destination space: this can result in blocked or grey shadows but this can be exploited should the black point of the source space be darker than that of the destination space. Unless you know better, keep this option selected.

Colour profiles

As there are innumerable combinations of devices — printers, inks and types of monitors as well as cameras and scanners — it would be crazy, not to say impossible, to define translations between any two of them.

The solution is to create a common colour space, then define a device's colour characteristics as the differences between its gamut and that of the standard colour space. Then, any device can be related to another by referring back to that common colour space. The description of the differences between a device's colour space and that of the standard is called its colour profile or, properly, its ICC (International Colour Consortium) profile.

The essence of colour management is that each device in your imaging chain carries a profile which is used by the next device to adapt its output — from one item to the next, extending all the way down the line. For example, when Photoshop opens a file it looks for an embedded colour profile. It uses this profile with the profile for your monitor to display the colours accurately. So, if you were to open the same file on a different monitor — with its own profile loaded in the system — the image should look exactly the same as on the first monitor.

Rendering intents

Further, the system needs to be told what to do when it encounters profiles which define different colour behaviours. You then need to decide on the rendering intent. In essence, where a colour in the source image file falls out-of-gamut in the destination space, the colour management software has to decide how to approximate it.

One strategy is a match which looks balanced and pleasing overall, one in which colour relationships are maintained — this the perceptual intent, and is most often used for digital photography. Or the system can make a match that is the pure colour closest match: this is a colorimetric intent (there are two types, depending on whether or not you correct for differences in the white point). This sounds like an obvious strategy to prefer but as colour relationships may be distorted, it can lead to photographically unsatisfactory results. A fourth strategy — saturation intent — which keeps colours bright at the expense of hue-matching is intended for graphics work.

This Indian temple in Singapore seems to be demanding for colour systems but as the typical viewer probably has no precise idea what the original colours were, you can get away with inaccurate reproduction. Which image received no colour distortion? Answer: the smaller one is nearest to the true colour.

Understanding file formats

In a perfect world, using image file formats would be like gaining entry into an exclusive night-club: you get in with the right card and if not, you are rejected. If an image file carries the right suffix at the end of the name or a hidden four-place designation (like 8BIM for Photoshop) and if the data is structured correctly, then your application can open it. Unfortunately it is not so straightforward. The rapid proliferation of digital cameras and scanners has increased the number of different applications which open image files. For another, the computer becomes confused if what you want to do is not what the software designers expect you to do.

The range of formats you can save a CMYK file in.

The TIFF format

The TIFF standard is in fact a mixed bag of formats because its very nature is to allow for a wide variety of image sources and uses. This versatility has been built-in by the use of tags – hence the name: Tag Image File Format. Largely for this reason the format is the most widely used in mass printing and is supported by every important software or system using photographic or digital images. However, the variety of tags does occasionally cause a TIFF file to be unreadable: if so, you may need to return to the application which created it to see if you can save to a different format.

Note that there is one major exception to the rosy picture of TIFF's general acceptance. The HTML standards do not support TIFF; as a result of which TIFF files cannot be viewed on the World Wide Web. TIFF files can nonetheless be downloaded on the Internet, like any other file.

TIFF is a bitmapped format (also known as a raster format) i.e. it provides data on each pixel, one at a time. A file's resolution is therefore fixed to its actual pixel dimensions. It supports 24-bit colour per pixel i.e. 8-bit colour per channel – with extra information such as colour look-up tables and spaces stored as tags or

The very wide range of formats you can save a RGB file in.

extra blocks of data. This is a consequence of TIFF's ability to store up to 24 channels – the so-called alpha channels – which enables you to save masks with your image.

TIFF would not be such a widely supported format if it were not possible to compress it in order to save on file storage space. TIFF supports only lossless compression, so no data is abandoned. The standard regime used is LZW – after Lempel Ziv Welch. It uses a technique which is similar in principle to that used in popular file compression utilities such as Stuffit. LZW is an adaptive process, which means that images with much detail compress less than those with large areas of even tone. As it is lossless, you cannot adjust the amount of compression: the algorithm does the best it can.

The dialogue for saving to TIFF offers 'Byte Order': it usually does not matter which, but to be on the safe side, tick the system you use most. You can always change it back.

Saving space

File compression provides great sport for the mathematically cunning. LZW works by creating a table of the strings of data as it comes off the image and catalogues them: a data-string the same as one already catalogued is recognized and counted instead of being coded – that way, large areas of even tone can be compressed to an enormous extent, but more detailed areas may receive hardly any compression. A noisy picture, for example, does not compress well.

JPEG is even more clever but its mathematics is demanding. It takes regular blocks or kernels of pixels and simplifies the data held. One key mechanism exploits the fact that less data is needed to store straight lines (histogram) than to describe a curve. A new standard, JPEG 2000, uses an extremely crafty method called wavelet analysis. Suffice to say that wavelet (also called sub-band) analysis achieves even greater compression than standard JPEG but perhaps a more significant advance is that artefacts are greatly reduced because the compression adapts to changing levels of detail. Fractal compression is yet another method: it uses the eponymous branch of mathematics to model data to gain outrageous compression ratios with virtually no visible data loss.

A noisy picture does not compress well

The JPEG format

With the rise of the Internet and its insatiable appetite for images, JPEG has overtaken TIFF as the most used image format. It offers flexibility, great ability to compress file sizes and – as a result of its wide acceptance – virtually universal support at both hardware and software levels. Its name – Joint Photographic Expert Group – comes

A 40X enlargement from the 3.6MB file below is equivalent to a picture over 3ft (1m) wide.

After ten generations of JPEG compression to lowest quality, the file size reduces to 14K.

1600% close up of the heavily JPEG'd file is top, that from the LZW compressed file is above.

from the support given by two international standard-setting groups, the former CCITT (now ITU-T) and ISO.

The key feature of JPEG is that it is a lossy regime or algorithm whose level of loss can be selected by the user (although there is a rarely used L-JPEG scheme that is lossless). 'Lossy' means that data is discarded in the process of diminishing file size, but you can decide how much data you wish to lose – this is achieved by setting a 'quality' (actually the quantization coefficient), where 'High' discards the least data to maintain image integrity, while 'Low' discards a great deal of data and sacrifices image quality to save on space. The greatest weakness of the JPEG standard is that it does not allow for adaptive compression i.e. where data loss varies inversely with image detail.

Clearly, every time you save and re-save a JPEG file, it discards more and more data (see images above). This loss is permanent, so returning a JPEG file to TIFF does not – indeed cannot – recreate the information: it simply makes the file bigger. The advice that is usually given is to work in a lossless format and leave the saving to JPEG untill the last. The loss in image quality due to successive saves in JPEG may be exaggerated: I find there is no significant loss in image quality consequent on saving and resaving a file at medium quality even after many times.

Visually, an image with too much compression is seen as 'blocky': differences within a kernel are less than differences between adjacent kernels (see top right images). But the blocks are not easily seen unless the image is hugely enlarged. In short, use JPEG files without hesitation where you need to economize on data-storage space.

You can set quality levels to balance compression against image quality, but even 'Low' may do little harm to the image.

At this reproduction size (above), you cannot see any significant difference between a full-size 7MB file and a heavily compressed one a small fraction of its size (which this is) – even using the '0' quality setting. And look at the images (top right) showing two enlargements comparing a TIFF to a heavily compressed file. Admit it: the differences are not huge.

File opening strategies

The simplest option is to open files only from the image manipulation application. Your digital camera may save files with the file association set to the camera download software or else to some generic software such as QuickTime PictureViewer. However, be aware that images from some systems, notably from Kodak, may need to be opened first in the native application for best quality. In these systems, although the file can be opened in Photoshop, for example, the native application may make corrections as it opens the files which other software will not. The resulting (improved) image can then be saved into a standard format.

TWO
Pixel processing

3
A life in the day of an image

If you are new to image manipulation, the number of issues and technicalities you have to keep in mind can be bewildering; it easy to lose sight of where you are in the process. This chapter summarizes the basics of each step in pixel processing so you do not lose track: you can skip this section if you are experienced.

Which project?
Being able to decide on exactly what you are working on is the greatest gift of the creator spirit. An obvious priority, but surprisingly often forgotten. Sketch out on paper what you visualize – it's a great test, a free but priceless way of spotting problems in advance. Locate all the CDs and images you need and pile them together so they are easy to hand. Manage your time so you have sufficient time for breaks to avoid eye-strain and cope with any problems e.g. computer crash.

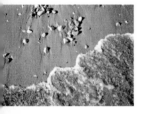

The application
Before you open any files or use any other software, launch Photoshop. Set up a quick way to open Photoshop: it can even launch automatically every time you start up the computer or you can set up a shortcut (Windows) or alias (Mac) on the desk-top so you can find it easily. Mac users can create other shortcuts: function keys can be assigned or Photoshop can be placed in the Dock (Mac OS X). And ensure you have lots of RAM and hard-disk space available.

Pixel processing allows you to experiment without end on numerous images with minimum use of resources.

Open the file
Open your files from within the application: this process is more likely to be successful than double-clicking files, and saves on the nuisance of opening a digital camera utility or scanner driver by mistake. You may also be able check basics like file type and size.

Save and save

Your most-used keystroke should be to save files. Nothing is more frustrating – or less inexcusable – than losing an hour's work at a white-heat of creativity because you failed to save the image before the computer crashed. Save often and also save to a back-up if possible.

Saving As is a feature that is not used as often as it should be. One of your first acts on opening an original image file should be to save it as another file i.e. save it under a different name. The original name could be something impenetrable like img1253.jpg: change it to a more friendly 'goldfsh Alhambra 01'. You will be leaving the original file untouched and will now be working on what is effectively a new, duplicate, file.

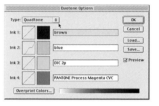

Check image
Look at the image's overall quality: if colour appears poor, or the image is very dark or too light, trying to improve it may turn out to be a waste of time in the long run. Examine the Levels or Histogram display: if the histograms are ragged or clipped, you may have a poor-quality image. Consider re-scanning the image. Check the image size: is it sufficient for the task or is it too large? Down-sample if too large, consider re-scanning if it is too small. Save your work.

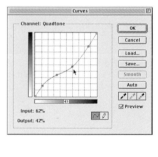

Crop unwanted
Remove all parts of the image you definitely do not need. For example, Photo CD scans usually contain a little black border: crop this off. At the same time work with file sizes appropriate to the task. For example, if you want simply to try out filter effects, ensure you use a small file – it's faster. And is more fun. Working for the Web, you can make do with tiny files – lots of fun. If you are aiming at professional results, ensure you work with a 'streamlined' set-up i.e. with no unnecessary programmes running, big memory allocation with lots of hard-disk space. Save the resulting files (are you getting the idea?).

So it's easy to create quadtoning (above) – but can you repeat the effect when you want to? Save, and save not only the image file itself but also data such as curves and inks you use.

Clean the image

Zoom into the image at high magnification to check for defects: it's not just scanned images which motes of dust and stray hairs like to mess up: images from digital cameras can suffer too. Carefully remove the worst defects in the image by using cloning techniques or whatever is appropriate to the defect. Try not to create new artefacts in the process. Take care not to smudge pixel-level definition: the area will look too smooth. To prevent this you may need to reduce the Spacing for the brush to zero (above). Save the files.

Process pixels

Improve overall tonality using Levels, then move to the detailed tonal balance with local burning and dodging. Examine colours and improve balance, checking also the colour saturation and match to desired result or master print: using either Color Balance or Hue and Saturation. Do this globally as well as locally by using the saturation and desaturation tools. Reduce noise if necessary and sharpen or blur the image as needed. Save the files.

Prepare output

Confirm that the image is in the correct format, uncompressed if required, at the required dimensions and resolution, correct bit-depth. You may need to check with the end-user of your files – e.g. laboratory, Internet service provider or printer. Collect images together into the correct folder. Back up your final files to separate, removeable media stored at another address. For up-load to Web server, check that your files conform to conventions regarding file names, file types and resolution, etc.

> Crashes always occur when you most want to get on with work

Output image

For a local print job: check that the printer is on, has lots of ink and is loaded with the correct paper. Check the printer settings i.e. quality, paper type, colour controls. Take a deep breath and hit the 'Print' button. For up-loading files for your Web site, choose a quiet time – e.g. do a pre-dawn up-load – so you don't have to compete with everyone else and wait ages for files to transfer.

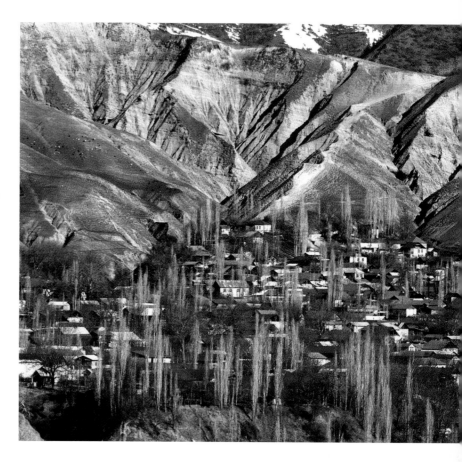

Only yourself to blame

The fact is that crashes always, but always, occur when you most want to get on with work. And crashes usually occur because you are working the computer hard – hitting one key after another, demanding the computer start another task before it has had a chance to complete the last orders you gave. Disastrous hard-disk failures are, these days, much rarer than they used to be. Today, the main cause of problems are bloated software working on computers loaded with a great deal of software and hundreds of little files such as those accumulated from surfing the Internet – sooner or later a passing conflict between software will cause a computer to freeze up and force you to reboot or restart, so losing any unsaved work.

So save often and, if possible, save to a back-up e.g. another hard-disk or a removable drive. Then, should the system crash, you will serenely restart the computer and sail on working, having only lost the last few minute's work. How much more preferable is this to causing bodily harm to the monitor (a favourite target of frustration) and kicking the desk – after nursing your stubbed toe, you will find you still cannot recover your work. If you lose work because you failed to save it, do not expect any sympathy from me.

You can have as much resolution in your picture, but the useful limit is set by the print itself. The original scan is 57MB in size but for this size print, less than 7MB of data is ample.

4 Mastering Levels and tones

The Levels dialogue box for the Levels command is one you will – or should – see every day of your pixel processing life. It shows you whether many pixels are dark or light – it shows the distribution of the population of pixel values. More than that, it enables you to adjust overall tonal rendering of your image. Such is its power and facility that it is easy to fall under its spell and think that it cures all poorly exposed photographs. But, to the contrary, using Levels to salvage poorly exposed originals – from a film or digital camera – will only re-affirm that properly exposed images are the only solid basis for any image manipulation.

You may be tempted simply to look at the image to check on its health: if it looks good, you can say the data at its heart is beating soundly. This is based on applying an analogy with correctly exposed film where indeed, if the image looks excellent, the exposure and processing has been satisfactory. Unfortunately, the image on the monitor is likely to be aliased and dithered – as data is smoothed out in order to deliver a clean image. This results in deficiencies in the image being blurred.

The only reliable check on the image's health – and its ability to hold quality all through manipulation – is therefore to examine the Levels display or, for the fullest information, the Histogram display (see p. 40). In fact, it is the only dialogue box which presents information about the image prior to any manipulations you perform. This makes it an important diagnostic tool.

Over-exposed

One way to approach over-exposure is to note the fundamental difference between positive and negative. Over-exposure in a negative may be beneficial at best and possibly retrievable at worse: eg. light over-exposure can offer increased flexibility with tonal control and, with colour negative, improved colour. The over-exposed positive is, however, a pretty hopeless case. And remember that the image from a digital camera is a positive image – see the paucity of data displayed by the histogram (right): prognosis is for hard time for manipulation.

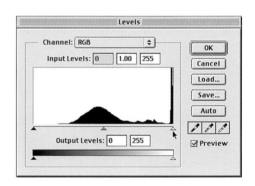

Under-exposed

The scan from the transparency shows poorly saturated colours and overall the density is too high – reflecting a somewhat under-exposed image. The Levels histogram shows not only that pixels are piled up to the left i.e. most are darker than midtone, but it also shows that highlight information and shadow details are also missing.

This kind of histogram distribution is said to be 'clipped': the dynamic or contrast range is limited due to poor setting up of the scanner. Or it may be because the original was under-exposed. Verdict: re-scan with new settings if original was correctly exposed.

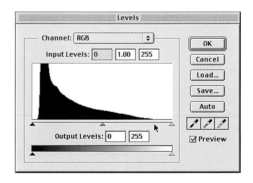

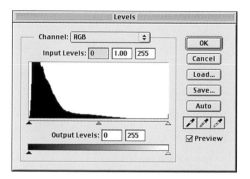

Above: clipped histogram of a dark image.
Below: a noisy one from adjusting the above.

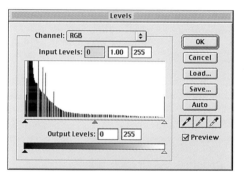

Dark but full

An image – like that below – can be dark overall yet not be under-exposed (and by the same token, can be bright all over without being over-exposed). The image of a monastery chapel in Greece is very dark and low-key. The histogram (left) shows the range of tones stretches from left to only just above midtone i.e. from deep black to lighter grey with, as expected, a great piling up to the left. But the peaks at far left are at maximum: the scanner was unable to dig into the shadows and has simply thrown in some hopeful values – but we will disover much of that is merely noise.

This is proved by the next histogram, which results from adjusting the mid-point slider to brighten up the image (far right). Many pixels which were bunched to the far left suddenly make an appearance like hairs standing up: this is image noise. In most circumstances this noise is not visible but would show up as spots when greatly enlarged.

Fully normal

Here, just for a surprise, is a fairly average and normal histogram resulting from a perfectly exposed and utterly average picture. It has a full range of tones, lots of colour and contrast from its mix of half-shadow and diffused bright light – however as this is a small file, the peaks are not as high as we might wish. Look carefully at the histogram and you will see there are many pixels at the extreme left. These are not a fault, but signal the deep blacks in the central window of the image. Overall, this is an image you can do business with.

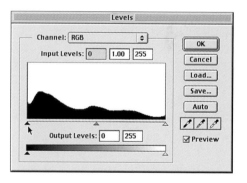

Odd but OK

Half of this image is in deep shadow and much of the rest is blue sky. The resulting Levels display looks strange because there are large numbers of pixels with high values of what turn out to be blue and green pixels – which define the cyan colour of the sky – combined in the composite view.

The very high peak at far left shows there are very many totally black pixels. This is largely due to poor scanner performance – it was unable to extract real data from the shadows, so made it up as it went along, to produce noise. This, as with the Greek monastery shot above, would manifest itself when corrections are made.

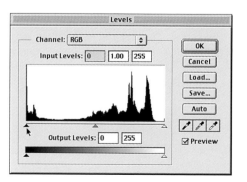

Basic mani-pulations

From a 1600 speed transparency, we expect colours to lack depth, the shadows to be full of noise and highlights to be degraded. Yet the image's histogram appears to be that of a perfectly mannered digital image. The three histograms – left – show the contributions of each channel. Note the weakness in midtones reflects the paucity of midtones in the particular image.

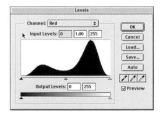

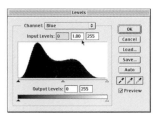

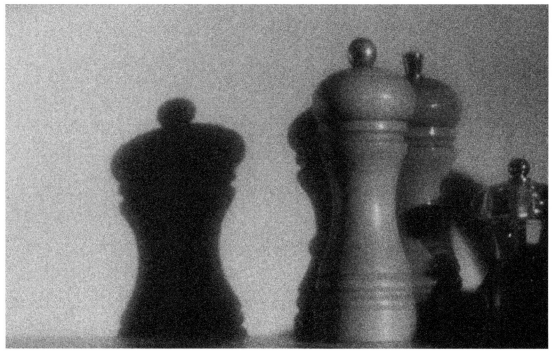

As a digital image, it be may appear to be low in quality but in fact it was the original 1600 speed slide that was grainy: the data needed to capture low-definition grain is as much as to capture high-definition from a fine-grained original.

Raised black point

The black triangle under the left-hand end of the histogram controls the black-point: every pixel here and to its left is rendered full black, or value 0. So when you slide it to the right, you are increasing the population of black pixels throughout the image. But note particularly the improvement in the solidity of the shadows: slightly dark pixels are now completely black. Notice how the middle slider has also moved to the right, showing that more pixels are now darker than midtone.

Lowered white point

The white triangle at the right-hand end controls the white point: every pixel to the right is pure white. So when the slider is moved to the left, more pixels are made pure white and at the same time the middle slider also shifts in the same direction.

The net result is overall a brighter image, but notice that while you may think adjustments are restricted to highlights, in this case they are not. The grainy shadows are degraded and become too light because they contained many light pixels even before lightening.

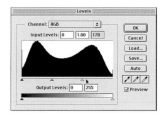

Tonal compression

Now if the black slider tends to strengthen the blacks and the white slider brighten the whites, when we combine the two actions we increase the apparent contrast of the image (left). Note that actual luminance range stays exactly the same, but the transitions in the middle range of tones have become more rapid. In short, gamma (if defined as the slope of the middle portion of the characterisitc curve) is raised. Yet the middle slider has not moved (top right). This slider is often referred to as the gamma control – inaccurately, as we now know.

Note that there is no such thing as a free contrast improvement: you lose data in the process, shown by the resulting histogram (right). This – a sad sight – shows a vast amount of data was discarded in the tonal compression. More: it shows adjustments like this should be made using adjustment layers – which allow changes to be made to an image without touching the original data until you flatten the image. You try different settings out as different layers, all without damaging the data If you tried to re-trace your steps you will find it impossible: you have lost too much data to be able to return to the original image. In fact, the more you do, the more you lose (third right).

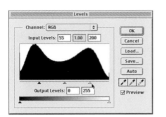

The above sequence shows the increasing deterioration in the histogram resulting from increasing the contrast.

Following the increase in contrast, the image appears sharper. Visually, it is also more immediate, thanks to the increased brilliance of the colours. But this improvement can be illusory: visible on the monitor, but poorly reproduced in print. On my monitor this image was not only brilliant it had displayed much more detail in the shadows, now lost in print.

Auto-Levels

The 'Auto' button in any dialogue is a standing temptation. However, more often than not the result is startling. It has its uses as a quick check on the image: if Auto-Levels causes a big change, the image is poor and may need to be re-acquired or, as here, there is little change so the data is sound. Auto-Levels indiscrimately spreads out the available data in each channel into the full space available. In version 7, Photoshop offers an Auto Contrast which can, at times, correct exposure without displacing colour balance.

Auto-levels is a good test: a drastic change often indicates problems ahead.

Absolute or relative values?

Numerate people will ask whether the values displayed on the Levels display are relative or absolute: do they show actual numbers of pixels for each value or proportions from the total? The answer is both. The right-hand display is that of a file of some 28MB: compare that with the other displays on this page – e.g. top right – from files 11MB in size. Clearly, data is expanded or compressed in the display so that the the highest value fills the height. The left-hand display is from a very small – 22K – version of the pepperpot image. The difference in the profile is due in part to errors caused by image down-sizing and in part to the difference compression applied to the display.

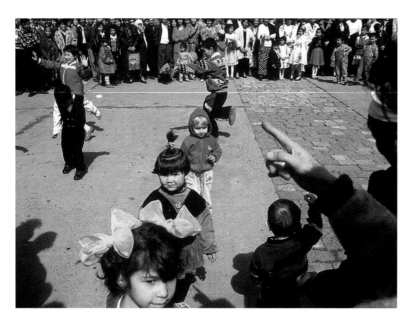

Grey point control

The central, grey pointer or slider under the histogram display represents the mid-grey or midtone. It is also incorrectly described as the gamma or contrast slider. Although moving the midtone necessarily changes the slope of the line joining blacks to whites, gamma can change only with either the black or white sliders. That is, manipulating the black or white points also changes the slope – it must become steeper as you compress the tonal range.

But never mind the technicalities; the practical point is that the grey slider effectively controls the overall 'exposure' of the image – that is, how bright or dark it appears. You will have noticed that it moves when either the black or white one is manipulated: move the black slider to the right and the grey slider moves, but not by the same amount and overall the image gets darker. To correct this, you need to slide the grey slider back to the original position. It is usually more convenient to use the arrow keys to control this slider.

Darker 'exposure'

The grey slider has been taken a long way to the right: overall the image is darker because we have increased the number of pixels which, formerly mapped to values lighter than midtone, are now mapped to darker than midtone.

The effect is similar to under-exposure on transparency films: the shadows become more solid and midtones take on richer colours, while highlights are largely untouched, giving the image a look of greater saturated colour.

Lighter 'exposure'

By moving the grey slider a long way left, we are forcing pixels which were once mapped to values darker than midtone now to be lighter than midtone. Not only does the image become lighter overall, notice how colours appear weaker, while details are lost from highlights and shadows lose their solidity.

The result is similar to serious over-exposure of colour negative films: notice how the graininess of the image – its 'noise' level – appears to increase as stray very dark pixels are revealed.

Histogram

The command Image > Histogram... provides information pure and simple. (These are the displays for the three horsemen on p.37.) Note there is no 'Cancel' button. Under the Histogram itself is information designed to win statisticians over to Photoshop – but which mean little to the rest of us. And those who do know see little point in knowing the Standard Deviation for pixel distribution. But if you want to know exactly how many pixels you have, or that three-quarters of your pixels have a luminosity lower than 182 (left) or that there are hardly any pixels in the midtone region (right), this is where you'll find it.

Using the droppers

The dropper tools enable you to make rapid corrections to the image. You use them to tell the software that you think the area you are sampling is a neutral black, grey or white according to the one you select. The software then shifts the values of the entire image around your chosen pixels in order to fit your sample. You can use the droppers one after another.

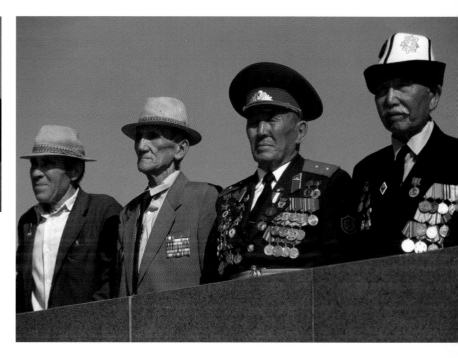

Top: The middle, midtone dropper. Above: Levels display after sampling.

Grey dropper

The trickiest dropper to use is the grey. You need to find an area this is not only midtone in density, it should be neutral in colour too. The above is the result of sampling from a medal on the General's chest in the original (right): it looks grey but was in fact a bit blue – hence the overly warm result.

Black dropper

The black dropper defines the pixel which is taken as black, and there that from which all others will be mapped to be lighter. If it is already fully black, no visible changes will take place in the image. If you choose well, you will anchor the blacks without making great changes: the image (left) resulted from selecting a dark pixel on the bearded man's jacket. But if you select e.g. the blue shirt) the result is too dark and red, as seen in the small image (right).

White dropper

As you would expect, the white dropper tells the software what you consider to be white and accordingly turns that pixel white and maps all pixels as darker. You obtain alarming results if you select a strongly coloured pixel (below right) but a correct selection results either in no change or in a paler image – in this instance because the values have been stretched across the range. A tweak of the mid-point lowers exposure so the midtone greys are correct.

Controlling Output Levels

The Output Levels part of the Levels dialogue tends to be under-used. Not many pixel processors realize it provides a way of saving ink, of improving colouration effects and raising reproduction quality. Output Levels controls the maxima both of density and highlight: in effect it decreases maximum density i.e. it lightens shadows; or it increases minimum density i.e. it puts density into highlights.

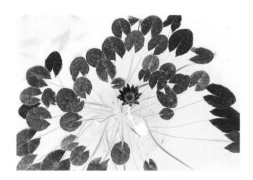

Very light original

An image with great swathes of white or very high values: on an ink-jet printer there would be no problems, but with mass-printing such as off-set lithography, empty areas cause large spans of paper to be unsupported which can cause a number of problems. Usually a reduction in white of 5 units from 255 to 250 – is sufficient to prevent problems yet leave highlights still appearing clean. The change shown here – 255 to 230 – is exaggerated to demonstrate the effect.

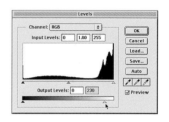

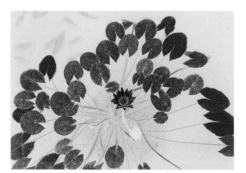

Highlights reduced

As a result of reducing the highlight output levels from 255 to 230, the Levels shows the histogram is clipped. That is, there are no values above a certain point, namely 230.

The image is in fact little the worse for the change, although on screen the effect can appear to be a dramatic loss in its sparkle and shine. In fact, you will discover this can be another case of watching the numbers, and not the image – trust the output result, not the screen's 'soft proof'.

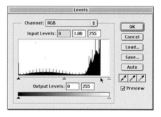

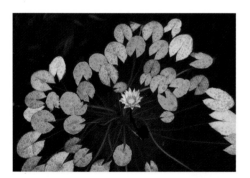

Very dark original

As photographers, we like this sort of dense image: saturated colours with solid blacks. But it is unpopular with printers – both the desk-top and industrial variety – as it takes up a great deal of ink and can saturation-soak paper.

Experiment with reducing the black levels by a small amount each time you print to see what effect it has on your output. A rise in the black output level to 5 or so is usually invisible. Here the change is a large 25 to exaggerate the effect – not too painful, as you can see.

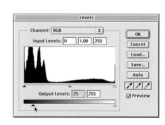

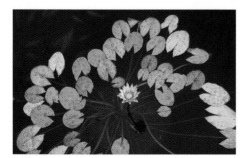

Shadows reduced

Following the rise in black output level in the above image, the histogram shows the clipping in the shadow values: no values are lower than a certain value – 25. The screen image looked unacceptable and the printed version appears unacceptable but consider: if you saw the image by itself, whether you would accept it. Only by direct comparison with the sensitometrically correct image is it clear which one we find unacceptable.

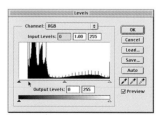

Putting it all together

The most popular way of working with Levels is to 'suck and see': you fiddle with the black, midtone and highlight sliders while watching the effect on your image. When it looks good, you hit 'OK' and you're on to the next step. But you can use the droppers as checks on your actions. You should keep an eye too on the shape of the histogram. And remember to use Output Levels to avoid printing problems.

Using all options

The midtone contrast was improved by pulling the black and the white sliders closer together. The black dropper was selected and a sample taken from the dark coat of the woman near the far right. The highlight dropper was then selected and a sample taken from the little white cloud peeping out from the mountain range. There were no great changes in the overall density of the image, confirming the full tonal range was available to the image. Next, the midtone dropper was selected and samples taken from shadows of the white rocks in the foreground. This corrected the shadow colour balance from the blue bias (caused by the unclouded sky). This work was on a 7MB file: the data lost is seen in the histogram display (below left). In contrast, the same manipulations were performed on a 22MB file (the original, in fact): the resulting, fuller histogram, is shown middle left. Finally, you could pull back output levels very slightly to lighten the dark mountains and put a touch of density into the white rocks.

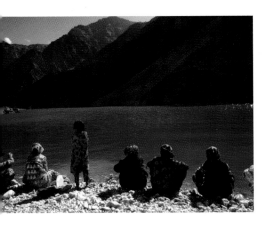

After Auto-Levels is applied, the result (above) is improved but still too dark.

A histogram showing a good filling of data across the tone range.

Noise in the shadows shows that dark detail has had to be sacrificed in order to obtain an overall lighter image.

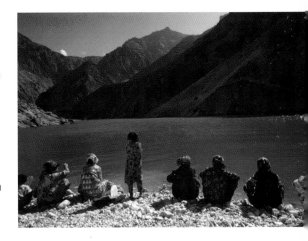

The scanned image a fair representation of the transparency but is, as a result, just a little on the dull side: a little dark and lacking in contrast.

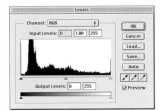

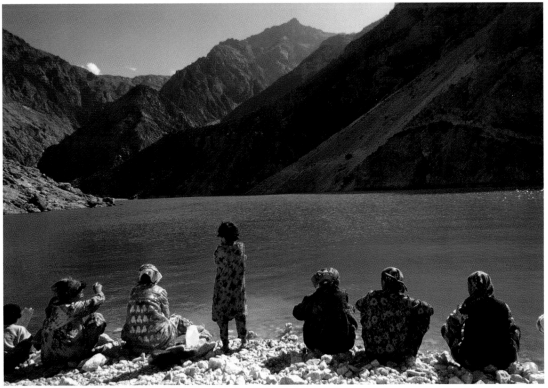

5 Adjusting for colour

which matches the correlated colour temperature of the light-source with the balance of the film or sensor. Now, let us heed these words by Matisse: "Colour is a means of expressing light." From this, colour adjustments are not merely a technical matter. To have correct colour reproduction simply means expressing light as we wish to. Now that pixel processing techniques give you near-total control over colour adjustments you really can express light like a painter. Before, you had to accept the limitations of film – its peculiar colour palette and specificity to correlated colour temperature. Generally speaking, colour correction is easy and accurately done with digital techniques. But it is with colour balance that Matisse's words are most relevant: the correct colour balance is not necessarily the right expression of light.

There are two kinds of colour adjustment. Colour correction is a small shift to ensure accurate hue reproduction. Colour balance is a larger-scale adjustment

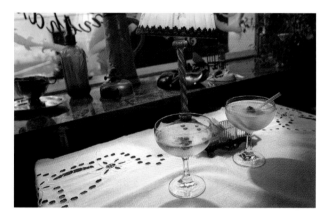 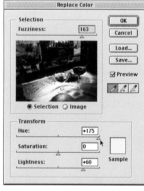

Replacing colour

The mixture of light sources with different correlated colour temperatures puts the photographer on the horns of a dilemma. Here, in a restaurant in Budapest, Hungary, the warm yellow-red from the table light and the skylight from the window offer their own version of colour balance. The dilemma of which to prefer would be proffered whether you shot this on film or digital camera (I used a digital camera). You can use Replace Color control (above, far right) to make adjustments. This control, like the Magic Wand tool, selects pixels similar to that sampled, within the tolerance or fuzziness you set. You can then apply Hue and Saturation changes to the selection, but only from within the control. The result is shown above right. Well, perhaps it was best to leave the image as first captured.

Replace Color is a great control for cross-imbalance. Light orange areas under the near glass were sampled. The hue was then set to blue and greatly ligthtened until it was very nearly white. This corrected the table cloth and also the balance of the window sill. But beware creating artefacts at the edges of altered areas.

Using Adjustment Layers
All the image adjustment controls such as Levels, Curves, as well as Color Balance can be very destructive on pixel data. If you lose sight of the original state of the image e.g. if the History palette fills up and you did not take a snapshot or if you save and close the image, any data lost cannot be recovered. The safest procedure is to use Adjustment Layers. Point the cursor at the half-black half-white circle and choose the adjustment you wish: a layer is created and you can make adjustments in the dialogue box that follows. You can set up many layers, each with different settings to assess their merits.

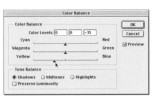

With Shadows selected, the bluish shadows were corrected by shifting the colours towards blue, making the rest of the image warm.

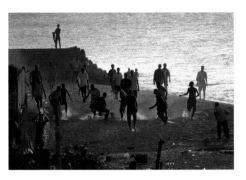

With Midtones selected, cyan and blue were increased to correct for the orange cast.

Using Color Balance

At sunset in Zanzibar, the light is very yellow-red. You could leave the image as it was recorded on film (above) but the experience was closer to the corrected image (bottom left).

The Color Balance control was fully exploited to get the final result. One problem with using this control is that one change – e.g. to shadows – can seem inappropriate or excessive until you correct the midtones or highlights. This is clear from the sequence (left) of images: you have to keep your eye on the tonal regions your are correcting, and ignore the impact on other regions. In the end, you may have to return to the other tonal controls and refine earlier adjustments.

Try working systematically: in this sequence, the bluish shadows were first corrected, which made the midtones too warm. By selecting Midtones with a large amount of blue-cyan correction, the shadows are taken nearer to neutral. Blue was added to the Highlights to complete the colour balance correction. Finally, Levels was invoked to render the image lighter. For further refinement Replace Color could be used.

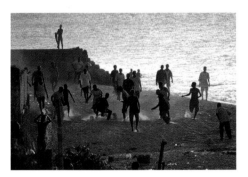

With Highlights selected, the warm light on the water was corrected with extra blue and a touch of green.

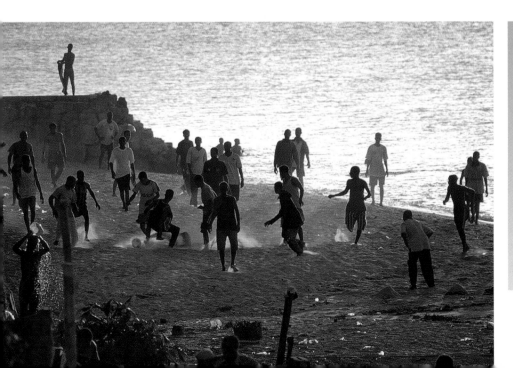

Preserve Luminosity

The 'Preserve Luminosity' check-box in the Color Balance maintains tonal relationships in the image while you change colour balance. Below left the image was given a large red shift without luminosity preserved: the midtone contrast has been reduced. Below right shows the same shift but with Preserve Luminosity: tonal relationships remain true.

Levels colour correction

As all digital colour images are essentially sets of greyscale images or channels, in theory you should be able to make colour adjustments by manipulating individual channels. This is correct; and the methods available are powerful. On this page we look at an intuitive but somewhat more hit-and-miss method. Opposite we show a method that involves calculation but which still needs some subjective assessment.

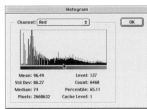 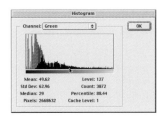 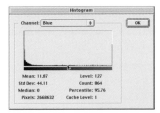

Analysis by Levels

This very warm image, taken in Kyrgyzstan, was analyzed in the Histograms display. These show clearly a richness in red and green data but virtually nothing in the blue channel. This means there is no point trying to colour-correct from the Blue channel (right: it is nearly all black); the work must all be done in the Red and Green channels.

Correction by Levels: Red

The Levels control (effectively it is a filter) was invoked. (Remember that it is best to work with Adjustment Layers if you expect to bring extensive changes to the image.) The Red channel was adjusted by eye to reduce the strength of red without allowing too much green to overcast the picture – it is arguable there is no 'proper' correction for this image. The Red midtone point was reduced by 0.19% to 0.81 (right).

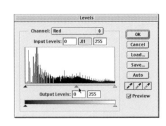

More digits
Don't forget that values in boxes can be set simply by hitting the up and down arrow keys to change in tenths or units according to the box. To change in whole units or in tens, hold down the Shift key when pressing the arrow keys.

Correction by Levels: Green

Next, the Green channel was selected and corrections made, again by eye, to reduce the red in the shadows by increasing the green value (from 0 to 15) and the midtones were increased to 1.09 – keep pressing the up/down arrow keys until the image looks right. This also helped to reduce the darkening effect of the Red levels adjustment. The image on the left shows the effect of the Green levels adjustment alone.

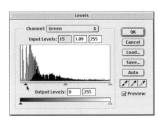

To access any of the channels in any multi-channel display, you hit Command (Control) + 1 for Red, 2 for Green, 3 for Blue and so on. For luminosity, i.e. all channels together, hit ~ (the tilde key).

Correction by Levels

The two channel adjustments, once applied, have improved colour correction but also created an image that was a little dark. So the luminosity i.e. the composite of the RGB channels needs to be adjusted. The midtone slider was taken to 1.4 which not only lightened the image, by opening up midtones, it allowed the colour correction to show more clearly.

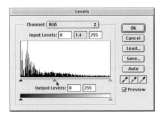

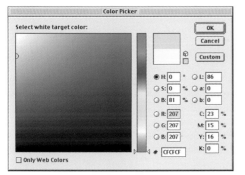

The sample area in the image (circled above) was chosen to be the targe white point.

Color Picker

Select white target color:

OK
Cancel
Custom

- H: 0 °
- S: 0 %
- B: 81 %
- R: 207
- G: 207
- B: 207

- L: 86
- a: 0
- b: 0

- C: 23 %
- M: 15 %
- Y: 16 %
- K: 0 %

CFCFCF

☐ Only Web Colors

○ L:	86
○ a:	12
○ b:	40

○ L:	86
○ a:	0
○ b:	0

The sample point in the image (top) is mapped to a white when you change the Lab values so that the a and b values are all zero i.e. you neutralize the chrominance values. This defines the target white point for Levels to work to. Alternatively use the table below to translate the K value from the Grayscale reading (Info palette) into RGB values which you enter in the RGB boxes (left).

○ R:	207
○ G:	207
○ B:	207

Use this table to calculate the new white target colour from the K value:

K value	RGB	K value	RGB
10	230	18	209
11	227	19	207
12	224	20	204
13	222	21	201
14	219	22	199
15	217	23	196
16	214	24	194
17	212	25	191

Calculated correction

One approach to colour correction is to map pixel values to a white. There has to be a pure white in the subject. Now, if there is a colour cast, that white will pick up the colour. If you were to define that colour as a neutral white then you force all other pixels to be mapped around it, thus correcting the colour cast.

One method is shown here. First ensure you sample a 3x3 grid of pixels: call up the Eyedropper tool and alter the Options (right).

Next you set the Info palette to Grayscale: click on the dropper in the Info palette (right). Measure from a suitable point (e.g. that circled, above left) to give a high three-quarter-tone reading of between 10% to 25% (i.e. a highlight with detail) which should be a neutral highlight. The measurement of K helps locate an area with the correct density.

We want this coloured highlight to be mapped to a neutral highlight of exactly the same density. Now call up Levels and double-click on the Highlight dropper to give you the Adobe Color Picker. Click on the same sample point – in this case a pale orange (left). Now you will move this to neutral by defining the white target colour. If you have Lab values displayed, simply change just the a and b values (chrominance channels) to zero. If you do not have Lab values, you calculate the percentage of 255 which gives you the K value: e.g. a K of 19 means its is 19% so it must be 81% of full white (100%–19%). 81% of 255 gives RGB values of 207, 207, 207. Click OK, then click on the original image at precisely the sample point. The image instantly maps around your white point and corrects the colour (below).

The key steps are: set up greyscale Info, find the K value from a white patch in the image, then work out the white target colour. Open up Levels and define a white target colour for the Highlight dropper, then click on the original sample point. Colours then map around your target white.

The original sample point – light orange – and the new colour, its achromatic equivalent.

47

CMYK colour correction

The majority of pixel processing is done in RGB colour space. This is intuitive and easy to understand, while file sizes are minimized and results look (deceptively) great on screen. But CMYK space is better for many technical reasons – not least because four-colour printing is the final output form of the vast majority of all pixel processing. And more, for colour correction, CMYK space is simply easier.

CMYK benefits

The key advantage of working in CMYK space compared to RGB is that the tonal range of each colour channel is less widely spread out in CMYK. This is an advantage because changes to one channel or tone-band are then less likely to infect other colours or other tone-bands.

The intuitive reason is that cyan, magenta and yellow are by their nature weaker colours than red, green or blue. Furthermore, having four channels to work with naturally offers more flexibility than three. Being able to manipulate the black or K channel – i.e. vary density without affecting colour – is extremely handy. And, as CMYK is the native space for printing, changes are more likely to reproduce accurately: so, no more nasty surprises when you forget to check whether the whole RGB image is within printing gamut. The downside is, of course, that in CMYK you have to work with a larger image file, but with modern computers that is only a minor drawback.

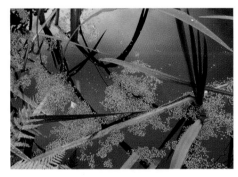

To correct the overall magenta cast in RGB, you have to work with both R and B channels (magenta is the additive result of combining red and blue).

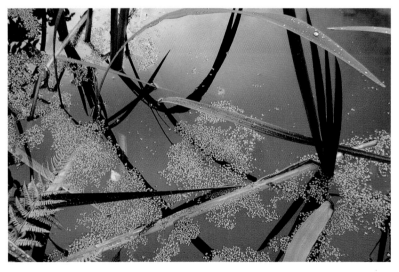

The M channel change gives satisfactory colour correction.

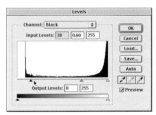

RGB and CMYK compared

The magenta cast on this image (top) suggested that CMYK correction would be easier than RGB. We have to correct only one channel, instead of two. And so it turned out: in RGB, a bit of juggling with settings was needed for a correction. But it was a quick adjustment in the M channel of the CMYK version of Levels. To strengthen density in the shadow areas, the K channel strength was increased by bringing up the shadow slider (moving it to the right).

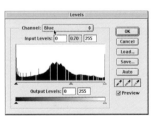

But as we are working with subtractive inks, reducing one channel makes the image lighter overall (less ink). So the K channel (above) was used to improve the black ink.

Other ways to adjust colour

The major colour adjustment tool that has not been considered so far is the Hue/Saturation control. In Photoshop, this actually combines not only hue and saturation but also lightness. In addition you can limit manipulations to wavebands of colour. The control is mostly used for improving saturation of colours and for large-scale hue changes. But on occasion it is useful for colour corrections.

Hue/Saturation

The Hue part of the control is based on the colour wheel: if you take a sample colour half of the way round the colour wheel, you have changed it to its complementary hue. And all the way round takes you back to the original colour. In pixel processing we usually need only the slightest nudges on the hue slider. Although you can restrict changes to wave-bands of colour, Hue/Saturation is most useful where one colour predominates, as in this portrait.

The original shot by a digital camera (near right) consists almost wholly of varieties of red, and some yellow. The first attempt at correction was restricted to red colours: a slight shift of +14° towards green (below) reduced the red. But a reduction of saturation gave a satisfactory correction (right).

Now, as the image is almost wholly red it might not be necessary to restrict changes to reds. So I tried changing hue in the Master, or all colours, 'channel'. Slightly different settings (bottom) to Hue and to desaturate all colours gave surprisingly good correction (far right) within seconds.

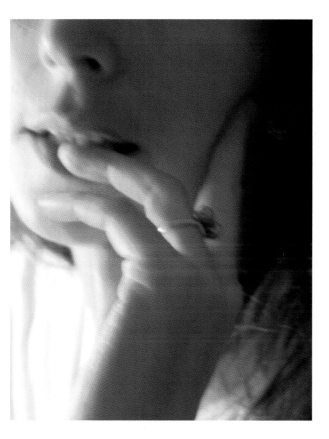

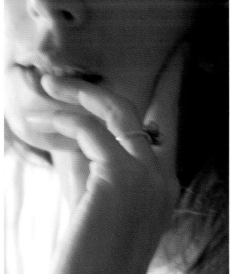

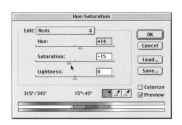

Desaturation can 'improve' colour balance.

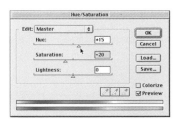

H/S droppers

One look at Hue/Saturation shows it offers very powerful tools for colour adjustment. The droppers allow you to sample a colour to set a range of colours over which the control works (left-hand dropper) while the other two allow you to add or subtract colours. The 'Colorize' option converts the image to the foreground colour.

Controls in other software

Photoshop does not have a monopoly in methods of colour correction. And you cannot have too many methods. Corel Photo-Paint 10 has a very powerful method which allows you to set three different targets, around which the software shifts all the colours. The control shown below is from the FotoStation utility – primarily a tool for managing image files, but it offers some image editing features. This one allows you to adjust colour balance within five tone-bands and five bands in each colour separation. Excellent.

6 The art of dodge and burn

Tonal corrections applied to localized regions of the image need a good deal of skill whether you are working in front of the monitor or under the enlarger head. The difference is in the skills required. In the darkroom, you need to work quickly with intense concentration and an intuitive feel for the image. In the computer, you need patience and an awareness of how the software is reacting to your commands – and still you need a steady hand. Burning-in and dodging for the pixel processor aims to achieve local control of contrast. Dodging reduces local density (makes it look lighter) while burning-in increases density (makes it look darker). Note: in pixel processing, each tool has the same effect whether working on positive or negative.

We also use dodge and burn-in in order to control the prominence of detail – that is, how easy it is to see that detail. Being able to see detail in the bottom and top portions of the image is intimately tied to the visual experience of density and highlight. A shadow cannot be completely dark if detail can be seen in it, nor can a highlight be completely white if detail is visible.

The strength of digital work is in being to pick off pixels one-by-one. The corollary is that it is tricky to cover large areas in a convincing way. The obvious tools for burning-in and dodging are, well, the burn and dodge tools. But the Color Burn and Color Dodge brush modes are also invaluable in pixel processing.

This image presents us with opportunities for digital burn and dodge which would present darkroom workers with a big challenge.

Work at opposites

You want to darken some highlights. Do you choose the Burn tool and set to burn in highlights? Do that just once and you learn that is the fastest way to obtain unattractive results. If you want to reduce highlights, work on the shadows or, next best, the midtones. The reason is that you want to locate any darker pixels in the highlight region – a few pixels darkened may be sufficient to give a sense of detail in the highlight. This, after all, is what you are after: you are not trying actually to darken the highlight: there is no hue information in a highlight so making it darker results in a dull, flat grey.

By the same token, if you want to burn in shadows, you now know to set to burn in highlights. And if it's midtones you want to burn in, try setting to burn in the highlights too. Both these approaches build up where density is most lacking – just what we do in the darkroom.

Naturally, dodging calls for similar strategies. If you set the brush to dodge only shadow values you will produce messy blank areas. Set dodge to highlights or midtones while working in dark areas: then the brush looks for and raises the brightness values of any lighter pixels it can find. In effect you are selectively raising toe contrast – what darkroom workers have always wanted to do.

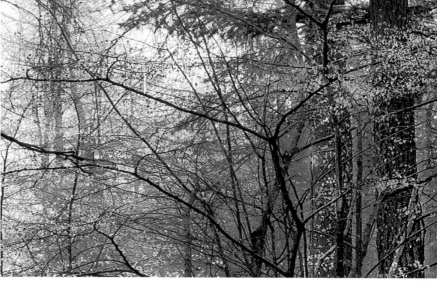

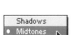

Dodging in detail

Dodging raises pixel values equally across the channels. In other words, it lightens pixels achromatically. One consequence of this is that any imbalances in data in the channels can be shown up in changes in colour. Oddly, this is just what you expect when you dodge heavily with silver-based colour materials. Dodging can be limited to bands of tone, rather than to colour. Dodging shadows is best limited to working on highlights e.g. to remove noise from highlights of scanned negatives. The most-used tone-band for dodging is the midtones (lower left): a few strokes at 20% on the right-hand side of the image lightens the paler leaves without exaggeration. Similar strokes applied with the shadow tone-band selected (upper left) result in a smudged effect that is of little use to anyone. But it has usefully lightened the thin dark branches. Best results seem to come from using the highlight tone-band: it has made the lighter leaves more brilliant and improved the tonality of the large trunks. But notice how tone colour has changed: the scan is not of the highest quality.

Further dodges

The rough results shown above were due to using too high a pressure. You seldom need a pressure greater than 10% – if you do, you are probably simply being impatient. The result of using a pressure of 10% and a large brush are shown here. With the highlights tone-band selected, there is a distinct increase in contrast: the image appears snappier, with more bite. This is thanks to the lighter tones, e.g. in the leaves, being taken to pure white while the shadows were left alone thus there is a true increase in contrast … there is an increase in the range of values. On the other hand, when the image is dodged with midtones selected, there is an overall lifting in the lightness of the image (right). It is as if you increased exposure when taking it (or reduced exposure during printing). Highlights are lifted, but not dramatically, while both midtones and shadows are also lightened to reveal much improved shadow detail without sacrificing blacks.

Localized dodging

The power of digital burn and dodge is such that it is tempting to charge at any shadow or highlight that offends the eye. But that is a sure way to create over-manipulated images, which look as if you had walked around with a gigantic reflector or lit up offending shadows with a torchlight. While the need for restraint is obvious, knowing when to stop dodging and burning-in can only rest on what your eyes tell you.

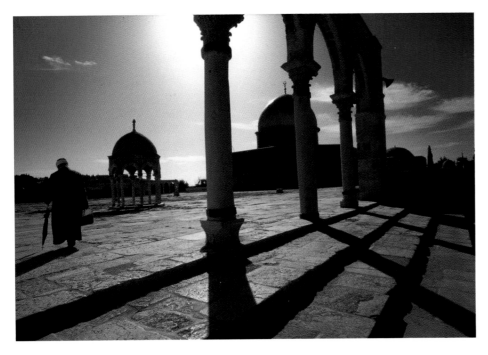

Very high contrast

One mid-morning in Jerusalem the sun shone very clear and bright. By placing it behind a pillar I could shoot straight into the light – but the high contrast meant that shadows would be strongly underexposed on the transparency film I was using. The image (left) is a fair scan from the original.

A little probing around in the shadows showed, however, that even a moderately capable scanner extracted a surprising amount of detail from the original. The task now is to return the image to something closer to the actual visual experience. The large image below shows the outcome of a combination of dodging combined with some application of painting with the brush set to Color Dodge mode as well as some burning-in.

In contrast, the image below right is the result of a wild application of the Dodge tool set to dodge highlights and pressure at 100%. Compare this with the original and you may be surprised to discover how much colour had been retained in seemingly totally black areas of colour transparency film.

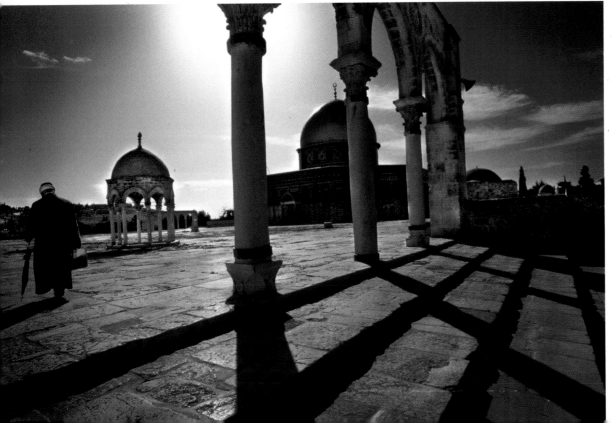

Real or super-real?

To obtain the final image (left) I dodged the columns, right-hand wall and mosque, then burnt the lower right-hand corner and finally desaturated the mosque's colours. The result is perhaps a little more than life-like but not as cartoon-like as the full treatment shown above. On-screen the image looked much more – and overly – brilliant compared to the printed verson.

Color Dodge

When you work with the burn or dodge tool you are changing only the luminosity of the pixel – how bright or dark it is. If you want to change saturation, you need to call up the Sponge tool. Now, the Color Dodge mode does both at the same time: it lightens and saturates underlying pixels where they are darker than the upper layer. Therefore, painting with black has no effect, but even small shifts of grey make a big difference. Compare the results of a dark grey (left) with a slightly lighter grey (right). Notice how the

 lighter grey has increased colour saturation in the exposed bricks. Add opacity control to this to fine-tune your dodging effects.

Dodge

As the Dodge tool affects only luminosity, you have to choose and use it with great care. You have three controls: the size of the brush, the band of tones affected and the pressure. The midtone band is most often chosen as it gives quick results which actually look quite photographic. But we can do much better than that.

The image left shows the result of applying a midtone dodge at 50% to the two right-hand pillars. Compare this to the result of dodging highlights, also at 50%, in the right-hand image. This one is far more subtle than the pallid result of dodging in the midtones. In addition, there is only a slight apparent enhancement of colour saturation compared to Color Dodge, which helps ensure a natural-looking result.

Burning-in

To complete the picture, I felt it would help to darken the corners of the image. I set a very large brush (300 pixels diameter, below) at a low pressure of 10% (just hit the '1' key to set 10% pressure) with the burning set to shadows. This surprisingly brought out a lot of colour in the slabs of stone (left) – which was not desired. With the burning set to highlights, darkening is more neutral both in the sky and the stone slabs. To finish off, I dodged some of the brighter areas in the stone to return a little sparkle in the stone: the result is the big picture, far left.

Another method of burning-in is to paint with the brush set to Color Burn or (better) to paint into a layer whose layer mode is set to Color Burn. It darkens and saturates the receiving layer and the darker the colour, the greater the effect: white in the top layer has no effect at all. This is very useful for increasing local colour saturation and contrast.

Localized burning-in

Localized burning-in is, in principle, simply the opposite of localized dodging. But when you work digitally you have to remember that you are working with a positive. Although the darkroom metaphor is of burning-in, we are not in fact working with an area of negative that will yield its secrets if given enough exposure. Rather we are working with an area which is very deficient in data.

Controlling contrast

The situation, seen in Bukhara, Uzbekistan, is a classic case of having to fit a wide subject luminance range into the narrower dynamic range of film while keeping an eye on the image – youthful tomfoolery against the background of hobbling old age. I exposed for the boys, knowing that the sunny parts of the scene would be blown out to pure white. The image to the left is a print with already some burning-in done in the darkroom. I experimented with burning-in in different tone-bands – shadows, midtones or highlights – at various pressures in different parts of the image to work out an action plan. I then reverted to the original image. The first action was to use highlight burn very lightly to give density to the foreground and distant sunny areas. Then midtone burn brought the background in. Finally shadow burn was applied extensively to give some density to the very bright foreground areas.

Now there are alternatives, you have to make a decision

If you look long enough at the original image, you will find it becomes more and more acceptable. Your brain is filling in the blank areas, using imagination and past knowledge to make up the details you need. As a result, the manipulated, tone-balanced image may look too painterly, not like a photograph. Which you prefer is a matter of taste, but more tricky than that, now there are alternatives, you have to make a decision.

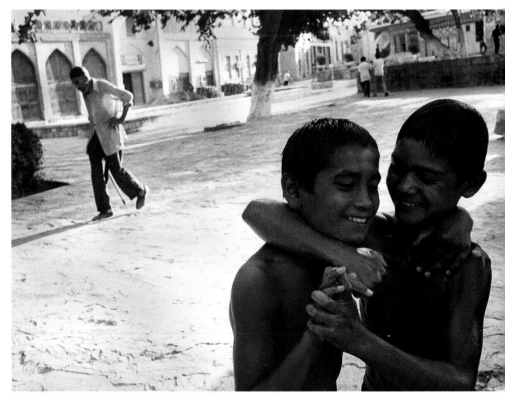

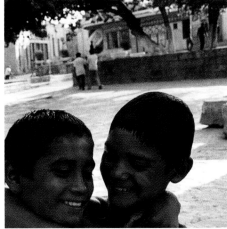

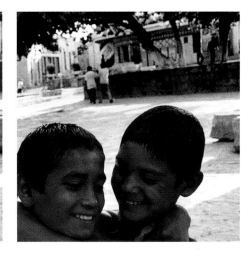

Highlight burn

When you apply burn-in restricted to the Highlights tone-band, you darken all three-quarter tone pixels i.e. the lighter ones. Heavy applications to light areas tend to reduce contrast overall, as is evident in the top image where highlight burn was applied only to the top portion. In the lower picture, highlight burn was applied lightly throughout: note that the bush is slightly darker without the dark leaves getting too dark. Highlight burn is best applied to dark areas which you wish to darken further. In lighter areas, working in this tone-band is usefully for painting density into empty areas which you then improve by using midtone or shadow burn.

Midtone burn

Burning-in to the midtone region is the most generally useful and provides the result closest to darkroom experience. It appears to darken light and dark pixel alike, therefore holding subject gamma. The burn applied to the above image – using 20% pressure and large brush – is entirely usable: compared to the original, it has brought out details without exaggeration. The image below received more exposure during burning-in that it should have. But you can adjust with the Fade

command to reduce the burn (or the effect) by fine amounts.

Shadow burn

Burning-in that is limited to the quarter-tone band i.e. the tones below midtones is most effective on lighter areas and usually too powerful on darker ones. Only a few strokes were enough to make the upper image excessively dark and see the hedge below. But with lighter areas, shadow burn is very useful for bringing in density without the pallor given by highlight burn. This exploits the presence of darker pixels within light areas: they may be invisible but the burn tool hunts them down and darkens them. This gives the appearance of density in the highlights. In fact the true highlight pixels may still be bright white, but now we can see the darker pixels more easily.

Regional burn and dodge

Working over large areas or regions of the image can present a tough problem for the pixel processor. The reason is that it is hard to simulate the darkroom action of covering only a part of a print during burning-in so that the exposed portion is evenly and controllably exposed yet ever so smoothly blended with the unexposed part. The key digital technique is the gradient combined with different layer modes.

Using gradients

The original image of a sea loch in Scotland (right) was taken on a digital camera. It has adequate exposure, fair colours and sharpness.

In the darkroom, the temptation to improve it by darkening the skies by a tad and lightening the foreground proves, like all good temptations, irresistible. So why not do the same in the computer? The equivalent of giving extra exposure to burn in the sky (if working with colour negative material) is to apply a smooth gradient of density over the top half of the picture. And we apply a lightening layer to the lower portion of the image to lighten it: note that when we apply gradients we are not actually applying the burn-in or dodge tools themselves.

First, we create a new layer to make the work easier. Then we exploit layer modes to control the way the underlying pixels are expressed – in fact, we are doing more than burning-in and dodging. Through our choice of layer mode we can change contrast, saturation and do so with a high degree of finesse, by adjusting gradient colour and layer opacity. The trickiest part of the technique is drawing the gradient itself, which only experience and systematic experimentation will improve. If you need shapes more complicated than a simple gradient, you need to create extra layers – each holding a simple gradient – to build up the final shape. With both layers set to Overlay (right), the result is the image on the left.

Normal mode

When we create a new layer, the blending mode – how it interacts with the underlying or receiving layer – is set by default to Normal. If we apply a gradient running from black to transparent on the top layer, the underlying layer starts dark and progressively more of the underlying image shows through.

We create a gradient by choosing the gradient tool with the gradient running from black to transparent, then we drag a line starting from where we want it darkest. The point you let go of the line defines the end of the gradient i.e. in this case, the rest of the gradient is transparent. In this image, I drew from the top of the image and let go when the line reached the central profiterole-shaped cloud.

The resulting 'burn' wins no prizes for subtlety: the sky is darkened alright but of course the effect is too heavy. We could alter the opacity (above right) but that does not correct for the loss of contrast (right).

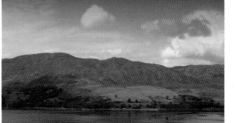

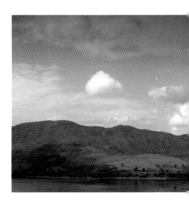

Soft Light mode

Now, you can apply a gradient directly in one of the layer modes such as Soft Light, Overlay, and so on. But the advantage of working with layers becomes clear when you change your mind. It is then simply a matter of changing the layer's blending mode rather than selecting another mode for the gradient then re-drawing the gradient.

For this attempt, we change the blending mode to Soft Light. This mode looks at the composite pixels i.e those that result from combining the layers. The mode multiplies – i.e. darkens – dark pixels and lightens light ones, but only by a small degree – thus the effect is usefully soft. To see what doing that to a large degree is like, invoke the Hard Light mode, which is generally not nearly so useful. The result of applying the gradient as Soft Light is better than Normal, as the clouds are darkened yet colour is preserved in the sky. However, one cannot help feeling more could be done.

Color mode

Now let us try another approach. Instead of a neutral gradient, we will apply some colour. First I sampled sky colour, which shows up as a foreground colour (below right). By clicking on the colour, the colour picker is displayed, which enables a darker colour to be selected.

The gradient was drawn with this colour with the blending mode set to Color, and at full strength. This resulted in the image shown on the left. The Color mode adds the hue and saturation of the blending layer together with the luminosity of the underlying layer. So, like the companion Saturation mode, it does not darken as such, but it can have a similar effect by intensifying the pale colours normally associated with high-key areas.

In this image, intensifying the colours has brought out a slight magenta cast in the highlights, which is not desirable.

White overlay

To deal with the dark foreground portion of the image, we need a mode that lightens colours without loss in colour or contrast. The Overlay mode is perfect for this as it screens light-coloured composite pixels – i.e. pixels which are between midtone and highlight as a result from the blend are lightened – and it multiplies i.e. darkens composite pixels which are between midtone and black. In short it increases contrast. If you apply a black gradient on Overlay you darken and improve contrast at the same time. In short, the Overlay mode is one of the most useful for large-area burning-in and dodging.

Now, applying white as Overlay will lighten pixels but without the usual cost of loss of contrast and desaturation in colour. For this image, the foreground colour was set to white and the gradient drawn from the bottom of the image – but, for sake of illustration, the opacity is set too high so that the foreground appears too contrasty.

The gradient tool shows a checker-board pattern to indicate the gradient into transparency.

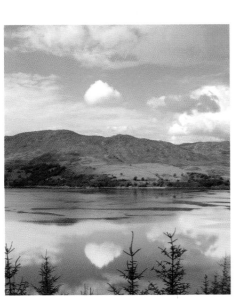

7

Controlling the Curves

The beginner must be forgiven for wondering why the adjustment control is called Curves when the first thing seen is a straight line. You should always remember your first questions, because they are almost always good ones. The fact is that the line is a transfer function, not a curve. It is important that it is a straight 45° when you invoke Curves (when you do so without applying a previous setting) precisely because you have not yet done anything to change the way the original pixels are transferred or altered to the new pixels.

So, what you are doing when you manipulate the Curve is you are altering the transfer function. This means that instead of, say, starting with a midtone pixel which ends as a midtone pixel, when you change the shape of the curve, the original midtone pixel becomes a dark three-quarter tone. Or it can become a lighter tone. This explains why the horizontal axis is labelled 'Input' and the vertical axis is labelled 'Output'. Follow a value – your original pixel – from the horizontal axis up until you reach the line, then read from the vertical axis to find out the value of your output or new pixel.

The beauty and power of this control is that you can draw different curves for each of the channels you are working in. As a result, not only can you control tonality overall, you can adjust colour balance in shadow regions separately from colour balance in midtones.

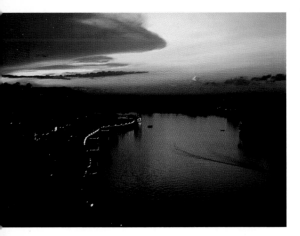

The basic curve

The Curve command when first invoked always looks the same at the beginning, irrespective of the image you open. The sunset gives exactly the same shape curve (right) as does the negative of palm-trees (lower right). The only difference is that if the image is greyscale, there is only one channel available. The Curves command is essentially a graph – a representation of the relationship between two scalar quantities: what you put in is measured along the horizontal scale, what the command delivers (output) is on the vertical scale.

Note that the scales for the graph runs from the origin in the lower left representing zero density up to maximum density on the horizontal scale towards the right, and also zero density to maximum up the vertical scale. This is the convention in the pre-press world but you can click on the central double-headed arrow to reverse this (right). Also, option (Alt) click on the line will show ten sub-divisions on the graph – easier to read. A click on the line places an anchor point - the Input/Output boxes will then appear.

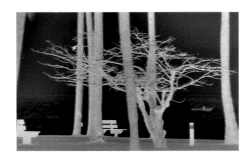

It is easier to read values off the graph when you display the grid of ten squares.

High curve = darker

The following three manipulations are the basis for all work with Curves. A high curve results from 'lifting' it up: (click on it, hold on the mouse button as you pull it up – or click on the curve, then press the 'up' arrow key). A darker image results: follow a midtone point up to the curve: as it lies higher on the vertical scale after adjustment, the output is darker. Note that as you pull up on the curve, the rest of it follows so that it is steeper in the light values but shallower in the darks. See image (left): the darker areas have lost contrast and blend together while the lighter areas are more contrasty and are more clearly defined.

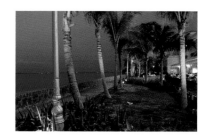

Low curve = lighter

In contrast to the above, pulling the curve down lightens the image overall. The overall density is lower because the area under the curve is less: if you pick up a midtone on the horizontal axis you can see that it is transferred to a lower – i.e. less dense – one on the vertical axis. At the same time, there is a useful gain in contrast in the dark values (the curve here is steeper) and a lowering of contrast in the high values (the curve levels off) – which can also be useful. These somewhat different results – of pulling the curve up or pushing it down – hint at what you might be able to achieve when you create more sophisticated curves.

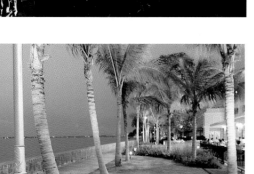

Inversion

The third fundamental manipulation is inversion, the result of changing the direction of the curve. You may not need to use this very often in pixel processing as the result is rather dramatic. However, as a photographer you very likely still scan negative film. You may find the results of carrying out the process of inverting the positive scans of your film more controllable than allowing the scanner software to do its own inversions. Note that while photography's natural mode of operation is in the negative, while that of the scanner is in the positive. For a scanner to create a positive from a negative film, it must apply some software-based manipulation. But should you want to be in control, then you should take charge of the inversion.

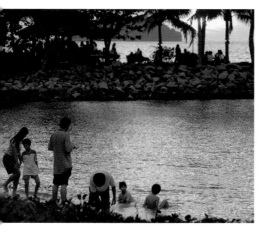

Note that with colour film, inverting the image turns not only the density map upside down but also the colours so that the original hues flip over to their complementaries (left). Should you want to reverse the density map but retain colours, first convert to Lab mode, then invert only the L (Lightness) channel (right). We will use inversion later to imitate the Sabattier effect.

The inversion will reverse colour as well as flipping over the density map but the curve shape controls the reversal.

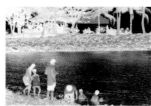

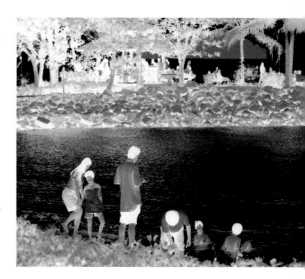

To invert tone values but keep the colour, convert to Lab, then reverse the Lightness channel curve.

Different types of curve

The Curve that you draw results partly from your actions but also the behaviour programmed into the command. Different software offer behaviours which are more or less useful e.g. the curve consists of straight lines between any points which you set. Photoshop's offering of only two ways of behaviour keeps things simple but can be limiting.

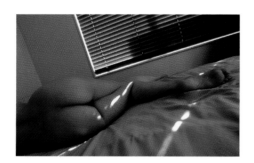

Clipping curves

By clipping we mean the same as with the Levels control: we restrict the range of values which pixels are permitted to take. We either force more pixels to be black or white or we reduce the maximum shadow or highlight which any pixel can attain. However, with Curves you have more control and can see what you are doing.

Now, if you clip from either highlights or shadows, you tend to increase contrast – the slope of the transfer function increases. You are turning more pixels which are dark

into black ones or pale pixels into white ones, so contrast must increase. Do both at the same time and contrast increases greatly (the curve top right and result top left). The opposite effect is to limit the maximum values of that either dark or light pixels can take. Contrast will then be lower (you decreased the dynamic range). This is evident from the shallower slope of the graph (right), and resulting image (left).

Clipping highlight and shadow increases contrast (the slope of the graph is steeper).

Limiting the maximum and minimum reduces contrast as the slope of the curve becomes shallower (below)

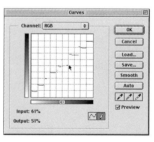

Posterized curve

A posterized effect – in which bands of even colour contour the tonal transitions – is best created in the Curves control. Click on the pencil tool first (far right). and simply draw steps in the line - as few or as many as you wish. If you need a larger step to separate detail, just draw it – (right: the arrow points to this). I also clipped the black to lighten the shadows and reveal the bands.

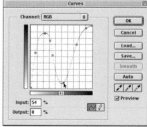

Posterization of the image is also available directly through Image > Adjustments > Posterize, but you have little control.

Extreme curve

We can now combine them all – inversions, extreme slopes or clipping – to apply extreme curves. The pixel processor seldom calls for this, except to imitate darkroom effects such as reversals or extreme contrasts e.g. the Sabattier effect. One of the rewards of applying extreme turns is that posterization effects are unpredictable.

Adaptive tone correction

We know that the characteristic curve of an image, which does indeed characterize the image's tone reproduction, is not linear. In fact it is low in contrast where we would like more contrast – namely the shadows – and in the highlights carrying detail. With the Curves control, we can straighten out the characteristic curve (both for digital cameras and film).

The original image was lightened in Levels (above) before the Curve was applied (top).

Bow-shaped curve

For the first time in the history of photography, we can directly match the output curve to the input characteristic. Until now we have had to use crafted printing papers, subtle developer formulations plus burn-and-dodge manipulations (not to mention rubbing in the developer when no-one's looking) – all to ensure that we had decent contrast in the low tones with detail and some density in the highlights with detail i.e. in the crucial Zones III and VII.

Now with the Curves control, you simply put in a bit of steepness where the characteristic curve is too flat. First, anchor the curve at five or six points by clicking on it (option/alt click the grid to get the ten-zone scale). Now pull the three-quarter tone up a bit: this increases contrast in the shadows. Now pull midtone up if you want to darken it or down if you wish to lighten. Do the same with the quarter-tone to improve contrast in high values. The exact shape of the curve varies, of course – the better to adapt to each image's own character.

A fair shot by a digital camera, but somewhat underexposed and lacking in sparkle. Correction with an adaptive curve results in a good representation of what I saw (below).

A simpler shape can give more dramatic effects e.g. to compensate for dull printing results on some papers.

Curves for colour

Non-linear tone reproduction – where contrast varies with intensity – has its counterpart in colour reproduction. In fact, uneven colour balance – where colour balance varies with intensity – is a direct result of messed-up tone curves. So gross global controls are seldom successful. The crucial trick to colour balancing with curves is to work in CMYK mode.

RGB correction

There is nothing to stop you working in RGB mode. And there are some advantages too: file sizes are a quarter smaller than with CMYK, and the thought processes for colour balancing are more intuitive. However it is not so easy to produce subtle effects: small changes in the curve can have a substantial effect on the image because each curve controls a good third of image data. I recommend using the up/down arrow keys to control the curve: click on a point on the curve, hit the Tab key to highlight the Input or Output box as needed, then press on the up/down arrow keys as needed – this method can give your mouse-hand much needed exercise.

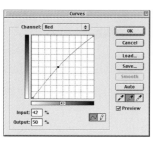

In this shot, snatched at an airport in Malaysia, the colourful display is overcast with red and yellow. A simple reduction of midtone red – achieved by pulling up the red separation curve (above right) – somewhat improves colour balance but introduces green cast in the shadows and darkens the image (right).

Using droppers

One quick method of colour correction is to use droppers. They work just like droppers in the Levels command (which proves the close relationship between Levels and Curves). In the shop image, the red-yellow cast is most objectionable in the paler regions such as the tiles and the ceiling. By using the dropper, we are telling the software: where we click, we want all values to be mapped round this so that it becomes pretty neutral.

The Information palette (right) tells us that there is a strong yellow and even stronger red in the highlights. The result of clicking the dropper on a ceiling tile near the top left-hand corner of the image is a much better result (right). Two of the separation channels are shown left. The red channel has been clipped: its starting higher up the output scale means that it is reduced in strength. The blue channel is much weaker (lower left). Not only is the curve starting from an input of 30 giving an output of 0 (that is, all values from 30 and up are maximized), this clipping increases its blue contrast, which improves shadow detail. Colour corrections do not need to be complicated to be effective.

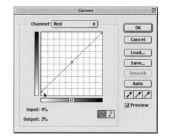

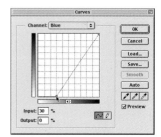

The curve for the blue channel shows the lighter input values all forced to white, so making blues weaker in the highlights.

The white dropper defines the white point round which other values adjust.

CMYK correction

For critical and controlled colour correction using Curves, the best colour space to work in is CMYK – the four-colour separation world used in mass as well as desk-top printing. You do have to put up with the larger file size, but you will automatically have an image that looks closer to the output (assuming that you have set up colour management in your system).

The beauty of doing colour correction in CMYK mode lies in the K channel. You can alter midtone and shadow without worrying too much about colour balance. Therefore, you can change colour balance without worrying about midtone or shadow density. (See also p.48.) The separation into four, instead of the three channels of RGB space means that changes to the shape of any of the curves do not produce such drastic effects as with RGB curves.

The reason for this is that when you work on a separation colour, you are limited to making changes to a quarter of the total information on the image, rather than changing a third of the data at a time.

In this image, yellow rays of the sun mix with blue shadows from the blue of a Greek sky. Apart from the black, there are no neutral tones which we can safely use as standard (see right), so we have to work by eye. The first step is to compensate for the Cyan cast – visible but also confirmed by the Information Palette read-out (above right) of the black in the depths of the jug.

Notice that although the light cyan areas appear to be midtone to three-quarter tone, their C values are in fact high (i.e. there is a cyan cast) – so you concentrate on pulling down the C values. At the same time, it is clear that we want to improve the shadow detail. So we turn to the K channel to pull it down, therefore lightening the image overall, then adaptively create increased steepness in the curve at the vital three-quarter region – equivalent to the 'shoulder' of the characteristic curve (above right). The M curve (below left) was also brought down, to reduce the magenta tint present in the yellow petals.

In colour images, tonal correction cannot be wholly divorced from colour correction. Clearly another advantage of CMYK curves is not only that they offer you a one-stop shop for tonal and colour correction, it's an image-friendly shop.

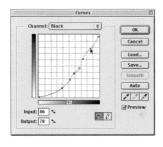

The deep black in the top right of the image is shown in the Info palette to be a high black with a cyan cast.

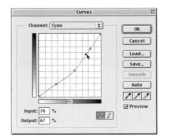

The cyan input of 76% (above) is dragged down to 67%, so correcting the cyan cast in the shadows. Below: similar corrections in other colours.

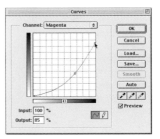

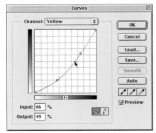

Posterizing the smooth

You may observe strange effects when you manipulate the Curves control: colours no longer change smoothly; formerly smooth gradients of tones break up into distinct patches or contours. These can occur with any image manipulation application, and do not represent a fault with the software. Rather it shows up deficiencies in the completeness of data in your image file.

It happens in the parts of the image characterized by steep portions of the Curve. These place fierce demands on the data: a small quantity of original input data (i.e. small changes in tone or colour) must be spread over a wide range in the output image i.e. to represent a big change in tone or colour. If there is not enough data, the gaps show up as sudden transitions in tone or colour – this is posterization, also known as contouring.

8 Methods of cloning

Imagine a world in which there is not a single speck of dust. Well, that is beyond science fiction. Wherever you are in the Universe, dust is a nuisance. And worse in the fully digital world: a speck on a CCD sensor can record itself onto a hundred images.

The fight against dust is led by cloning. In essence this copies one part of the image – from the source area – to another – the target area. You start by defining the source area (usually Option (Alt) click with the clone or rubber-stamp tool). Where you next click is defined as the target. You can keep the target lined up to the source (aligned) – which is most useful for dealing with dust. Or else keep the source area the same while cloning anywhere in the image (non-aligned). Note you may be able to clone in different modes e.g. to lighten or colourize. Modern cloning can copy texture but not colour, or vice versa.

This chapter keeps to basic cloning as that is most widely available.

A panorama of Kuala Lumpur at night: not only is any dust in the image lost in downsizing the image from 32MB to 7MB, so is the image noise reduced.

Where there is no need

So we are not on a planet where there's no dust. Before you roll up your sleeves and set to, permit yourself the delightful question 'Do I really need to do this?' Take the panorama above: not only is it almost black, the original file size came to 32MB. But the data needed for this printed image amounts to less than a quarter of that. So any but the largest lumps of dust will be swallowed up in the downsizing. Other operations will also conceal a great deal of dust. If you do any of the following, you may not need to remove any specks at all. If you greatly reduce the image in size. If you print onto rough paper. If you increase graininess by adding noise. If you greatly JPEG compress. Or if you apply any art materials filters.

Once you have performed the changes, then of course it is prudent to check to see if any defects are still visible by zooming in closely – then it's the right time to remove them.

The secret of dust cleaning

The key to success in dust removal is to look slightly sideways: instead of concentrating on the defect, look at the immediately adjacent areas. That is because what you are doing when removing a speck is actually to fill the adjacent area into it: you are reconstructing the image damaged by the speck. Sometimes this means making a spot disappear, sometimes – e.g. in a grainy image – it means simply reducing its contrast. To make it disappear may create an artefact – an area too free of grain. Veteran spotters of fibre-based papers will recognize similarities to the technique they use for cleaning up gelatin-silver prints. Removing dust specks and defects in a digital image is the same: really what you concentrate on is the repair of the background image.

Other books on image manipulation give you the idea that the only way to remove specks and scratches is to use the clone tool. It follows from the notion of repair of the background that there are other methods.

Press the '[' key to reduce brush size, ']' to increase.

Hold down shift key and press '[' or ']' to change hardness.

Set brush spacing to zero (uncheck the box) to prevent smearing. Splatter tools – rows 4 and 5 give poor results.

Control centre for cloning: 'aligned' keeps the distance between the source point and target the same.

Clone tool settings

Clone with a brush only a little larger than the largest defects to be removed and set a soft-edge brush: too hard an edge produces unsatisfactory results (left) but can be useful when working close to a sharp edge. But too soft an edge can smear image detail. When working, you will generally want to click a zillion times – one for each defect. Don't drag the clone brush or you create smeary results (above). The Spacing setting for the brush causes smoothing. Brushes are usually set to 'lay' colour only every other quarter of the radius of the brush i.e. colour is dabbed on only four times in a distance equal to the size of the brush. Turn the Spacing setting off or set spacing to zero (far left) if smudging or smoothing is a problem.

Dust filters

The much-maligned Dust & Scatches filter has it uses, rough and ready as it is. Dust from scanned prints and large negatives are often very sharply defined and high-contrast. This enables the filter to pick off the high-contrast specks without badly affecting the underlying image. Set, in the dialogue box (above right) the threshold to 14 and radius to 5 pixels to minimize effects on the grain. While grain is softened by this filter, on certain images, that is a small price to pay for a one-click dust killer.

A truly excellent filter, however, is the Pen Duster (right), but it comes only with Wacom graphics tablets as a plug-in. Simply open the filter, draw over the specks (settings can be changed to preserve grain, or ignore certain threshold sizes - right). What you had drawn was in fact a special cloning filter which used adjacent pixels to fill in the defect. I find it superior even to Photoshop 7's healing brush tool.

Making lines disappear

The worse and often trickiest objects of cloning attention are long thin lines. They are often in visually central positions, they may traverse a wide range of differing image colour, contrast and detail. And they may not be straight. Help is at hand in the shape of Paths. These allow you to define the path at leisure, then stroke it i.e. draw it, using the Rubberstamp tool. It is then easy to make smaller touch-ups.

Using Paths

Beginners to pixel processing are often wary of Paths – with reason: it is easy to distort a line wildly (right). But for this technique, however, you will not manipulate the path at all; simply run it down the image to tell where the Rubberstamp tool should run. In this image, we want to remove the prominent rope tying the fishing boat to the pier.

After selecting the Pen tool (press 'P'), simply click down the centre of the rope. This is fine if your line is, at most,

gently curved. For narrower radii, use the Freeform Pen which allows you to draw freer lines. When you have defined the path, choose the Rubberstamp tool with a medium-hard brush set to a width just wider than the rope. You need to define a source point: choose this carefully as it will determine the relationship between source and target (the path) for the whole of the path.

Now, you can create a new layer to give yourself flexibility e.g. chance to create a mask to tidy up the work, or you can work quick and dirty – directly on the image. If you create a new layer remember that the clone should be from 'Use All Layers' – check in the options palette. Now stroke the path: the method varies with version – use either the menu on the Paths palette or press the button on the palette (left) and choose Clone Stamp tool (above). You can also change the blending mode – usually Normal is fine, but Lighten or Darken will give better results with some images.

Removing the long rope with normal cloning is tiresome and tricky. Using Paths is much easier to control, and gives you a chance to adjust and refine as much as you like, without running up dozens of 'Clone Stamp' in Histories.

If you set the source point incorrectly, the clone is out of synch with the rest of the image. Simply hit undo and try setting another source point.

Removing large features

Cloning can apply to the duplication of larger areas of image. You can do this where you have a defect that stretches right across a substantial stretch of even tone: typical examples are telephone wires seen against a clear sky, a long twig sticking out from a mass of leaves. You can deal with them by cloning or take advantage of the even background, and simply copy a large chunk of it over the offending feature.

Duplicating areas

In this scene, of water taxis on the Sarawak River, I remember wishing I was higher up to give more space between the trees and the boats (right).

As an exercise, it is a two minute's work to remove the trees entirely by exploiting the relatively even tones of the river. First, I selected the Lasso tool and set a Feather of 22 pixels. The shape drawn was deliberately made

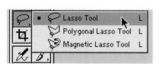

irregular (below), in order to disguise blends between areas when one is laid on top of another. By holding down Command (Control) + Alt (Option) keys, I duplicate the area when I drag it to another spot, then another and so on (far right). In four strokes, most of the trees have disappeared – much faster and easier than working with a large brush set to clone.

There is detailed cloning work to be done where the trees overrun the lower boat and its shadow: this is carried out using a very small, feathered brush working at high magnification. Finally, the tonal changes in the water opened up by removing the trees are smoothed out by cloning with a large, fully feathered brush.

Photoshop 7's Patch Tool can be useful with this type of image.

An irregular, feathered selection helps smooth blends between duplicated areas.

Prevention is best

Your parents were right, you know: prevention is better than cure. Taking precautions to avoid problems with dust saves a great deal of time and trouble further down the line. So: work with clean filtered water when processing film, especially during the final wash. When drying the film, make every effort to dry in dust-free, filtered air. Then keep your negative files perfectly clean before and after filing them. Avoid stacking negatives flat on top of each other: their combined weight will squeeze any dust particles together to create permanent damage. Keep transparency film in slide mounts – ideally – or if that is not possible, do not stack piles of films on top of each other.

When you print, clean the film carefully and handle with utmost care. You will also clean your film and handle with utmost care when scanning. Keep the scanner meticulously clean: cover with a plastic sheet when it is not being used. Use microfibre cloths of the kind designed for cleaning camera lenses to clean the glass plate.

Electronic vacuum-cleaners

It sounds like the answer to digital photographers' prayers the world over: automatic removal of dust and scratches. So why doesn't every scanner manufacturer use it? Apart from the cost of the license required, there's always that problem about free lunches. There are none. So dust-removal during scanning brings costs which are slower scanning and loss of fine detail. For the majority of users, however, the costs are insignificant while the gains in time recovered from dusting operations is significant.

The basic principle used is that dust and film respond differently to certain wavelengths of light e.g. infra-red light picks up the dust and ignores colour film, so a mask can be created which defines the dust-specks. The rest is then clever software interpolation to fill in the holes left by the mask. It is this interpolation which can soften image detail. But you can always turn off the dust removal and do it yourself – for quality-critical work that may be the best approach. Or just say: Praise be for all time-savers.

9 Working with duotones

of a gelatin-silver print, even when reprographed through very fine-pitch screen rulings.

It was found that if a black ink was given to the shadows and a very dark but subtly coloured ink was given to the lower midtones through to highlights with detail, far richer and satisfying prints could be made. Hence the name of duotone. And, of course, apart from the expense of creating extra printing plates, there is nothing to stop you using more than two inks or, indeed, brightly coloured inks which are far removed from black.

The secret to success with working with duotones is learning how to divide the relative contributions of the different inks. You can operate at the subtlest levels through to using strong colour contrasts to give results similar in feel to heavy toning, but – in the computer as opposed in the sink – with infinitely more control and repeatability. In this chapter we start by working with, then explore, split toning.

Before four-colour printing became commonplace, it was the practice for the best quality black & white printing to be carried out not only with the highest frequency screen rulings – to give minimal print grain – but printing was carried out with two inks. A single black ink has a very hard time simulating the sleekly smooth and subtle tones

Duotone in easy steps

Sofware such as Photoshop work with duotones as a special imaging mode – one in which each ink is treated as a separate greyscale layer with an overall colour (which is exactly what a duotone plate is). To use the image, however, it is best to turn it back to your normal working colour space.

Therefore, first ensure your image is greyscale – do not simply desaturate a colour image: you must discard colour information. This will probably cause small tonal changes – which can be adjusted during duotone creation (but see also pp.74-79).

Then enter duotone mode through the menus: Image > Mode > Duotone …. Your image may change immediately as any previous settings will be applied and if the Preview box is ticked (if not, tick the box – preview is one of the best features of this control). You can change the colour of the ink by clicking on the sample box of colour. Then you change the transfer curve applying the ink by clicking on the thumbnail of the curve and adjusting the resulting curve in the dialogue – ensure preview is turned on (ticked) to monitor changes.

Once you are satisfied with the results, return the image to your working colour space, in which the separation colours are used to recreate the greyscale layers. As usual,if working in RGB, hit Command (Control) + Y to soft-proof i.e. check the quality of the CMYK output.

Basic settings

Working in the duotone mode is like cycling: no instruction can make much sense unless you actually do it yourself. And once you've tried it a few times, you'll be hooked and can't stop.

Start with two inks, and change the colour of the second. Then play with the transfer curve: notice that as you increase the area under the curve the image darkens i.e. when you raise any part of it, and it tends to lighten when you do the opposite. You will also discover that, even if you draw an extreme curve – with steep portions and reversals – the effect on the image is not too violent because the other curve is holding the basic tone reproduction level.

In this pair of images, I made one (left) normal in tone apart from its colouration – compare it with the original (top right). The other version (below) uses a low reversed curve for the cyan, which puts more cyan into the highlights – giving a light, cold glow – and less into the shadows, so they are less dark, which opens up the image.

The colour picker (above) allows you to pick colours by eye but you can also specify them precisely in e.g. CMYK (far left).

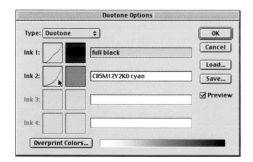

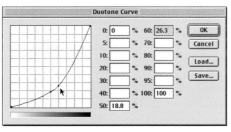

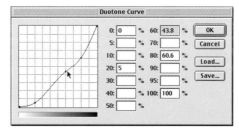

The pulling down of the transfer curves for both inks has lightened the image overall.

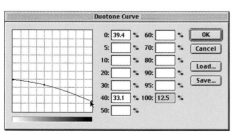

The upper curve (left) shows the transfer for the cyan: its reversal raises cyan in the lighter areas, while reducing cyan in the shadows. To compensate for the resulting flattening of midtones, the black curve (left) was pulled down: compare with the midtones in the first curve (above).

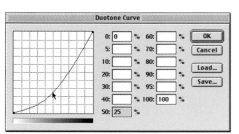

Colours and duotones

The great strength of duotones for the digital photographer is that it combines the great dynamic range of colour with the emotional power of the black & white. Then further: working with colours within a narrow, carefully chosen range often sets the mood of our work more effectively than full-colour images can. To learn to work with duotones, a great place to start is with Photoshop's own presets.

Cyan duotone

This series of three images explores the use of the separation colours. This is useful because duotone production in mass printing needs to be approached with care, as the use of bright or deep colours can be tricky to control. By using the pure separation colour, you reduce the number of variables to deal with. Here, the curves show that blacks have been reduced in the midtone portion, but boosted in the cyan (right). Note the lowered maximum in the cyan, to avoid over-inking the shadows. The result is an attractively cool tone.

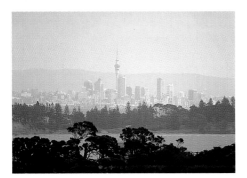

Magenta duotone

As magenta is a warm colour, like other warm-toned colours, you generally need less of it to set the mood. This is demonstrated in the curve for it (right) which has been pulled down, so reducing the area beneath, resulting in lighter pixels overall. Note that the steepness of the slope at the important three-quarter tone section – of shadows with detail – has increased somewhat, helping the shadow separation. The black has also been reduced compared to the above image, so overall the image is lighter.

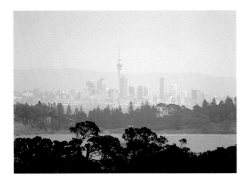

Yellow duotone

Compared to the other separation colours, yellow is weak – i.e. it reflects a good deal of light energy – and as a result you generally need more yellow than other colours to make an impact. This is reflected in the curve for the yellow. It has been raised in the mid portion: more area under the curve means more ink, yet the image (left) does not appear any darker than the others. Note the way weakness in the mid tones due to the feeble yellow gives rise to low contrast, causing the buildings to disappear into the haze.

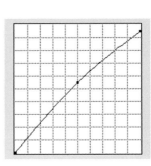

Blue duotone

Here we use a pure blue to partner the black. Of the images on this page, this showed the greatest difference when its RGB incarnation and its CMYK equivalent were compared. The reason is that some blues in the RGB gamut of a monitor fall outside the CMYK gamut (see p. 28). As blue is such a dark colour, the preset curve reduces the black ink by a very substantial amount as shown by its curve (right). Pulling back the black enables the blue to make its mark.

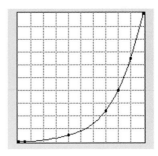

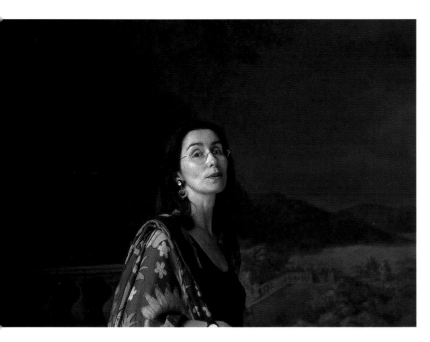

Creating sepia tones

A most obvious, and by far the most frequent, call to duotones is to simulate sepia toning. The brown results from the carbamide staining of the print which has a long history and well-documented longevity: it provides image warmth, simultaneously improving image dynamics. A good place to start is with the Photoshop brown (found by clicking the 'Load' button found below the 'Cancel' button, and navigating through the Photoshop folders): this uses Pantone 478.

Applying the preset curves gives a rich but dark image (far left). This is because the original (above right) is somewhat low key, with a dark background that appears empty. In fact, there is a good deal of detail in the background – a painted studio wall in Budapest – and it takes a lifting of the black curve to reveal it. This has been done in the image (middle left) but the result now lacks depth, while the face has been lightened too much. To balance this, we turn to the brown channel to raise levels.

Compare the original curve (right) with the modified one (below left) and you can see that highlights have been clipped (see the input value of 0 becomes 9.4) so there are no whites, only pale browns. This improves the facial tones by adding weight to the highlights. At the same time, the overall gain in density gives the image the body it needs without losing details in the dark background.

Black curve above, brown curve below.

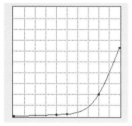

Curve for black ink.

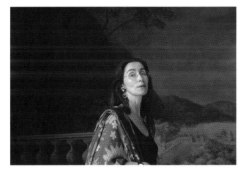

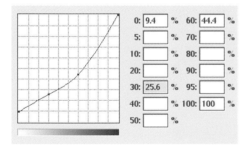

0: 9.4 %	60: 44.4 %		
5: %	70: %		
10: %	80: %		
20: %	90: %		
30: 25.6 %	95: %		
40: %	100: 100 %		
50: %			

With a heavy black ink, the first attempt (top) is too heavy but a simple reduction in the black returns a palid image. The shadows are insubstantial and overall there is a loss of contrast and snap. Increasing the brown ink in the values higher than midtone through to the highlights fills in the high values – important for the face. But note (above) that mid tones between 30 and 60 have been reduced, which lowers high-value contrast – helping the face again – and improves contrast in the shadows.

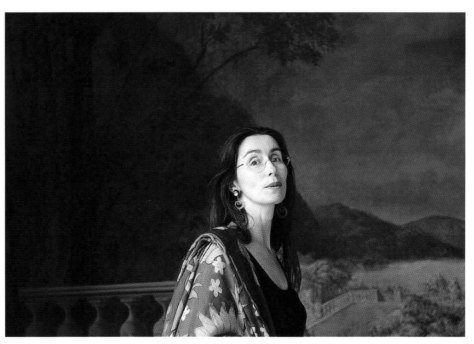

Tritones and quadtones

For the digital photographer, working with multiple tones is something of a contradiction – manipulating different coloured inks only to turn them into RGB in the end. It would surely be simpler to work in RGB from start to finish. In fact not; working with multitones (two or more) allows the most subtle control of monochrome images as we limit our manipulations to a very narrow band of colour – that of each ink we use.

Tritone variations

When printing on an industrial scale, you are better off using tritones based on easily obtainable colours, and none are easier than the separation colours themselves. The sepia tint given to this ceiling, in a citadel near Budapest, uses pure black, magenta and yellow. The tone curves used for the first image (left) are those given by a Photoshop preset which gives rather heavy results, reminiscent of the gravure-printed duotones favoured by photography and travel books from the 1950s.

Let us say we decide on a lighter, slightly more airy rendering while at the same time attempting to lift shadow detail in the organ loft in the lower right-hand corner and also tame the brightness of the light in the cupola and bring in the sky by adding a little density. We can work on the yellow curve, to bring it up and increase its strength overall – compare the yellow curve in this small box (right) and that below. At the same time, yellow in the highlights tames the bright areas.

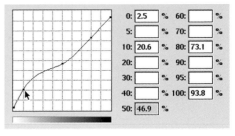

0:	2.5	%	60:		%
5:		%	70:		%
10:	20.6	%	80:	73.1	%
20:		%	90:		%
30:		%	95:		%
40:		%	100:	93.8	%
50:	46.9	%			

The original picture (top) has been easily, but vastly, improved by giving it a tritone treatment.

Cool quadtones

One of many ways to colour a print is to use quadtones. The advantage of quad-tones is having four very precisely defined colour channels to work with. These images show what can be achieved using exactly the same colours with a few simple changes in the curves. First, we use the standard colour separation colours to present a

 cool tone. This is the result of being generous with the cyan (above right) and slightly down on the magenta (right), with yellow very low. As it is created in CMYK colours, you can be sure that it will print satisfactorily and – if you have a calibrated monitor – it will be very accurate too.

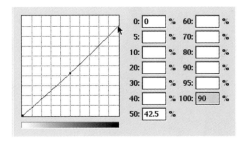

0: 0 %		60: %	
5: %		70: %	
10: %		80: %	
20: %		90: %	
30: %		95: %	
40: %		100: 90 %	
50: 42.5 %			

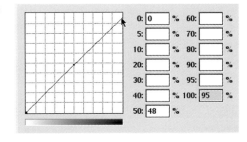

0: 0 %		60: %	
5: %		70: %	
10: %		80: %	
20: %		90: %	
30: %		95: %	
40: %		100: 69.4 %	
50: 35 %			

Warm quadtones

We can use precisely the same inks as above to give an opposite result. Raise the end of the curve for magenta (right) as well as for the yellow (below right). As these are light-coloured inks, increasing their strength adds little to the overall density. You need only a small adjustment (around 5%) in the cyan to keep the

 overall density unchanged. Yet the result is a long way from the cool rendering above. When you have mastered separation quadtones, try using Pantone colours from the pastel end of the palette: combinations of pale colours can give the most creamily rich and rewarding prints.

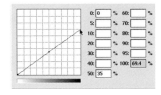

0: 0 %		60: %	
5: %		70: %	
10: %		80: %	
20: %		90: %	
30: %		95: %	
40: %		100: 95 %	
50: 48 %			

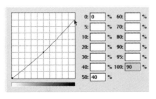

0: 0 %		60: %	
5: %		70: %	
10: %		80: %	
20: %		90: %	
30: %		95: %	
40: %		100: 90 %	
50: 40 %			

Super-toning

When you apply extreme curves with steep slopes and reversals to a colour image, the result is usually a quagmire of wild colours, contouring effects and image noise. Do the same with multitone images, and you can have wild effects too. But it is much easier to obtain toning effects which are challenging to conventional ideas of tonality but without the posterization artefacts and extremes of hue contrast which accompany working in RGB. Again, it is the restriction to narrowly defined colour channels which saves you from excess.

The aim here was to put some colour into the sky while preserving the hard tones in the modern buildings, also trying to keep the clouds looking as natural as possible. Firstly, the cyan curve was reversed (top right) taking cyan out of the midtones but placing a great deal into the

 light tones like the sky. The magenta curve needed a lot of manipulation (middle right) with this double peak giving the most pleasing results. Finally the yellow curve (right) with the magenta gives a brown in the quarter tones which are lighter than the cyanish tones.

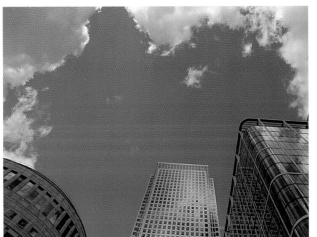

0: 92.5 %		60: %	
5: %		70: %	
10: 64.4 %		80: %	
20: 33.1 %		90: %	
30: %		95: %	
40: %		100: 100 %	
50: 15 %			

0: 0 %		60: %	
5: %		70: %	
10: %		80: 47.5 %	
20: 44.4 %		90: 40 %	
30: %		95: %	
40: %		100: 0 %	
50: 8.1 %			

0: 0 %		60: %	
5: %		70: %	
10: %		80: %	
20: 44.4 %		90: %	
30: %		95: %	
40: %		100: 100 %	
50: 4.4 %			

10 Working with Channels

In the good old days life was simple. Black & white photography was merely the recording of light and shade: technically, you are recording the sum of intensities over time when you expose film. However, it never was that straightforward. No sensitive material or sensor is equally sensitive to all wavelengths of electromagnetic radiation – even over the very narrow frequencies which constitute visible wavelengths. Black & white film is no exception – most demonstrate lower sensitivity to red compared to blue light, for example. Add the complication that the values given to different visual percepts are also not the same. For example, in many societies, reds or yellows carry more psychological (and even religious) weight than blues and purples.

The net result was that, from even the early days of photography, black & white records of certain scenes were found to be unsatisfactory. In landscapes, green leaves appeared too dark. Still-life scenes with lively colour conflicts such as reds and greens were drained of the lively contrasts. It was soon realized that you had to suppress certain colours in order to allow others to show more clearly; and so was filtering born.

Using Channel Mixer

Photoshop and other image manipulation software all provide powerful and flexible methods to manipulate the appearance of colour when seen in monochrome – after all Photoshop is, essentially, a grey-scale editor. You will find the Channel Mixer control under Image > Adjust > Channel Mixer (right). If your software lacks channel controls, you can obtain equivalent effects by manipulating individual channels, but that is a work-around which provides poor feed-back. For many tasks involving conversion from a full-colour image to greyscale, a simple channel mix will suffice. In many instances, you will find that the green channel most often offers satisfactory results – reflecting the fact that detail information is largely carried in the green channel. For quick results, then, you simply choose the green channel and delete the other channels. The next pages show you the features of this powerful and useful adjustment.

Image	
Mode	▶
Adjust	▶
Duplicate...	
Apply Image...	
Calculations...	
Image Size...	
Canvas Size...	
Rotate Canvas	▶
Crop	
Trim...	
Reveal All	
Histogram...	
Trap...	
Extract...	⌥⌘X
Liquify...	⇧⌘X

Adjust submenu	
Levels...	⌘L
Auto Levels	⇧⌘L
Auto Contrast	⌥⇧⌘L
Curves...	⌘M
Color Balance...	⌘B
Brightness/Contrast...	
Hue/Saturation...	⌘U
Desaturate	⇧⌘U
Replace Color...	
Selective Color...	
Channel Mixer...	
Gradient Map...	
Invert	⌘I
Equalize	
Threshold...	
Posterize...	
Variations...	

Losing the colour

There are several methods of converting the colour image into one with the appearance of a greyscale image. One is to use the Hue/Saturation control: by sliding the saturation slider to the far left, colours turn to grey while remainging within RGB space. The result can be very flat and unsatisfactory – see left. It has the advantage that you can apply this on an adjustment layer, so you can continue to manipulate without losing the base data.

You can lose the colour information entirely by converting directly to greyscale: how exactly this is done depends on the colour settings you make for greyscale conversion. However, you cannot recover colour data without returning to the original state. The good news is that the result of most conversions give much livelier results than simple desaturation (see image above right).

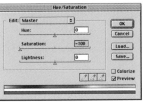

Extracting channels

If the variety of hues present in an image is wide, working with channels offers you great control over greyscale conversion. If you choose to output 100% from one channel, you are effectively extracting that channel by ignoring contributions from the other channels – you have set them to zero. Note that the result would look grey even if the 'Monochrome' box (at bottom left of the dialogue box) were not ticked. The default setting i.e. what you get when you first open the dialogue is 100% red. In terms of black & white photography, you are effectively applying a red filter.

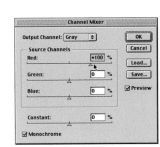

In the image of a medley of garden flowers, reds predominate throughout the image. As a result, if you output to grey using only the red channel (left) the result is very light with bleached out highlights (above right). Yellows bleach because of their high red content.

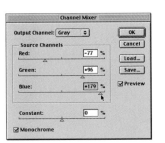

If we extract the blue channel we would expect a darker, lower-contrast result (upper left). Note, however, that differences in hues of the flowers are much better separated than by extracting the red channel. It would take a simple manipulation of Levels or an increase in the Constant setting (bottom slider in the Channel Mixer dialogue) to improve the tone of the image.

Now, to mix channels: aiming for a rich look in which flowers can be easily distinguished, with a long midtone range, I lowered the red channel and greatly raised the blue channel (middle left) to obtain the somewhat old-world looking result shown below left.

Note that if the 'Monochrome' box is not ticked and more than one channel is not at zero, you will get a colour-toned image. It offers a coarse method of controlling the emphasis of colours (right). Note that the printed result is rather dull but the image on screen showed very vivid violets and indigos.

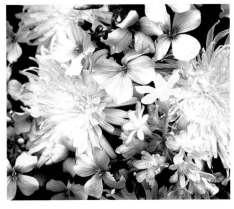

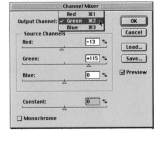

Filters or film sensitivity

The conversion of full-colour to greyscale is the digital equivalent (one might say 'analogue') of making a black & white photograph of a scene. The tonal translations and distributions result from an interaction of bands of film sensitivity with the colour distribution and ranges in the scene. Indeed, each of the colour channels mimics a corresponding orthochromatic film type.

Spectral sensitivity

By understanding how spectral sensitivity relates to channel mixing, we can exploit the properties of the colour analysis to produce the exact greyscale image we wish for. No film responds equallly to all colours – indeed the same can be said of photonic sensors such as CCD or CMOS arrays.

The red channel (left) gives a striking result, with dramatic dark skies but the roofs of the temple (in Penang, Malaysia) are too bright (above left).

The green channel extracted (left) gives a good range of midtones in the roof of the temple – notice that highlights produced by the red channel extraction now show as light greys. However we are in danger of losing interest in the sky. The image is reminiscent of that given by panchromatic films – reflecting the fact that most of the achromatic or detail data is held in the green channel.

In contrast, the blue channel (below left) gives a strongly orthochromatic result, with the temple roof returning almost a black while the skies are blown out with highlights. Many early black & white films responded in this way, with abundant sensitivity to blues but too little response to reds.

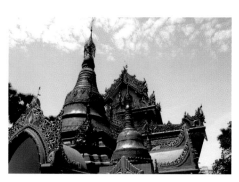

The best of both worlds comes from mixing colour channels. By first increasing the green and reducing the blue, with a small correction in the red (middle right) – we obtain a well-balanced and natural-looking result (right). For the image to stay the same brightness, the various values should add up to 100%. Here the sum comes to 105, which we have allowed in order to obtain a slight overall lightening of the image.

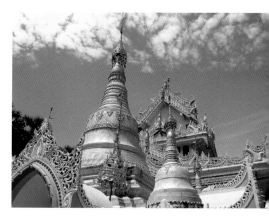

If you want to maintain overall brightness the total of all the channels must equal 100.

> The best of both worlds comes from mixing colour channels

Simulating infra-red film

With its sensitivity to the longer wavelengths and relative insensitivity to shorter ones, infra-red films typically give you ghostly light leaves and preternaturally dark skies. But that is not all. Most lenses cannot focus infra-red wavelengths to the same focal plane as visible wavelengths – the little red mark on focusing mounts indicates the infra-red focusing point. The wavelength-related aberrations cause the image to blur.

Boost the green

Simulating the look of black & white infra-red film consists of two main steps. First, to imitate the selective spectral sensitivity, we need to boost the greens in order to replicate the high exposure given by the infra-red light reflected from leaves. We achieve this by using the Channel Mixer control. In this image – of a garden in Kyrgyzstan – I pushed the green to maximum, then worked at reducing the red and blue channels – effectively further boosting the green – until I obtained a promising-looking image (middle left). This has the greens very light and overall somewhat darkened other parts of the image, which results in an overall increase in midtone contrast.

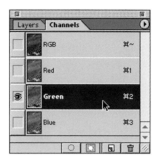

Introduce blurs only into one channel if you want control over the effect.

The next step is to simulate the soft-focus look caused by poor corrections for chromatic aberration in the near infra-red. We have to cheat here: we create a blur, then combine it with the base image. If you try blurring the whole image, all you get is, well, a blurred image. But if you blur only one channel, you can combine it with the others to mix detail with blur – exactly like the film-based phenomena.

So we first select the green channel (top right). This we blur considerably using Gaussian Blur: you will need to experiment with the best settings. For this image, with its fine detail, I gave a large blur radius. Now to combine it with the base image: simply call up Edit > Fade (+ filter name) or hit Shift + Command (Control) + F. This gives you a dialogue (bottom left) in which you set opacity and, more importantly, the blend mode. For this image I used Lighten as I wanted the blur to show up clearly in the shadow regions. You can try using Screen too. Adjust opacity to taste.

The result (far right) gives a very good simulation of infra-red film with its characteristic blur centred on the highlights, being the main source of infra-red.

11
Selections, masks and montages

Masks may seem tricky to master and appear far from normal darkroom techniques. But if masking is the isolation or separation of an effect so that the image is selectively affected, then burning-in and dodging are mask-based operations. To burn-in, you use your hands to shadow off most of the image, allowing light to reach only the selected areas. And when you cut out a shape so that you can burn-in certain parts but not others, you are again using a mask. Notice the difficulty in talking about masking without referring to a selection or working selectively. In fact, a selection and a mask are two sides of the same digital coin – one shows the outline, the other is a greyscale representation of the selection.

Digitally, masks are far easier to create than the scissors-and-swearing operation of the darkroom; and they also offer greater precision and flexibility. The basis of digital masking is the creation of another image in effectively a new channel. This image is greyscale and has transparency so that its masking effect can be softly graduated from fully opaque to wholly transparent – and all grades between.

All your manipulations are therefore directed towards this end: that the greyscale image hides precisely what you want it to hide and reveals exactly what you wish.

All extraction starts with defining the area to be kept.

Image > Extract

The isolation or the extraction of the image from its background – fundamental to the creation of montages– is a specific instance of masking – one in which the mask is discarded on completion. Specialist software such as Corel KnockOut and Extensis Mask Pro exist solely to carry out this task – of which KnockOut is the more efficient.

In Photoshop, the Extract Image command (right) works on a principle similar to KnockOut. Extraction takes place within a special window in which you first have to draw the outlines of the image you wish to preserve. This can be done fairly roughly (above left): the green line defines the transition zone between the extracted image and its background. You then define the saved portion by filling the image with blue (below right). This helps you check that you have correctly enclosed areas that need preserving – it is easy to leave a hole, then no background will be removed. Notice you can draw 'islands' of transition, as in the lower left, allowing sky to show through gaps in the Toi-toi grass.

With the image extracted, you can place it on any background you like: for this, I simply filled the background with a sky blue.

Image	
Mode	▶
Adjust	▶
Duplicate...	
Apply Image...	
Calculations...	
Image Size...	
Canvas Size...	
Rotate Canvas	▶
Crop	
Trim...	
Reveal All	
Histogram...	
Trap...	
Extract...	⌥⌘X
Liquify...	⇧⌘X

Using Quick Mask

It is often easier to create a selection by first painting a rubylith-like or red mask, then converting it into a selection. That is because on-screen a selection is difficult to interpret: it shows only a line of black and white ants marching round and round, which – apart from anything else – does not give a good indication of the feathered edge of the selection. To the software, however, a mask and a selection are the same thing.

Top: click the right-hand button or press Q to enter Quick Mask mode; press Q again or the left-hand button to turn into a selection.

Enter Quick Mask

The buttons for Quick Mask are near the bottom of the tool-box. But better to tap 'Q' to get it. If you now paint with a brush, you get a red blush on your image: that is the mask. You can vary the sharpness or softness of the brush in the normal way, through the brush controls. You change the colour of the mask through the preferences panel. The red or rubylith areas that you paint protects the pixels which lie under it. They do not have to join up.

Applying the changes

In this image, I wished to retain the glow from the sun burning through the early morning mist in New Zealand, while darkening the sky and foreground. The mask was applied, quite roughly, to the glow (left). When exited out of Quick Mask, we see the marching ants of a selection – shown right in enlarged view – which indicate the mid-point in the transitional zone. I increased the feather to a very wide 22 pixels through the Select menu to ensure that the blends are invisible.

This frees me to use levels to achieve the tonal adjustments. To increase the orange in the highlights, I reduced the highlight output levels of the blue and the green channels – the blue by a large amount (near right). This gave a warmth in the skies which puts density into the otherwise blank area. To touch up, I dodged the highlights in the wires stretched across the foreground to improve their visibility.

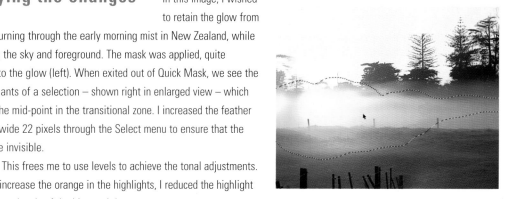

You can soften the quick mask directly by blurring it with Filter > Blur > Gaussian Blur, which gives you good control.

Selection by Color Range

The Color Range dialogue is found under the Select menu. Which clues you in to its function: you use it for selecting pixels according to a range of colours – either from presets or a colour which you pick from the image. It is rather similar to Magic Wand, but acts over the entire image. Also different from Magic Wand, you can select colours which are out of gamut from your output space.

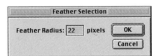

Feather the selection to smooth out colour transitions.

Selecting colours

Color Range is most useful for working with complex images where you want to deal with numerous parts falling within a visibly narrow colour range – like this image of a wooden window blind. Here the play of light and shadows caught my attention and I thought I'd like the slats a less predictable colour. To select the light wooden tones using the Magic Wand tool would work but adjusting the tolerance level (or fuzziness) is clumsy. With Color Range (left) you can change tolerance at will.

The Fuzziness slider (above right) could be called the unFussiness slider: if you want the colours selected to be very similar to those you pick, set a low Fuzziness, otherwise set a higher Fuzziness, so the selection is based on a wider spread of colours.

Notice the useful 'Invert' tick-box: you can easily invert a selection from within this dialogue box. It is sometimes easier to select a large area you do not want selected, then invert the selection, than to try to pick at a small area.

When you hit 'OK', Photoshop selects the pixels falling within the colour range you've defined by your choice of colour and the Fuzziness setting. At this stage you may want to increase the feathering to improve blends. Note that this is distinct from the Fuzziness setting: feathering ignores colour differences and works solely on location. To make it easier to see your work, you can hide the armies of marching ants with Command (Control) + H.

Then it is a simple matter of changing colours from the Hue/Saturation dialogue (right) to deliver the final image (left).

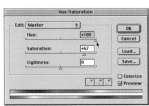

Incidentally, you might think, and who can blame you, that Color Range works only for colour images. But it handles greyscale images with aplomb: you can select shadows, midtones or highlights or the tone of your choice.

Finally, the control perhaps most used by pre-press experts: Color Range can select out-of-gamut colours, enabling you to work on them in order to bring them into line.

With the 'Select' drop-down menu, you can pick out-of-gamut colours or from pre-set ranges. Fuzziness sets the tightness of selection.

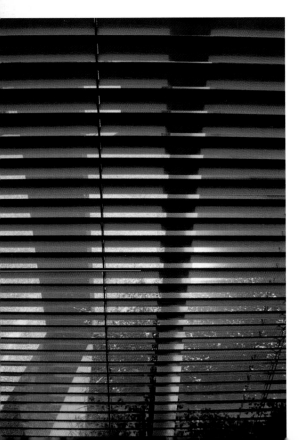

Selection by Magic Wand

A most popular tool – probably because of its inspiredly irrelevant name – Magic Wand selects pixels according to the pixels you set as the reference. It is more fun than Color Range because you can watch as suddenly marching ants take over your image. 'Tolerance' is the equivalent of Fuzziness and you can choose whether the chosen areas are touching each other (contiguous) or not.

Refining selections

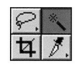

The Magic Wand tool answers to the key command W or you can click in the toolbox. The four options to the right of the tool in the Options bar (middle right) show whether you are working to join or subtract areas, etc. Set a low Tolerance if you want to select less – but beware the selections may be very small and isolated – or a high setting to select more: but make too high a setting and you may select more than 50% of pixels, in which case Photoshop cannot display the selection.

In this sunset scene, taken in Sabah, Malaysia, I want to raise the black shadows of the palms and foreground without affecting the serene sunset.

Clearly Levels or Curves need to be applied but limited to the dark areas. Magic Wand allowed me to select some but not all of the dark areas as it is important to leave some parts of the palms dark or the result would look unnatural. By clicking the tool with the Shift key held down I could add to the selection (or with Option key down, subtract the selection). For this to work, you need to untick the 'Contiguous' box.

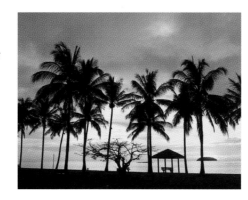

The first selection (far right) shows the complicated areas which Magic Wand has quickly rounded up. However, the foreground is patchily selected, so I held down the Shift key and clicked in there, increasing the coverage to nearly all of the foreground. You can also use the Lasso tool in combination with the Shift or Option keys to, respectively, add to or subtract fine detail from the selection. Once you are satisfied, hide the selection with Command (Control) + H or you can click in the menu to judge tonal changes.

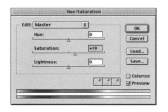

I then called up Levels to increase midtone levels; then used Hue/Saturation to increase the saturation. The result takes us away from the stark, bare silhouettes to a pleasant softness of lighting.

Working with masks

As masks are greyscale images, you can do anything with them you can with a greyscale image. And that includes adding to them, erasing bits, changing opacity and – less well-known but vital for good-quality montaging – you can blur the edges of any mask. The key point is to remember: masks can only be applied on a layer, not to the background image; so you must always create a layer before anything else.

Removing skies

This tranquil landscape from northern Scotland might benefit from a livelier sky, methinks. First I remember to turn the Background into a layer: double-click on the layer in the layer palette and accept the dialogue (right), giving the layer a name if you wish.

Next, I use Magic Wand to select the sky, both in the water and above, remembering to get all the little bits of sky in the gaps between trees and the reflection of sky between grass blades, starting with contiguous selection, then switching to non-contiguous for doing the detail work.

If I accidentally select too much, immediately hitting Command (Control) + Z undoes the selection. Next I click on the button in the layer palette

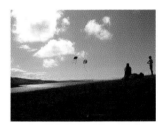

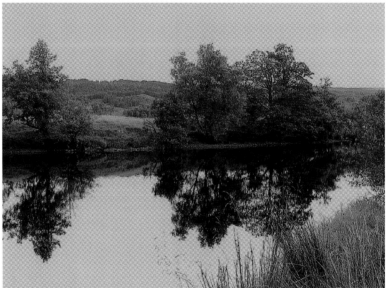

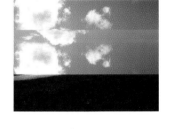

Above: the mask button hides what you did not select: don't panic if the result is not what you expected. Right: click on the far left box to reveal a channel.

Right: press the Option key when clicking on the mask button to hide or mask off the selected pixels.

(left) for making a mask while holding the Option key down: this masks off the selected area.

The result of masking is clearest when you can actually see it (above): turn to the Channels palette and click on the far left column for the Layer Mask.

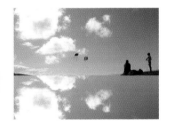

This reveals the masks as a red overlay over the transparency – the checkerboard pattern.

While working on this I am thinking about the sky. A shot of some kite-flyers is promising (opposite): I select the sky area and duplicate it, then flip it horizontally so it is a mirror-image of the original sky and drag it to the bottom of the picture. Now, a reflection of sky is normally seen at an angle, so I distort the selection by stretching it vertically (opposite, left). Usefully this served to extend the sky so that there was no danger of running out of blue or clouds for the reflection.

Next, I copy the sky image and drop it into the river image, making sure they are the same size and resolution. By default the pasted-in image sits on top, so the order of images must be reversed.

At this point it is clear that there are jagged edges to the selection with fringes round the trees, while the horizon is not clean (above left in close-up). To correct this, I select the mask channel and apply a blur – Gaussian Blur is best as it gives you most control. The blur I use is too much (creating new artefacts), so I cut back its intensity with the Fade command (below) by 45%. Note this gives a different effect from setting a small amount of blur in the first instance.

At this point, the result is acceptable but not quite right. The clouds appear too bright and the water's reflection is the same brightness as the sky. In response, I introduce two new layers so that gradients can be applied. These run from black to transparent at 20% opacity and blended in Soft Light i.e. it is a very soft toning down of the sky. The only thing missing now are slight ripples in the water.

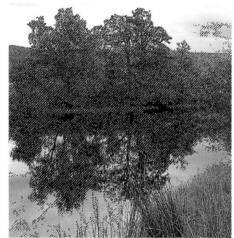

Left: by creating a new layer, you can introduce gradients or other changes to improve tonal rendering.

Left: if you select too much, it looks like this: hit undo to try again.

What is an alpha channel?

It may sound like a line from Star Trek but 'alpha' is just a variable in the maths of linear interpolation ('blending' to the rest of us) between two layers. Formats such as TIFF and Photoshop can hold multiple images, because they support separate Image File Directories within the one file. A channel is effectively a separate image – one which is the exact shape and size of the main image. The alpha refers to how the layers (images) relate to each other.

12 Adding local colour

You may wonder: why go to all the trouble of making an image in black & white in the first place only to add colour later? All that we gain from the abstraction from colour into a clearer, cleaner space of tonal shifts is at once thrown away. On the other hand, it was barely a heartbeat after people first looked on a photograph before they started asking for colour to be recorded in an image. The fact – whether seen on evolutionary or cultural terms – is that tones and shapes are not enough to feed the eye. In addition to the delineation of shape and the resolution of tone, the colour we demand is an expression of the need for discrimination of hue.

As we have seen (see p. 28) the hue of something is easily subtracted from its brightness or, in a digital image, its greyscale value. Technically, then, adding colour to an image is not the same as painting it with colours as this would destroy the greyscale information. Adding colour is literally to add colour data to the greyscale image, without touching the greyscale data one iota. This defines colourization.

But it is not so simple.

Colours applied at 'normal' intensity generally look false or comic-book in character. In general, colourized images seem to work best with pale or low-opacity colours. Naturally, this could be seen as an invitation to creative iconoclasts to use bolder colours.

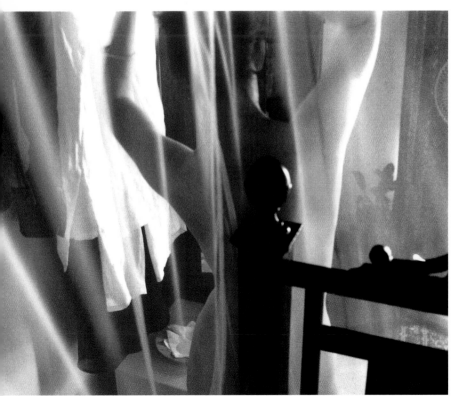

Starting from mono

In this snap taken in Zanzibar, the mosquito netting, turned bed-posts and flecks of hard light combine to create an elegantly complex, but far from easily readable, image.

Let's investigate whether a little colourization of the image might not help make more of the delightful, central figure. The first step is to ensure that the image is in RGB mode so I change the image mode from greyscale to 8-bit RGB.

Next I have a choice of painting directly onto the image or onto a layer. If I wish to paint directly, I choose a brush and size, then set the mode to 'Color'. If I work on a layer, after I create a new layer, select it and also change its mode from the default 'Normal' to 'Color' (right). This adds colour without changing the underlying greyscale image. For a more spontaneity, I prefer to paint directly onto the image.

For more spontaneity... paint directly onto the image

84

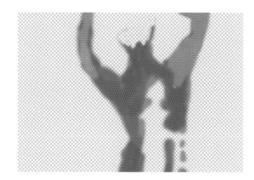

Colouring the figure

The simplest option is to bring out the figure by painting on skin tones. This can be done quite roughly if you work on layers, because we will lower the opacity to give only hints of colour. Alternatively, you can work at higher opacity with paler colours by painting direct on the image: while this will give you less control, it is artistically more of a challenge and makes you commit to each stroke you apply – not a bad thing in digital work. Obviously, manipulation of this nature is most easily carried out using a graphics tablet.

The top left illustration shows the colours applied to a layer with the checker-board pattern showing the transparency. Middle left show shows the layer applied at about 30% opacity. Notice that where there is no density in the original, there is no colour in the colourized image.

It helps to work from a good palette of colours. Photoshop's palettes are rather small but you have a choice of many

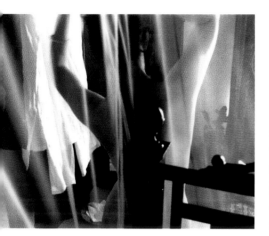

Isolating the figure

Choosing to colourize the surroundings gives you a much greater scope for creativity … and for getting it wrong. It is easy to apply too many colours, to allow too much fussy detail. As I worked on this, I tried different colour schemes and opacities – all working on layers, with each new attempt using fewer colours and rougher brush-strokes than the previous. To save on effort, it pays to make snapshots of each option before you move on to another (right): it is handy to create an action for this and assign it to a function key. Use a brush with minimum hardness/maximum softness.

The image left shows the coloured image – Matisse-like in its looseness and boldness (let me dream on). At 100% – i.e. with no reduction in opacity – the colourized result is rather bright and brash;

Snapshots taken as you work help keep track of progress and allow you to backtrack easily.

and it has its uses. However, it fails in its purpose to bring out the central figure (lower left). Reducing the opacity to 46% nicely tones down the colours to mere hints of hue which do not battle with the soft and neutral greys of the figure (left).

If you print out images to matte- or texture-surfaced papers – which colourizing treatment may suggest to you – you may obtain flatter-than-expected tonal rendering. Colours may then need to be boosted while the output level for the black may need to be reduced by 10–20% to prevent solid blacks to allow the pale colours to show.

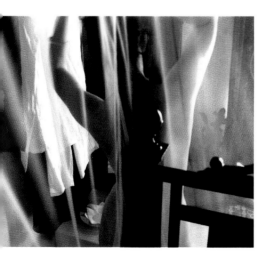

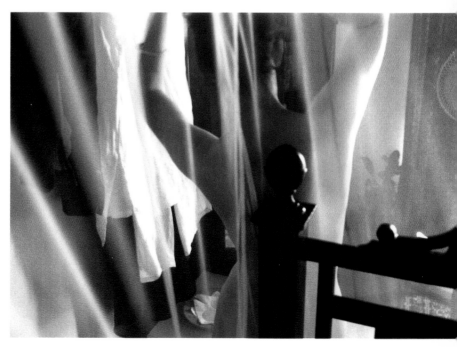

Starting from colour

The image you capture is only the beginning of the work you will do. The art of photography is in seeing the slim clue of that which turns the nearly random into an act of driven creation. Pixel processing brings a revolutionary power to that insight: the ability to unpick and then reassemble every element of the image.

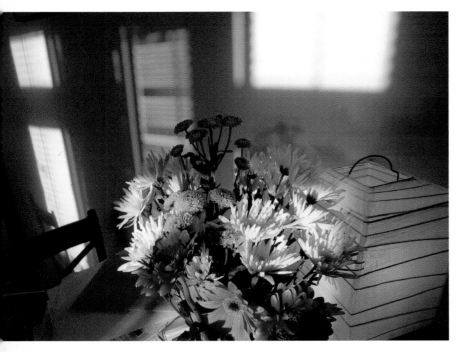

Using the Sponge tool

This snapshot (left) of a spring sunset projected onto our kitchen wall, while it is pretty enough, also cries out for more work, further excavation to reveal its virtues more fully.

Paradoxically, removing colour can reveal more of a subject. I first select the Sponge tool to set it to desaturate, with a pressure of 100 at an ample size.

The first attempt, to drain the colour from the walls and lamp (right) shows promise. At the same time it handily reduces colour artefacts from JPEG compression.

Note, however, how the loss of colour tends to make colour-rich areas appear darker. This is because the Sponge tool set to desaturation works by reducing the values of the channel which has the high

values (red in this case) but without fully balancing this loss with increases in the values of channels having low values. This results in a darker image, usually just where you do not want it gloomy – as on the flowers.

If you do not anticipate or correct for this tendency, the result is likely to be unattractively dark and dour (below right). Using Levels, I brightened the image overall (it needed it anyway) and also selectively brightened the red flowers. The work of lightening completed, I could continue to desaturate the colours of the flowers so the final effect is that of lightly hand-tinted flowers against a neutral backdrop (left).

Colouring by selection

It is important not to be fazed or daunted by wanting to work on images carrying very fine details. In fact, experience will teach you that images with low-frequency detail are usually much harder to work with. We can always work out a way: one important accessory for painting is the mask, which allows you to work freely yet with precisely defined limits.

Complicated selections

Given this picture of shattered glass, we might want to try colouring the features behind the cracks, which obviously means somehow being able to paint behind the glass. Cut to the Magic Wand tool riding to the rescue. The secret to success with this kind of image is to add selections patiently. Starting with a fairly narrow Tolerance of 11 pixels and contiguous not ticked (so we can select areas not touching each other), the first click on a crack gives us the basic selection (right).

We now add the small cracks missed out by setting a smaller Tolerance of 5 and ensuring 'Contiguous' is ticked and we hold the Shift key down as we click. Sometimes we make a mistake and select too much: the screen fills with marching ants. A way of checking how much has been selected is to make a mask (click on the Mask button on the Layers palette – remember you must turn the Background into a Layer first) and look at the result (left): the large dark areas show excessive selection. So we hold the Option (Alt) key as we click to subtract selections.

You may wish to grow the selection a little; but mind that pixels are added in all directions, so this tends to blur distinct shapes.

Once you're satisfied with the mask – it covers the cracks – you can paint. As before, create a new layer with mode set to Color and paint away. Next lower the layer opacity. This won't look great until you flatten the image, because the transparent areas of the mask will show through.

On flattening, the formerly transparent areas become white or pale, as intended, with a little unsharp mask to finish off (right).

A close-up of the selection shows how a really complicated subject can be worked with easily: you can add small portions by shift-clicking with a narrow tolerance set. Zoom in as you need.

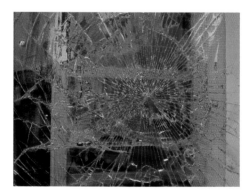

Above: the painted layer at full opacity. Right: top layer mode at Color and opacity down to 35% with mask.

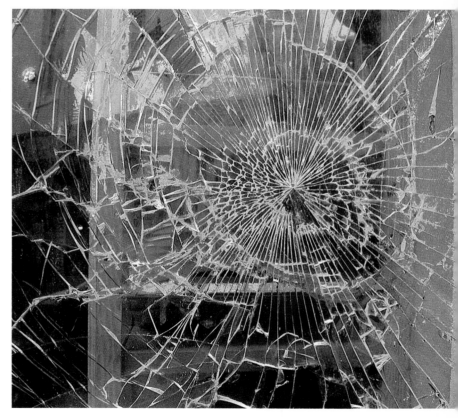

13 Processing and dark-room tricks

Purists may disagree, but I'll say it anyway. The best thing to happen to the old, classic photographic processes has been digital imaging. Of course, we all miss the musty darkness and perfumed subtleties. But also absent are the hours needed to prepare the brews, cleaning the encrusted bottles of chemicals and so on. And I have noticed that those who promote the archival nature of their prints will boast, in the very same breath, of the bio-degradability of the chemicals they use.

With mouse in hand, notoriously slippery techniques such as the Sabattier effect – with its never-to-be-repeated offerings – and others, such as split-toning, can be applied with total repeatability to any number of different images. Yet if you wish for chance effects to have their say, you can have it on the menu too. What you can wholly avoid is a teetering stack of near-misses and damp failures after a day's work.

The main points to watch when working in this mode is to ensure that your monitor and scanner are most carefully calibrated. You need this in order to be sure that the subtle tones that you pursue on screen are those that will be produced in print.

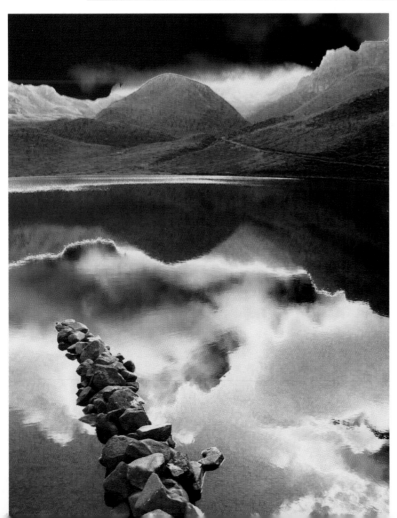

Sabattier effect

If any image manipulation should be done in full 48-bit mode, this is it. The Sabattier effect (often called, in error, solarization) results from the partial re-exposure of a print to light while it is developing. Some of the developed areas reverse in tone (solarization) while the undeveloped areas go darker. Digitally, Sabattier is simulated by the application of a V-shaped curve to the image.

The curve's steep slopes make heavy demands on the data so transitions may become banded. This is posterization, the two-dimensional or tonal analogue of aliasing effects or stair-stepping.

By working at a higher bit-depth, you increase the amount of data the software can work with, which may help reduce the effect of posterization. But of course it all depends on the quality of the original image. For instance, this 2-megapixel digital camera shot from the Scottish Highlands hardly merits high bit-depth manipulation.

On the other hand, you can exploit the 'defect' as it provides an unpredictable element to digital manipulations. Here, we look in detail at the manipulation of the curve and a little trick for obtaining the final result shown left.

The origianl shot – what you can't see are the millions of pesky midges.

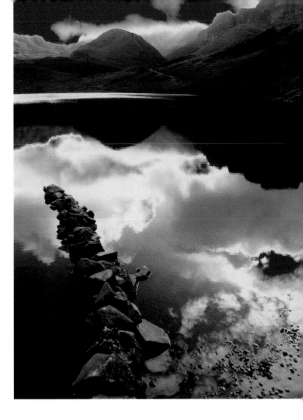

Partial inversions

To start the process, we first turn the RGB image into greyscale. Now, I notice that this reveals a great deal of colour noise: the dark specks visible in the image at top left. To correct this, I ran the Quantum Mechanics Pro filter (see bottom of p.97) over the image. This does not eliminate colour noise, but does help to give the smoother result after greyscaling (middle left).

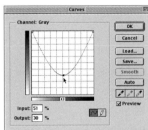

Now, the easiest way to put a 'V' into the Curves, is to anchor it at about the middle by clicking on the curve. Then drag the left-hand bottom end of the curve to the top. Watch as the image magically and vividly transforms. This makes all the highlights become darker from the mid-tone region instead of lighter (tone reversal) while tones from mid-tones to shadows retain their normal relationship to the scene (non-reversed). This defines the partial tone reversal we expect from the Sabattier processing. The bright white in the sky is now pitch-black and there is a lack of clean highlight (left).

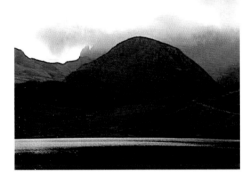

A few small tweaks to the curve are clearly needed to improve the tonal vivacity of the image. I find that pulling the left-end down from full black improves the shadows while pulling up the right-hand side of the curve puts a bit of sparkle into the mid-tone gradations. The result is seen top right. These tweaks seem common to many images. So, once you find a curve shape that you like, it is worth saving it (click the Save button and place the file in a Curves folder within the Photoshop folder) to use on any other new images. It will save you from re-inventing the curve.

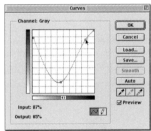

The top image shows, close up, how pixel noise disfigures the landscape with black specks after conversion to greyscale. Applying a filter such as Quantum Mechanic Pro (above) takes these artefacts down to a visually more innocuous level.

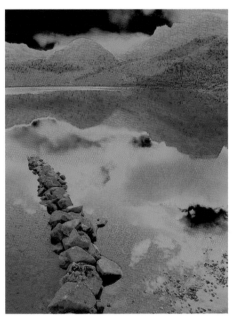

While this might be moody and attractive, it still lacks a certain something. I decide to work with the image in RGB. After reopening the image in RGB, I re-applied the curve (hold down Option (Alt) while typing Command (Control) + M) only to be presented with this violent red/cyan image (lower right). To return to subtlety, I cancelled and applied a partial desaturation of about −50%. With the curves re-applied, the result was much more satisfying (left, opposite) and needed no more work.

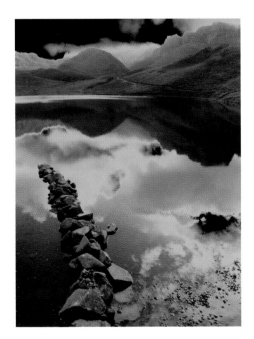

Above: partially reversed curves applied to colour images can give wild results.

Simulating split-toning

In the darkroom, toning is the replacement of silver with other metallic atoms or compounds. Split toning occurs where the proportions of silver replaced or the size of particles vary with image density or where more than one toner has been used. So, toning different image densities varies to differing degrees. This results in very subtle transitions of colours. Images with large areas of leisurely transitions in tone usually work best.

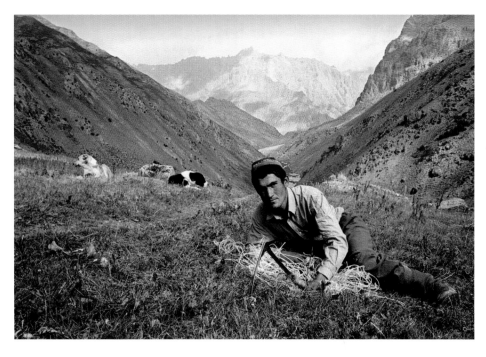

Splitting colours

Producing the basic image is surprisingly easy and depends, of all things, on the Color Balance command (under Image > Adjust > Color Balance: shortcut key: Command (Control) + B). In this image, shot near the snowline in the Anzob ranges of Tajikistan, I wanted to give an unwordly hue to the scene. The original (left) was a warm-hued RGB duotone.

The first step is to desaturate the image without discarding the colour information. This is done with the command: Image > Adjust > Desaturate or you can hit Command (Control) + U and pull the saturation slider to the far left. With some originals it is worth the effort of using Channel Mixing to obtain the best greyscale image. (Obviously, you will not use the Image > Mode > Grayscale command as that discards the colour information you will need.)

Next we need to tone this image with Color Balance (ensuring the Preview button under the Cancel button and the Preserve Luminosity buttons are checked). The command allows us to apply the changes into tone-bands: shadows, midtones or highlights. These bands are broad, but sufficient for most images. The idea is that you must select one band e.g. highlights, and adjust the colour sliders to suit. Then work on the other tone-bands. If the image is either too dark or too light for your liking, try unchecking the Preserve Luminosity button.

For quickest results you can work simply with the Color Balance command: work separately on the highlights and the shadows. You will find, however, that you have far more flexibility and much greater control if you work on separate layers or use Photoshop's adjustment layers. We look at the step-by-step process on the opposite page.

To obtain the final image, left, I flattened the result of blending two adjustment layers with their different colour balances. I thought there was too much colour in the shepherd's face, so I desaturated the colours there. But this made the face too dark, so it needed to be dodged. Finally, I decided all his clothes needed to lose colour too.

Colour balances

The next step is to create a new adjustment layer: click on the black/white button at the bottom of the layers palette and choose Color Balance (right). This gives you full flexibility without touching a hair of your original image data.

You now have to play with the controls to obtain a result you like: by default the command starts with midtones. If you use arrow keys to change the values, you can watch the image while you click – easier than using the mouse.

For my image, I first made the highlights purple but rejected the result (right). I then tried a strong blue (top right) with the result seen top left. This was more promising, so for the midtones, I created another adjustment layer and made the balance a contrasting red-brown. You will find that diffident amounts of colour balance do not work as well as a healthy slap of colour. If it is too strong, you can always tone it down later by desaturating colours in Hue/Saturation.

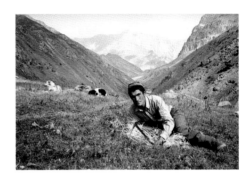

Blending options

You now have to blend the two layers according to their relative densities. Choose Layer Options in earlier versions of Photoshop or just double-click in the layer, away from other items (right: where the arrow is pointing). You will also find Blending Options in the Layer menu thus: Layer > Layer Style > Blending Options.

You will now blend layers with a lot of feathering so that the result is as smooth as can be. The secret is that if you drag on the sliders you change the blending alright, but the transitions will be very sudden. But if you Option + drag on a slider, it splits into two, whose parts define the start and end of the tone-band that is blended. The further apart they are, the smoother the blend. Now play again and look at the results.

For this image I forced a blend both of the shadows and also the highlights in the top layer only (left and far left). The bottom layer was not blended with the underlying one (the original image) but was needed for its warm midtone balance. Notice how the mix of blues and reds created the purple visible in the image. Next I reduced the colour in the face using the Sponge tool set to desaturation. But this was not enough: losing the colour made the face appear too dark and also suggested the clothes needed to lose colour too.

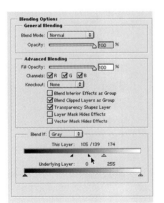

The Blending Options control is a very complicated one, with huge potential. The 'Blend if' control, shown above left, shows that tones in the top layer between the two shadow sliders are blended with the underlying layer and that highlights in the top layer down to 174 are blended with highlights of the underlying layer. The control, above right, shows no blending taking place.

Creating cyanotypes

Like the Sabattier process, the cyanotype is misnamed. More, Herschel is credited with its invention when he only suggested it; namely a negative-positive version of the true cyanotype or Pellet process. It was in fact Pellet and Poitevin who actually made it work, to be used most famously by Atkins for her volumes on British algae. Whatever. We bow to long misusage to create digitally blue-toned negative cyanotypes.

Selections and colour

A cyanotype is in essence a blue line-graphic. In essence it is the negative of a silhouette in blue tones, usually created by placing the object directly onto sensitised paper, as for a photogram. It is ideally suited to showing the outlines of plants.

We need to remember that a photogram of an object is usually detached, so it is isolated in a field of blue. Secondly, we need to show the defects due to uneven coating of the sensitizer.

To prepare for this image, I first cut the seaweed away from its pebbly background through simple selection with the Magic Wand. This is all we are interested in, so I masked off the unwanted background, with a bit of eraser to remove a pebble or two that were caught (left).

The new background can be created from scratch or by using an existing image of a slightly rough surface – those arty images of decaying textures may have a use after all. Here was an old notice board (top right) which I turned to blue using the Hue/Saturation command. I added an extra layer of blue fill colour as well as extra noise. I used Replace Color (right) to locate some of the noise to turn it light – to simulate areas left by the blue sensitizer.

Then it was a matter of pasting the blue background into the seaweed image, swapping layers so the seaweed was on top, then applying Hue/Saturation (right) to turn the seaweed white. I chose a large, messy brush from the palette (below) for my eraser to cut away at the otherwise clinically clean edge of the image. In truth, the Victorians were far tidier workers than I could ever be: the final image (far left) shows the kind of mess I would have made of applying the sensitizer.

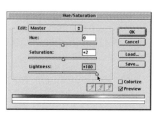

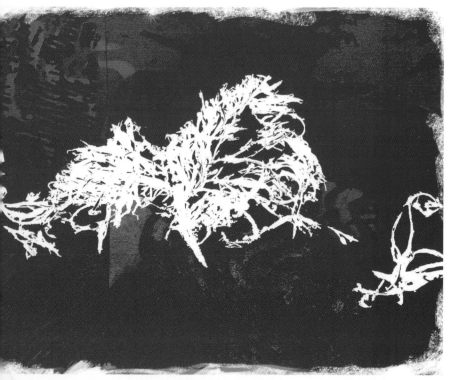

Imitating lith printing

Lith printing is really printing with nearly lifeless lith developer. Normally this produces extreme contrast results. But when it is exhausted or very dilute it can produce prints with good maximum density, toned highlights and midtones with crunchy contrast. It was very trendy once, especially for moody portraits and fashion but fell out of favour. One reason could be that it was very unpredictable.

Curves and courage

Lith printing is tricky in the darkroom because you must overexpose the print by about two stops, which means you will want to whip it out before development goes too far. The corollary with digital is that at one point, the result appears to be disastrous.

This image of a panorama of a hotel lobby in Malaysia would, I thought, benefit from losing most of its colours. I turned it to greyscale, then back to RGB. Using Color Balance, I pushed it towards red in anticipation of the pinkish tone typical of lith prints (right). Again, in anticipation of

the end-result, I then applied a curve (below left) which made the image very dark, overall flat in contrast thanks to the reduction of white by over 50%. The result is horrible, but don't worry.

Now, I open up Levels (below left) to correct this. I push the highlight slider to the left, which fully corrects the exposure. The image looks brighter, while the proximity of the highlight to the shadow pointer tells you contrast must be high, as is confirmed by the image. To improve the black density, you may wish to push the shadow slider by just two or three sniffs. Finally, a little unsharp masking puts some snap into the details.

The result of Curves may appear too dark, but will be corrected in the next step.

Use Levels to correct the exposure loss caused by the Curves applied.

Cross-processing

In the heyday of its popularity, cross-processing was an easy, effective and inexpensive method of being different. At a time when the range of characterization of images was very narrow, cross-processing was a treat for the trendy, fashion-conscious and adventurous. Its premise is simple. Instead of processing colour negative film in colour negative process, you processed it as if it was a slide film. And vice versa for slide film.

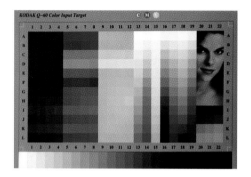

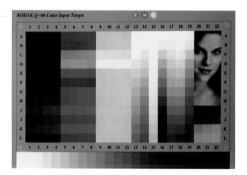

Top: the original target image. Above: target after applying the curves: it is low contrast with creamy highlights.

Colour negative in E-6

The basic method for digital cross-processing is to apply a custom set of curves. The key is that each channel, as well as the master channel, applies a slightly different curve. Use the ones shown here as a starter. When you find a set that works for you, save it so that it can be applied to other images. This gives you a big advantage over using film: results can be highly repeatable (far more than with film) – or not, as you wish.

Now, film gamma is set mainly by the emulsion make-up. And, if you were actually using film, you would also need to consider that colour negative film will retain its orange/pink mask. But you're not: you're working digitally and can ignore this and concentrate on the issue regarding film gamma.

Colour negative film is lower in contrast than colour transparency because the expectation is that it does not have to be projected on a screen (which causes a great loss of contrast). A side-result is that the information in a scan from a colour negative is highly compressed – which explains why it is difficult digitally to manipulate colour negative scans.

The cross-processed colour negative typically shows low contrast, thin colours and featureless shadows. Put like that you wonder what use it is, but of course every technique is good for something. The cross-processing variant is useful for an old-fashioned, warm look that makes it suitable for fashion and portraiture. Avoid applying it to images with a lot of blue, as the results often disappoint.

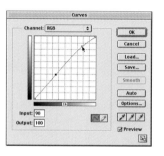

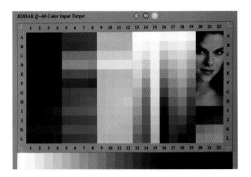

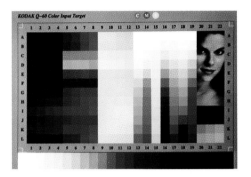

Transparency in RA-4

In practice, the cross-processing of colour reversal or slide film in processes intended for colour negative material produces more widely applicable images. The tone is modern cool – breezy, bright and brilliant. Those who have used it know, however, that results can vary considerably with the film-stock and it can be difficult to control exposure accurately – if it is not downright unpredictable.

In contrast to cross-processed colour-negative film, colour transparency film crossed-processed comes out very contrasty. When printed, you obtain brash colours with washed-out highlights (in the darkroom you also need to apply an overall orange mask, but digitally you avoid that).

What has happened is that colour slide film is inherently high contrast compared to negative film. Processing does little to lower contrast. Now, when a negative is printed onto paper expecting a low-contrast image – i.e. the paper is relatively high-contrast – the result is the product of two high-contrast inputs: a very high-contrast result. It is this high contrast that makes exposure control tricky: exposure latitude is always decreased with steeper characteristic curves.

As with colour negative cross-processed, you apply curves in each separate channel as well as the master channel to simulate cross-processed slide film (above right). As before, you can use this set as a starting point, then evolve your own. The secret lies in the Blue curve (below left): very small adjustments can have a very big effect.

Apply this set of curves to the image in one pass – do not set the master and hit OK, then re-open the command and set the other channels. You should set one channel one after another – the image will not look right until you set them all. Note the flexion points on the curves very carefully – a small difference, especially in the Blue channel can significantly alter the appearance of the image.

Very small changes to the Blue channel make a big difference to the final result. Top: original target image. The above shows the basic curves applied. The bottom image shows the result of applying the slightly different Blue curve shown below.

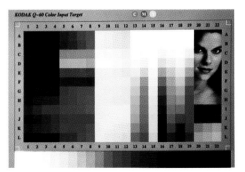

14 Noise as sweet music

It is a pity that noise has taken on negative meanings thanks to everything – from children to machinery – creating unwanted disturbances. Yet nothing so clearly demonstrates the lack of life than a total lack of noise.

So it is with images. In photography we have a love-hate relationship with film grain. Grain – photographic noise – can interfere with fine detail. Yet the clearest sign of an image which has been created *ex nihilo* in some graphics software is its lack of grain – that vital element of randomness, error and roughness in texture and line which gives an image life and character.

Now, it is interesting that while we will tolerate a good deal of grain and roughness in a photographic image, we instantly spot – and object to – areas which are grainless or marble-smooth, usually the result of inexpert cloning.

There is another way in which noise is useful: it aids in printing. Noise in otherwise totally black areas helps prevent the paper from being soaked in ink: the spots of lower density can keep areas with full ink from joining up and pooling. Likewise, a few specks of density in the highlights helps prevent them from appearing totally blank and white. This is important with mass printing as substantial areas of white are essentially unsupported when pressed onto the rollers: this creates a danger that the paper can drop onto the roller or be distorted by being squeezed under pressure.

Captured on an early digital camera, this image is full of colour interpolation artefacts as well as noise. But it is arguable that the defects suit the image's suggestive atmosphere.

Noisy shadows

It is always possible to have too much of a good thing. Noise in the shadow regions of an image is often more than we like as it makes itself evident as very bright pixels against a dark ground.

The reason is that, in general, noise in a system is always more evident when the input levels – in this case, light from the image – are low. Scanners and digital cameras all produce more noise in the darker parts of the image or where the subject is dark. In the case of scanners, this occurs when you present a dark print or dense film and in the case of digital cameras, that is when you are working in low ambient light.

This leads to two problems. Firstly you have to take precautions to remove the noise. Secondly the noise can mask or even destroy such detail as there may be in the shadows. Thirdly, and not so obvious, noise greatly reduces the efficiency of any file compression you apply to the image as few schemes are able to distinguish noise from pertinent fine detail. This is especially relevant when your image must be the smallest file size. On the other hand, noise that is present will disappear if you downsize the output, because low-resolution data will swamp the very high-frequency data from noisy pixels.

It is always possible to have too much of a good thing

Anatomy of noise

Noise is a very big subject in radionics and telecommunications – and it should be in imaging too. The arrival of digital technologies has increased the variety of types of noise; but this (you will be relieved to learn) is not the place to get into it. For our present purposes, it suffices to note that we have already mentioned two types of noise: that arising from the random grain structure of photographic film, and that arising from low strength of input signals during image capture. This type of noise may lie hidden to catch you unawares after some manipulation.

The pair of images to the top right and right show this in exaggerated form. The black shadows in the first image appear pure black, but an extreme brightening up of the image shows how much noise there is: huge blue blocks show up.

Another type is caused by errors in the analysis of colours in the scene by the capture device – scanner or digital camera. This is seen as pixels of markedly different value or colour from their immediate neighbours. If an image suffers from colour noise, this will be shown by the comb-like structure of the Levels dialogue or Histogram display. In fact it is often easier to evaluate the noisiness of an image using these histogram-based indications than by looking at the image, particularly with low-resolution, highly compressed images which are already populated with other defects. For example, the sequence on the left shows a close-up of a digital camera image, followed by the red, green and blue channels.

It is clear that while the red channel is quite noisy, the worse offender is the blue channel but the green is relatively clean. Applying a filter e.g. unsharp mask or blurring to all three channels at once will give you a different result from applying it to only one of the channels.

The right-hand trio of images show that to view the channels in colour makes it difficult to read the image data, particularly in the blue channel.

Zero-value shadows? Don't bet on it: it is safer to expect noisy shadows.

Display & Cursors

Display
☑ Color Channels in Color
☐ Use Diffusion Dither
☐ Use Pixel Doubling

Removing JPEG artefacts
Sometimes appearing as a noise because of their random appearance, artefacts from JPEG compression can be tricky to reduce. The best available method is a plug-in to Photoshop, the Quantum Mechanics Pro filter from Camera Bits. It is easy to use as it provides a full preview of results of changing settings such as the amount of filtration, whether to retain colour information and whether to filter the speckling (this is most useful). You can also choose to sharpen at the same time. On large files the filter is slow to work, but the results are worth it: tones are smoother without loss of detail; and it is a one-stop solution.

Creating noisy images

The Noise filters in Photoshop are incorrectly named as they are actually designed to reduce noise. But the Add Noise filter does what it says on the tin: it increases noise in the image. It offers four variants and different strengths. Appearing easy to use at first sight, in fact it can be tricky to get the results you want. The secret is to realize that the effect varies considerably with file size.

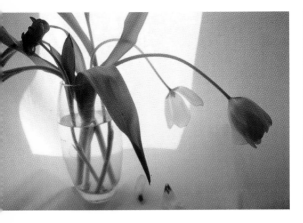

Add Noise filter

When working with the Add Noise filter beware that the effect visible on-screen may not match that in the print: the nature of noise means that a monitor screen is very hard put to display it accurately – check results at different magnifications. And always work on a copy of your image, because once you add noise, you will have by definition destroyed a good deal of data. If you change your mind, it is easiest to return to the original image. Another precaution to take is to sharpen up the image to help preserve outlines. And of course you probably do not need to clean up specks and dust if you are about to shower them in a lot of noise.

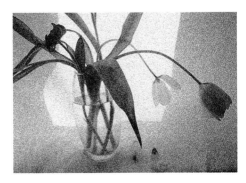

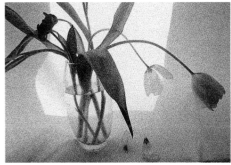

Uniform distribution that is monochromatic adds noise equally randomly throughout all colour channels. This noise is closer to that given by rough textured paper.

Uniform distribution that is coloured i.e. non-monochromatic adds noise equally in all colour channels, a little like random dye clouds in film, but is more disruptive of colour structure.

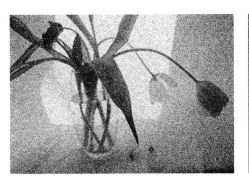

Gaussian distribution that is monochromatic adds noise with a range of sizes – what you set is the largest. It can be very effective when applied to a small file which is then re-sized up. Notice loss of colour (above right).

Gaussian distribution that is coloured is the filter closest to simulating dye-clouds of colour film, as the noise is calculated from the values of nearby original colours. Higher settings introduce a greater variety of colours.

Working with noise

Applying noise in one pass seldom does the trick as we cannot directly control the maximum size of grains. Also, the grain tends to be too sharply defined – differences in the quality of edges in digital imaging is always a sign of manipulation. The trick is to treat the Add Noise filter as just the first step in producing grain. In addition, don't forget other methods of adding noise – like the Mezzotint and the Pointillize filters.

Noise layers combined

A simple Gaussian noise fillter applied to a landscape yields simply a noisy image (below right). To give it more character I create a duplicate layer in which I introduce a very large amount of noise, then blurr it with Gaussian Blur which I combine with the original noisy image (below) with the layer mode set to Normal but at a low opacity to combine the noise with the blur. This does not quite do the trick either, so I sharpen up the blur with unsharp masking to yield the final image (bottom right).

The best images for adding noise to are those with clear outlines and broad areas of flat tone.

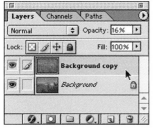

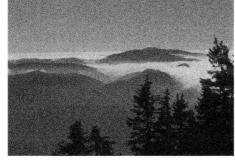

A simple Gaussian distribution monochromatic noise gives a fine-grained structure which is often too crisply detailed. The image below is more satisfyingly blurred and soft.

Two layers of noise, one blurred, combine to make a more natural-looking result.

Try the Mezzotint (right) or Pointillize (left) filters as alternative ways of creating a noise-laden layer.

15 Sharpening the image

All image acquisition systems – whether film-based or digital – tend to reduce sharpness. You should never feel ashamed about using digital sharpening techniques. There is a difference between sharpening to patch up poor technique and sharpening to compensate for system defects. Technically, if we call the whole process of image acquisition a transfer, then we can confidently say the transfer function is never perfect. It never delivers 100% of what is theoretically possible. Engineers would tell you that is not necessary anyway. The reason is that with today's sophisticated sharpening techniques, we can be sure that we make good use of the imperfect image data that we possess. One method is to apply a process that exaggerates edges and gradients.

The central notion is that digital sharpening is the maximising of available image edge data to fit a specified purpose. A small print on rough paper may need a great deal of sharpening which would look unnatural when printed larger on a gloss paper. An image for a book will need a different degree of sharpening compared to the same image for a newspaper. We will now consider the basic techniques, followed by more sophisticated ones.

Unsharp masking

USM emphasizes edges as you may intuitively do: it 'draws' a darker line on the dark side of the gradient and a lighter line on the light side. This exaggerates the contrast between one side of the gradient and the other, so making it easier to see.

The key question is 'how much?' For printing out, sharpen until the image looks a little oversharpened – this is 'sharpening for repro'. Depending on the paper you use, the degree of oversharpening will vary. You need to experiment for the best results. For use on Web pages, sharpen the image at the size it will be viewed at until it looks good.

In general, to evaluate the effect of USM, it is best to view the image at 100% magnification to avoid artefacts from the monitor's anti-aliasing or dithering.

In this night image, the slightly blurred night-shot of London is considerably improved by USM applied to increase sharpness as much as possible, without increasing the noise lurking in the dark shadows. (See pp. 102–3 for more on how to avoid sharpening noise.)

Basic USM controls

The USM dialogue asks you to make three settings. They interact with each other, so it is possible to obtain similar results using very different settings. The easiest variable to understand is the last one: Threshold. Set to zero, you are telling the filter to operate on every single pixel in the image. With higher thresholds set, the filter ignores sets of pixels in which the difference in levels is less than the threshold. A high threshold therefore limits the effect of the filter to edges with high contrast.

The Amount setting is roughly speaking the strength of the effect: it measures the gain in edge contrast as a percentage of the original contrast. In general you will operate within the range 50%–200%.

The Radius setting has the largest effect on overall results. Now, as you can't get smaller than a pixel, it is puzzling that this reads fractional pixels. In fact Radius is a statistical measure based on the range of values applied to the pixels: it measures how far the USM mask extends: a radius of 0.6 actually reaches 4 pixels. Too wide a radius results in the creation of false edges or artefacts. As a guide, use a radius of 0.7–1 for printing at 150 lpi (following the rule-of-thumb: radius = lpi/200).

A useful start for any image (top right) is Amount: 111/ Radius: 1/ Threshold: 0. (111 is simply easier to enter than 100.) This applies relatively strong sharpening suitable for most print-outs. Note that you can put in a very large amount of USM (500) and yet not overdo the result provided that the radius is kept very small. In short you can get a good deal of work done simply working with the amount slider.

However, even a modest Amount setting of 100 can be excessive if combined with the wrong Radius setting: these are immediately apparent from the artefacts which appear in the image e.g. the middle right image. But look again: the flowers are over-sharpened, but the background appears satisfactory, if not improved. From this we learn that larger Radius settings are suitable for images with low-frequency or very blurred outlines from which we hope to extract some detail. Conversely, then, a small radius is best for images with lots of detail.

If the Radius setting is at maximum (bottom left) it has the effect of brightening the image, provided the sharpening effect is reduced either in the Amount slider or by raising Threshold (bottom right). In fact, USM generally has the effect of slightly brightening the image – this can present a problem with highlights, as we shall see (p.103).

A close-up taken hand-held with a digital camera (above) will never be razor-sharp. But USM (right) can greatly improve an image, given enough basic image data.

USM techniques

We have seen that there is more image noise to be found in the blue channel than in the others. If you sharpen all channels at once, you will also sharpen the noise in the blue channel. You could try sharpening only the green channel because the human eye is most responsive to green light. But a better method is to sharpen where only detail is carried: work in Lab colour mode and concentrate on the Lightness channel.

Sharpening in Lab

The easy way to do the least damage to colour information is to sharpen the L or Lightness channel in Lab mode. The reasoning is that the Lightness channel carries the luminance information and therefore much of the detail, isolated from the colour channels.

The procedure is this: first convert your RGB image to Lab mode in the Image > Mode > Lab menu option. Then make the Channels palette active and select the L channel by clicking on it – this turns the image into a black & white. Now apply USM which will affect only the selected channel. The problem with this approach is that it is tricky fully to assess

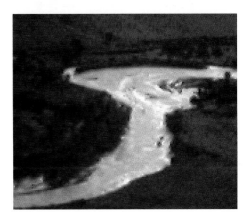

A close-up (above) shows excessive colour noise made prominent by USM sharpening applied to all three RGB channels. Below, the close-up shows much less colour noise following sharpening in the L channel in Lab colour mode plus an increase in contrast.

The Channels palette and USM settings applied to the image are shown left. Then, Curves were applied to obtain the final image (above).

the effect of the sharpening as the preview image is only in monochrome. You must click on the combined Lab channel at the top of the palette in order to view the image in colour, then return to the L channel to make any further adjustments. When satisfied, remember to return the image to RGB mode through the Image menu.

In this shot through an aeroplane window (above left), USM has enabled dramatic improvements to be made, revealing detail never suspected. A straight USM applied to the entire image in RGB exaggerated colour noise, so the image was converted to Lab. With the Luminance channel selected, very high amount and radius settings were made. The high Radius setting had the side-effect of increasing contrast, so Curves was invoked to brighten shadows. Finally Hue/Saturation was applied to improve colours.

Above: the image following USM is contrasty but dark. Below: with USM applied to the RGB image.

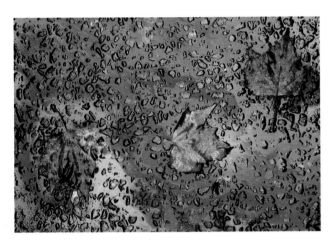

USM for better tone

A side-effect of USM we have already noted is a change in image tone: it has to be, because it is by a local re-distribution of lights and darks that USM succeeds in changing the apparent sharpness. By using a large Radius setting you can use USM as a one-stop method of improving tonal rendition as well as improving sharpness. USM can even improve colour saturation with some images.

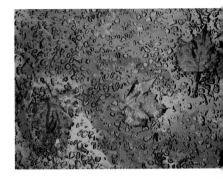

This trick belongs to the 'quick and dirty' category, but is not the less useful for the hard-pressed pixel processor. It works for this image — some 9MB from a 3-megapixel digital camera. A modest amount with maximum radius produces a dramatic improvement. You can always tune the effect down by raising the threshold setting. Beware, however of working only in one channel when you make extreme changes (left): when restricted to the green channel, the colour balance becomes damaged (second right).

Avoiding JPEG artefacts

JPEG not only drops data down a bottomless hole, it also introduces artefacts — image features which do not arise from the image projected by the lens. These are visible as square blocks of 9 pixels characterized by the differences between pixels in a block being smaller than the differences between adjacent blocks. As a result it is easy to see the edge of blocks. If you apply any sharpening to the image, you merely sharpen up the artefacts. It is therefore best first to remove the artefacts by blurring.

You can use any blurring method — these necessarily destroy image detail, but it is preferable to enhancing the JPEG artefacts. One specialist method is to use Alien Skin's Image Doctor in its JPEG Repair mode or Quantum Mechanics Pro. Both are one-step methods to reduce artefacts.

In this image, a high JPEG compression has left its mark as small blocks all over the image (left). Applying a strong amount of USM with small radius (above right) brings out the artefacts rather well (bottom left). But if we first remove the JPEG artefacts in an utility like JPEG Repair — complete with some blur and addition of noise — the result with USM (right) is far superior to sharpening the artefact-laden image.

High-pass sharpening

As you gain in experience in pixel processing, your work in sharpening will increase in sophistication. You will learn that the key to a higher class of sharpening lies in restricting its effects to those parts of the image you wish to sharpen and to leave the rest unscathed. In short, it is to sharpen selectively. You can select areas directly – as we will do on pp.106–7 – or you can work with the interaction of different layers.

Using layer modes

In the rush to capture this idyllic scene – on the Indian Ocean coast of Zanzibar – I allowed the image to be rather softly focused (left). In the strong light, a straight USM sharpening that is sufficient to compensate for the softness will produce harsh white lines in the sails of the boats and the surf at the lagoon edge (below left).

One technique exploits the little-known and even less used High Pass filter. It combines two steps – the seeking out of image gradients and exploiting the resulting masking of unwanted areas through the use of layer modes.

The High Pass filter retains edge details to a radius you set, where sharp transitions occur. At the same time, it suppresses the rest of the image by overlaying a neutral grey. It is called High Pass because it lets through high-frequency detail and filters out low-frequency data. Its action is opposite to that of a blur filter such as Gaussian blur. It is designed for cleaning up line-art scans. And it is worth noting that it is one of only a handful of filters which works with 48-bit images.

You find High Pass under Filters > Other. But first, in order to be able to use Layer Modes, duplicate the background layer. With the Background Copy layer selected, change the layer mode to Overlay, then invoke the High Pass filter. By having the duplicate layer in the correct mode, you can preview the effect of your settings as you try different settings.

At low Radius settings, all you get for your money are faint lines following image boundaries in the High Pass preview, but your image immediately looks sharper. At higher settings, more detail is let through, and the grey 'mask' is not only drawn back it is diluted. The result is that more image colour is revealed. This appears to change the tonality and colour balance of your image. But don't worry about that yet – just concentrate obtaining the level of sharpness you wish for. Once you OK the High Pass setting, you can then call up the Hue/Saturation command to return the colour layer's colour to neutral grey. This then corrects any distortion of colour, but – as with USM – this method of sharpening displaces the tonal character of the image.

A simple USM applied to the above image corrects the softness but introduces harsh contrasts. Using the High Pass filter controls contrast and can hide JPEG defects.

When not to leave USM until last
It is generally good advice to leave USM until you have finished all other image manipulations including re-sizing and conversion to CMYK. But check carefully, at high magnification, that USM does not bring out dust specks or defects which were invisible before. Also check that USM – particularly if strongly applied – does not create unsightly highlights, particularly in skin tones. You may need to adjust the white point after appying USM in order to ensure that highlights are not blown out.

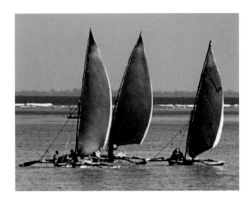

Note that, when working with JPEG compressed images, this filter enables you to judge just how much you can improve sharpness without making the artefacts too evident.

Obviously this technique opens up many options for finessing the result. You can perform USM on the High Pass layer itself. And you can change the opacity of the layer, as done on these images. Furthermore, you can experiment with different layer modes: Soft Light is useful for a softer effect and even softer can be obtained with version 7's Pin Light mode, whereas Hard, Vivid and Linear Light give more and more contrast.

If you are familiar with the Emboss filter you will recognize similarities in the appearance of the result to that from the High Pass filter. Naturally, you can also use the Emboss filter on a Background Copy layer to sharpen an image, exploring layer modes such as Pin Light and Overlay. It can be effective with very soft images.

Above: High Pass of 4: showing faint boundary outlines.

Above: High Pass of 4, layer opacity of 30%, layer mode: Overlay.

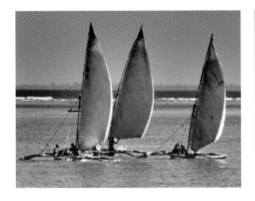

Above: High Pass of 100: showing colours penetrating the layer.

Above: High Pass of 100, desaturated then layer opacity of 100%; layer mode: Overlay.

Above: the layer which received a High Pass filter with radius of 100 is desaturated in Hue/Saturation. Notice that it shows increased contrast, which distorts the image tone when combined with the background layer in Overlay mode. So, to obtain the final image, Levels was called up to correct the tones and exposure.

Selective sharpening

Sharpness, subjectively assessed, is important only in certain types of detail. A portrait is not judged unsharp because the wrinkles are blurred but if, for example, the specular highlights in the eye are blurred. A landscape is not rated unsharp by reference to clouds but by examining the grass. It follows that if you need to sharpen a picture, you may not need to sharpen absolutely everything.

Choose the best

Also known as smart sharpening by those in 'The Know', selective sharpening uses the Find Edges filter as the basis for a selection which masks the operation of USM from certain parts of the image. In particular, we apply USM to the regions at major subject boundaries while ignoring the larger areas of more or less even tone. It is here that we find film grain, noise or JPEG artefacts – the very things we don't wish to sharpen. Selective sharpening cuts them all out of the equation.

In this Scottish landscape, taken on a digital camera (left), there is a lot of noise in the smooth tones in the still loch but the focus fell short of bringing the lovely grassy knolls into sharp focus. We could simply select the hill and apply USM only there. But early experiments showed that the result unbalanced the image – USM needed to be scattered over the whole image, but unevenly. For such a scenario, selective sharpening is ideal.

First we duplicate the background layer as preparation for a departure point for a selection. Then we explore the channels to see which has the best contrast and carries the most detail. Usually the green channel will be our choice. We now duplicate that layer, then apply the Find Edges filter. Long the favourite of those who are dabbling with Photoshop for the first time who find its quickie graphic results strangely gratifying, here at last is a serious use for it. If the results of Find Edges is too pale, when you come to load a selection Photoshop will find too little to work on. In this case you will have to darken the layer using Levels (right).

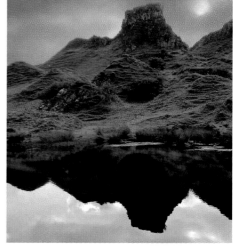

Above: the green channel shows good detail and luminosity. Left: Find Edges may be too light to be effective

Above: Levels for the Find Edges layer shows large amounts of white: reducing the mid-point darkens it, ready for loading selection.

If you pick the wrong channel, e.g. red (above), Find Edges uncovers all the artefacts.

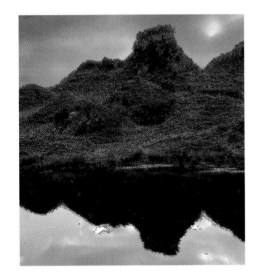

The darkened Find Edges (above) leads to the selection loaded (below).

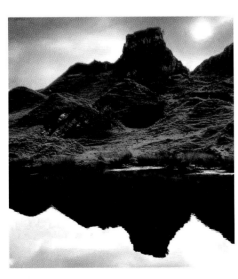

Partial inversions

A very large Radius setting for USM sharpens and brightens the image at the same time.

You will need to soften the Find Edges next: use any means that is suitable – Gaussian Blur, Median, Maximum, etc. Then the selection can be loaded: press Command (Control) + 4. For this image, I used a modest Gaussian Blur with a 2.2 pixel setting (right).

Ensure that the selection is of the areas surrounding the image detail that you wish to sharpen. If not, invert the selection with Command (Control) + Shift + I.

When USM is applied it will work inside the selection and ignore the rest. Try different USM settings and watch your image improve wonderfully. At this stage you will need to experiment freely with different darkness levels for Find Edges, with different blurring techniques as well as changing the selection settings (Select > Modify).

For this image, the best result came from a modest setting for the Amount, the maximum Radius setting (which brightens up the midtones) and minimum Threshold (top right). The same USM setting applied to the whole image would be very unsatisfactory (below left).

Instead, the final image is markedly improved over the original image without any overhead from increased colour noise in the foreground.

For finesse, the JPEG artefacts in the foreground could have been selectively cleaned out using the appropriate Alien Skin Image Doctor or Camerabits Quantum Mechanics Pro plug-ins. Finally, you should optimize image tonality using Curves.

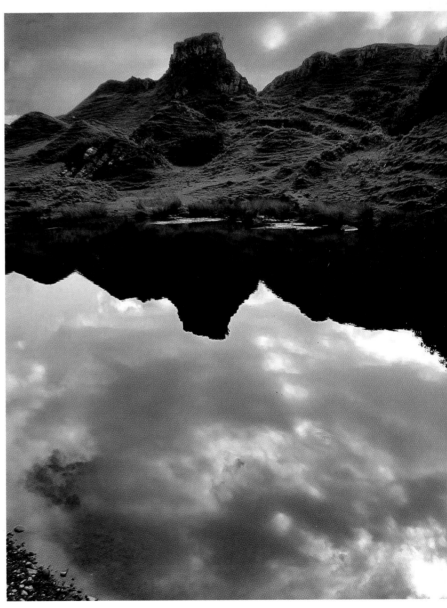

16 Preparing for printing

Proper file preparation for print-out means ensuring that the data you supply for output (whether to a third-party printer or yourself) are fit-for-function. This means that the recipient need do no work at all on the files before using them. But first we have to assume you are satisfied with

your images and that the files are of sufficient size for the task ahead – which should have been sorted from the beginning.

There are two major considerations in preparing files for output. The first is ensuring that the colours and tones you see on screen are those which will be seen in the output. For this, not only should the colours be accurate (and have been viewed reliably) they should conform to colour-managed workflows so that colour profiles are not lost. And they should be printable or viewable within the gamut of the output devices.

Secondly, you will want to ensure that the files are printable at 100% size; that the files contain no more data than is necessary and preferably possess no extraneous elements such as layers or paths. Of course they should be in a format compatible with the systems in use and they should be named consistently and helpfully.

For your printer testing, use a structured colour target. The above is from Binuscan.

Gamut warnings

The commonest problem with digital printing is mismatch of colours seen with the colours output. With modern colour management and increasing command of the processes by the entire chain of experts – software developers, printer manufacturers, ink producers, monitor manufacturers – reliability in overall colour balance is well within reach. For this to happen, there has been tremendous technical skill applied in keeping results consistent and, at the same time, a great deal of new understanding about how to match one device's colour behaviour with that of another.

However, one problem remains intractable. The range of colours reproducible on a monitor does not match that of paper prints – not even with loose proximity. Where it matters most – with brilliant or highly saturated colours – is just where you find the greatest mismatch. And this mismatch stretches through most of the spectrum – worse with deep indigo and blues through greens to reds, but good old yellows are reliable. And where you might not care much – with greyish, murky or pale colours and all the greys – is just where colour matching can be perfect. Now, is that not just typical of life and the Creator's sense of humour.

Use the Color Range dialogue under the Select menu to pick out out-of-gamut colours.

Select	
All	⌘A
Deselect	⌘D
Reselect	⇧⌘D
Inverse	⇧⌘I
Color Range...	
Feather...	⌥⌘D
Modify	▶
Grow	
Similar	
Transform Selection	
Load Selection...	
Save Selection...	

The Color Range command, under the Select menu, displays ranges of colours, sampled colours or out-of-gamut. And can create a Quick Mask of offending colours (above).

Color Range

The Color Range command displays various ranges of colours, one of which is out-of-gamut colours. Your image may appear full of problem colours but if you print regardless you may wonder that the fuss is about. This is because, more often than not, the image will look fine. You were just lucky – the corrections did not have an adverse effect on your image.

It is good practice to check gamut match: you can decide for yourself whether you need to take remedial action or not. If you decide you need to make corrections, Color Range will create a Quick Mask so you can bring colours into gamut – e.g. by using Hue/Saturation or the Sponge tool set to Desaturate – without altering other colours.

Another way to check is to use Gamut Warning (View menu) – type Command (Control) + Shift + Y. Grey patches are likely to appear in your image – usually replacing the saturated colours and coloured shadows. Don't be alarmed, this is not permanent. Turn Gamut Warning off by selecting it again the menu or toggling the same keyboard combination.

It is an instructive exercise to see the effect of different profiles on your image. Turn on Gamut Warning, then invoke Color Settings (Command (Control) + Shift + K. Now simply click on one of the drop-down menus and apply different profiles. Notice how the generic warning (top) is too optimistic while the US web offset colours for uncoated papers (middle right) offers a much restricted range compared to the Epson Photoquality paper at 1440 dpi (below left). .

Above: gamut warning for a generic printer – a generous view of printer gamut. Below, in contrast, the grim gamut warning for US SWOP uncoated printing shows few colours in gamut.

**Above: Gamut warning for Epson Photoquality at 1440 dpi.
Right: gamut warnings for a scan of a standard target.**

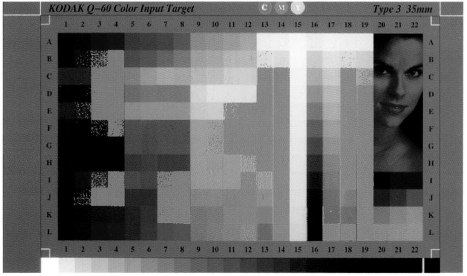

Resizing image files

Increasing the size of an image file operates by interpolation – the addition of new pixel data through calculation, not through acquisition from the subject itself. But, while resizing does not add to the detail that is visible, it can appear to do so. That is because fine detail present in an image is easily masked or submerged when output at a small size but at larger sizes fine details become larger than the output resolution.

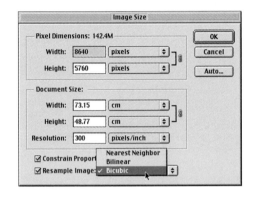

Selecting options

Photoshop offers what is widely regarded as one of the better bicubic regimes of image interpolation for increasing files sizes (left). So you can use it without reservation. But it is not the best route for very large enlargements.

One refinement for big enlargements is to do it step-by-step e.g. increase repeatedly by 10% but remember it will be cumulative (compound interest), so e.g. 12 iterations of 10% gives you 316% enlargement. The arithmetic may be tough, but your images will benefit.

While nearest neighbour is derided as perhaps no interpolation at all, it does have its uses. It is the best way to increase file size of line-art or bit-mapped graphics (black and

Top right: the central portion of the image below enlarged to 400% for viewing, with no change in file size. Right: the image enlarged 400% (142MB) in Genuine Fractals, then viewed at 100%.

white, no greys) as it does not blur detail. Now, if you wish to go much larger than, say, 200%, there are several routes.

One is by purchasing the LizardTech Genuine Fractals (GF) plug-in. From your open image, you must first Save As to the STN format. This converts the image into a fractal compressed form: you can choose to save an identical facsimile of your file in fractal format (lossless if opened to the same size as the original) or one that is claimed to be visually lossless i.e. visually identical but with greater compression.

The original 9MB image (below left) becomes a 628K tiddler. That is great news for a start – and immediately suggests what a good idea it might be to store all your files this way. However, to open the file (in STN format) you or your colleagues must have the GF plug-in. When you open the file, the dialogue box (above right) invites you to determine the size of the file. This is where the magic starts: even at the same size as the original, Genuine Fractals smooths out jagged outlines. It effortlessly creates a 400% enlargement, with good quality. One draw-back is that the rendering for a 400% enlargement takes several minutes. And of course the resulting file is huge – some 142MB. You can then save the file in any format in the usual way, including JPEG.

400% enlargement using nearest neighbour interpolation.

Below: the original image, taken in Auckland, New Zealand, enlarged by S-Spline to 400% and viewed at 100%. Bottom: the original image enlarged in Photoshop's bicubic interpolation to 400%, viewed at !00%: note outlines are less well preserved than S-Spline's.

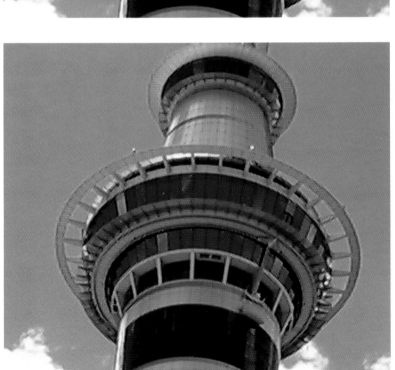

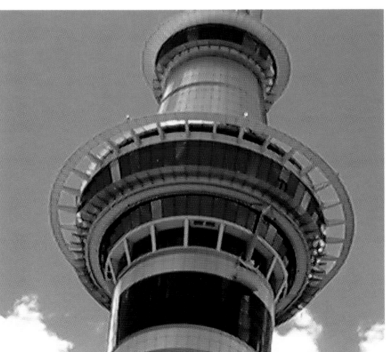

Another route is to use Shortcut Software's S-Spline. This standalone program (above right) is very simple to use: simply drag and drop a file into the window (or open one through the Finder as usual) and you can preview enlargements using different algorithms (none i.e. Nearest Neighbour, Bicubic or S-Spline) to compare results. Note that, for example, a 400% enlargement of the 9MB file to 142MB took over ten minutes to render but it is worth the wait.

Above: the S-Spline dialogue: it is resizable, so the preview can be seen at a usefully large size.

Resolution revealed

Resolution measures the fineness of detail that is visible or recordable. Naturally it takes different forms whether you are measuring the data gathered by a digital camera, or that read by a scanner. And, indeed, resolution varies whether you are talking about how finely a printer can lay down dots or the frequency of the raster used in mass printing. Then again, the fineness of output from a printer is something else.

Output resolution

For our needs what matters is the output resolution. This depends first on the device resolution: how finely or closely a printer is able to place its mark – e.g. a dollop of ink – next to an adjacent drop. This is addressability: if there are a lot of addresses in a block, there must be a lot of apartments – so the density is high. Thus, device resolution is expressed as a density i.e. so many dpi (dots per inch). Therefore, a printer with a 2880 dpi resolution can lay, nominally, some 2880 dots along a line one inch long.

The tricky step is that which takes the image file from the printer to the output. Digital output is based on tricking the eye into thinking that a full range of tones in thousands of colours are visible in the print while using merely six or seven different inks, a relatively small number of dots and even fewer varieties of dot size.

Two processes are used for this conjuring trick. One is the half-tone cell, which simulates the effect of half-tone reproduction (see side-bar). The other is dithering, in which a handful of colours are combined in different ways to simulate a range of millions of colours. It adds up to committing a large portion of a printer's resolution resources to providing the half-toning and dithering – and not to defining detail. 2880 dpi delivers an output resolution equivalent to a mere 120–150 lpi screen raster.

A very common mistake is for pixel processors to create enormous files of, say, 1440 dpi output in an attempt to match their printer's resolution. You realise now what a huge waste of data (and time and trouble) that represents. So, if the output resolution is about 120–150 lpi, the next question is what input resolution you need.

The key concept here needs a little mental gymnastics. Imagine we are making a representation of the output print. The output print is our original and we need to sample it for our digital representation. Telecommunications theory (from a certain Harry Nyquist) says that for a given frequency signal, we need to take samples at twice that frequency to be sure of capturing all the information in the original.

Now, the original signal is that of our print: its frequency is usually between 120–150 lpi. So, to sample it properly we need double that output frequency. Double 120–150 gives us a sampling rate of 240–300 pixels per inch. Hey presto. That is why you will read advice that says you need twice the number of pixels as the output dpi (they mean lpi).

In practice – because we are not dealing with pure electronic signals – you don't need a full doubling. A ratio of 1.5 will often be more than sufficient. Some processes, such as stochastic or frequency-modulated screening, need a ratio of only 1, i.e. no extra sampling.

Practical settings

What all this means in practice is that most people use files which are much larger than necessary. The common practice of working with 300 dpi output resolution is often overkill. Most magazines and books are printed to 133–150 lpi, with high-quality books at 175 lpi. Even 300 dpi is generous for 175 lpi output, as it represents a sampling rate of 1.7 times. Output resolutions of 225–265 dpi are fine for most mass printing. If you like the security blanket of extra data, and to give yourself some leeway if you need to increase file size, then by all means work to 300 dpi – but remember the overheads such as larger files and longer operating times.

Half-tone cells

Ink-jet printers create images by reproducing two distinct characteristics: tonality and detail. Assuming that an ink-jet printer can produce only one size of dot, then a set of dots are needed to reproduce variations in tone. Gather these into a group and you create a half-tone cell: placing no dot in the cell delivers white and completely filling the cell with dots creates full black. In between, the addition or removal of a dot changes the greyscale reproduced. Therefore, the number of greyscale levels you can reproduce depends on the number of dots used to fill a cell. A half-tone cell which measures, say, 10 dots x 10 dots can reproduce a range from no dots to 100 dots i.e. a total of 101 different greyscale levels (0 dots counts as a level). Now, if a printer has a device resolution of 1440 dots, and if sets of ten dots are needed for a half-tone cell, it follows that the output resolution is at best 1440 divided by 10, which equals 144 lpi. Notice that a smoother greyscale i.e. with more levels must be gained at the expense of output resolution. Some modern printers can alter dot size e.g. the Iris printer, but some ink-jet printers can produce three or four different sizes – a modest level of amplitude modulation – which permits smaller half-tone cells to be used.

Far left: manipulation of a digital image of a dawn (in New Zealand) has uncovered deficient data: printing it at best resolution is not needed. In fact, a low resolution may help disguise some of the image's defects.

With ink-jet printers, the quality of output varies enormously with the paper you use. Taking the hard glossy papers as the tops in quality, you will find barely visible differences between using a 300 dpi file from using a 200 dpi file. But you will certainly notice the difference in the printing times. For other papers, there is a barely visible difference between 150 dpi and 200 dpi. And if you use art papers – such as those with watercolour laid or canvas surfaces – you can get away with much lower resolutions – 100 dpi and even less. And if you use these art papers you can set the printer to its lower resolutions e.g. 360 dpi instead of 1440 dpi. Even more time can be saved by printing with the speed rather than quality setting.

Using art papers

One of the delights of the digital era is that the versatility of ink-jet printers has re-opened the range of papers able to receive an image. Gone is that boring old restriction to a handful of safe paper textures – from the pretty shiny to the not-so-shiny; and no more need the base tints range from the nearly white to the not-quite white. The potential is now limited only by what you can persuade the printer to take into its maws – coloured papers, watercolour papers, Japanese papers with embedded petals, textile textures and even unsized board – you can try any of these to see what results you obtain.

By using these papers you also throw away the output rule book. Their rough textures absorb a great deal of ink, they exhibit huge dot gain – i.e. the ink spreads a great deal when it lands on the paper – and you will have to account for any strong background tint. The net result is that you generally have to send highly saturated and contrasty images to these papers – which unfortunately uses heaps of ink. But the upside is that you can print very low resolution files with good results: it would be obviously be a waste of time to send highly detailed images into the morass of pretty plant fibres and the deep ravines of hand-made papers. For this kind of work, you are likely to find pigment-based inks be preferable to dye-based inks – the latter being the norm – if only because pigment-based inks promise much greater longevity in terms of colour-fastness.

One warning, though: if you plan to use these papers, ensure that you purchase a printer which offers a straight-through print path. This means that the paper is not curled or bent in its progress through the printer. Usually, you will need ample space behind the printer to feed the sheet straight in.

Far left: an output resolution of 50 dpi is more than sufficient for printing onto canvas textured paper – at almost any size output. Above: beware of images with masses of black and contrasting clear areas: the paper can buckle and corrugate from an overload of ink. Reduce black output levels by around 10 units in the Levels command.

How much resolution do you need?

About 30MB of data is needed for a print to A4 (say about 8"x11") size to meet the best quality standards and satisfy rigorous inspection. In practice and in many situations, a much lesser amount of data will be acceptable, thanks to variations in printing quality e.g. poor registration, losses due to substrate used – e.g. matte-coated paper – as well as the varying tolerances of a viewer. For example, most readers of magazines are likely to see no obvious differences between two reproductions where an expert would pronounce one to be of unacceptable quality. As a result, some will say that 3-megapixel cameras can produce images good enough for a full A4 (8x11") print on either ink-jet or off-set lithography, others will say that the quality is adequate only for A5 (8x5") size.

Another consideration is the quality reserve that you wish to work with: with a 5-megapixel you can obtain high image quality more easily and with less effort than when working with a 3-megapixel image – and of course you will be able to make larger prints to the same quality. In short, how much resolution you need can only be determined by you within the context of the quality standards you wish to maintain.

Pixels on a pinhead

A medieval philosophical conundrum asks to know the number of angels that could dance on a pinhead. Strangely, the answer to this demonstrates the true nature of our pixels: angels occupy no space until they enter the physical realm. In similar fashion, pixels have no dimension or size until they are output: you can have as many as you like on a pinhead, so to speak, so long as they are not output. Digital cameras understand this: they merely shove out a bundle of pixels and leave it to you to decide the output size. Unfortunately, most camera utilities and driver software force you to decide on an output resolution so that an output size can be calculated. In reality, there is no need for a file to carry any output resolution or size information at all – perhaps a good deal of confusion would be removed by keeping file size decisions to the essentials.

Optimizing print-outs

Much disappointment comes from print experiences because it is easy to approach the printer as if it has all been set up for you. All you have to do is press a button, and the magical box will do the rest. The truth is that you need to set the printer up as carefully as mixing chemicals in the darkroom, measuring everything with care, keeping procedurally correct. And that starts with reading the instructions for the printer.

Do not set the following in the printer driver or you greatly slow down printing: landscape orientation, rotation or reduction or enlargement.

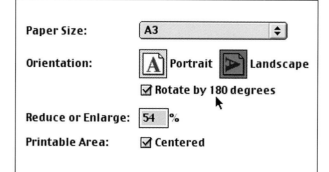

Keeping a happy printer

The key to keeping your printer happy is to realize that the space between the print-head and the paper surface is extremely fine and carefully regulated. If you feed the printer with fluffy paper, fibres can clog up the print-nozzles – not to mention the rest of the mechanism. Also the pinch-rollers and feed-rollers which take up and drive the papers through the printer are made with great precision. If the rollers are mis-aligned or damaged it is impossible to feed paper through with the high accuracy needed to prevent print artefacts such as banding. For this work, printers with a relatively straight paper-path are best. Always consult the manual. Do not ask the printer to accept very flimsy paper as that jams up easily but the use of a thicker support sheet may help. Very thick paper can also jam the machine – setting it to take envelopes may help. Check whether your machine has a lever which allows you to set an adjustment for paper thickness.

Quick print-outs

The best way to speed up printing out is to relieve the printer driver of as much work as possible. So create the file to exactly the right size – don't ask the printer to resize – and turn landscape format pictures around so that they print onto portrait format paper. And do not add anything else either: if you want to print your name or a watermark it is better to do it to the file rather than ask the printer to do the job. On the other hand, do not choose a low resolution print-out just to save time unless working on art paper, or else quality will certainly suffer.

Print longevity

One frequent question is whether to stick to the manufacturer's ink and avoid using so-called compatible inks. Certainly cleaving close to the manufactuer is the safer bet if, by far, the most expensive. It is not just a question of accuracy of colour and ensuring reliable consistency through the life of a printer, which is as near guaranteed as it can be with a manufacturer's ink. It is also about the longevity of the image.

Most inks are dye-based: at best (using specific inks with specified papers) their life is measured in 10–20 years. Pigment-based inks offer a much longer life – perhaps up to a century, but the colour gamut is a little less than that of dye-based inks and colour accuracy is more difficult to attain. Furthermore, pigments are more metameric than dye-based inks i.e. their apparent colour changes more with the colour temperature of the illuminant than do dye-based inks.

Scans at 100% of a 12"x8" print. Right: output at 50 dpi shows poor quality. At 100 dpi (mid right), the image is much better but at 150 dpi (far right) it is hardly any better than 100 dpi.

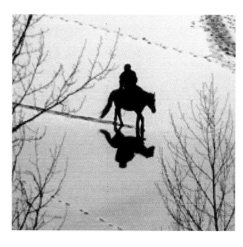
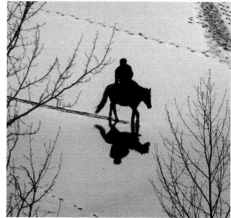
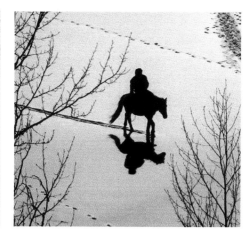

Tricks
for printing

We are only at the very beginning of what we know about pixel processing and its possibilities. There is so much to experiment with, so much to do and so little time to do it. The techniques described in this book, the instructions given in software, camera and printer manuals are best regarded only as the beginning. Set your mind free by continually asking yourself: what if …?

Experimentatal methods

The simplest ideas could lead you to interesting new discoveries. The results shown here merely sniff at the surface of all the possibilities. You could combine printing with drawings or photocopied artwork – it could make good use of old magazines. Apart from textured papers, try printing onto newspapers, or stick prints onto other media.

And instead of throwing away old prints you can make use of them as the basis for your ink-jet experiments. Multiple passes through the printer is a rewarding pastime offering pleasingly erratic results. In fact, it is a great way of using up trial or failed prints.

If you use a surface that does not accept ink, the dyes may not dry at all. You then have to photograph the print-outs before being able to use them – as I did for the work on the right: the globules of ink did not dry even after two hours under a hot lamp.

Left: the horse was printed onto unsuitable paper which did not absorp the ink at all. I found the resulting pooling rather interesting. Far left: the canvas print of the horse was put through the printer two more times, with different patterns of colour each time.

For fun, I created a colourful, if garish splash of colour (below) and printed it onto a normal silver-gelatin PE print (right). There was a bit of pooling of ink but it was not a problem. I scanned the result, then inverted the colours using the Hue/Saturation command (far right).

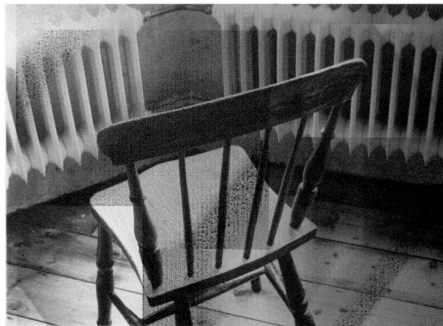

THREE
Reference section

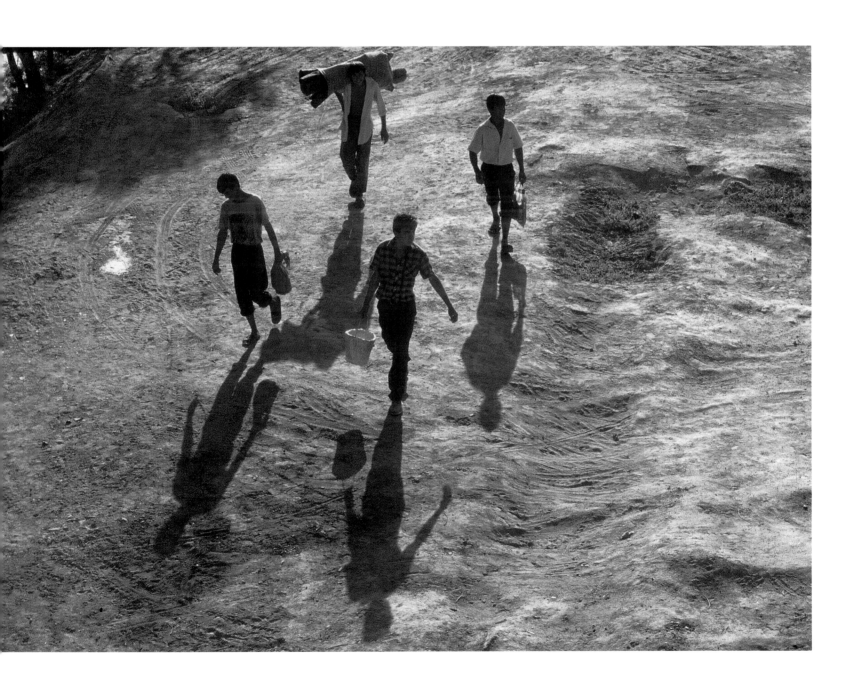

Glossary

\#

12-bit Measure of the size or resolution of data that a computer, program or component works with; e.g. 24-bit data sets are capable of coding nearly 17 million different colours. Similarly, 8-bit, 48-bit, etc.

5000 White balance used in pre-press and printing industry: a very warm white. Also D50, D5000.

6500 White balance standard corresponding to half-cloudy daylight: appears warm compared to 9300, cool compared to 5000. Also D65, D6500.

9300 White balance standard close to daylight on a clear day: used mainly for visual displays; appears cold compared to 6500.

A

achromatic colour Distinguished by differences in lightness but not of hue e.g. black or greys.

ADC Analogue-to-Digital Conversion: process of converting or representing a continuously varying signal into a set of discrete, digital, values as takes place e.g. during scanning.

additive (1) Describing process of producing colours by combining two or more lights of different colours. (2) Substance added to another substance – usually to improve its reactivity or keeping qualities.

additive colour synthesis Combining or blending two or more coloured lights in order to simulate or give sensation of another colour. Any colours may be combined. For colour synthesis, three primary colours are needed e.g. red, green and blue.

address Reference that locates the physical or virtual position of a physical or virtual item e.g. memory in RAM, a dot from an inkjet printer.

addressable Property of a point in space that allows it to be identified and referenced by some device e.g. an ink-jet printer.

alias (1) A representation or 'stand-in' for the original continuously varying signal or object e.g. a line, a sound etc. that is the product of sampling and measuring the signal. (2) In Mac OS, a file icon that stands for the original.

alpha channel Part of an image designed so that changing the value of the alpha variable changes properties e.g. transparency/opacity of the rest of the file.

analogue Effect, representation or record that is proportionate to some other physical property or change.

anti-aliasing Smoothing away the stair-steppping in a digital image.

apps Slang for application software.

array Arrangement of image sensors. (1) Two-dimensional, grid or wide array: rows of sensors are laid side-by-side to cover an area. (2) One-dimensional or linear array: a single row of sensors or set of three rows.

artefacts Unwanted elements or imperfections in an image caused by image acquisition, image manipulation or computer errors.

aspect ratio Ratio between width and height (or depth).

attachment File that is sent along with an e-mail e.g. image or other complicated or large item.

B

background Base or bottom layer of an image, lying under any other additional layers; produced when image is 'flattened'.

back-up (1) To make and store copies of computer files to ensure against loss, corruption or damage of the original files. (2) The copies of original files made as insurance against loss or damage.

bicubic interpolation Type of interpolation in which the value of a new pixel is calculated from the values of its eight neighbours. It gives better results than bilinear or nearest neighbour interpolation, with more contrast to offset blurring induced by interpolation.

bilinear interpolation Type of interpolation in which the value of a new pixel is calculated from the values of four of its side neighbours: left, right, top and bottom. It gives blurred, soft results less satisfactory than bicubic, but needs less processing.

bit Fundamental unit of computer information: has only two possible values, 1 or 0.

bit depth Measure of amount of information that can be coded, hence used as measure of resolution of a variable such as colour or density. One bit registers two states: 0 or 1, e.g. either white or black; 8 bit can register 256 states.

bit-mapped (1) Image defined by values given to individual picture elements of an array; the image is the map of the bit-values of the individual pixels. (2) An image comprising picture elements whose values are only either one or zero e.g. the bit-depth of the image is 1.

black (1) Adjective describing an area that has no colour or hue due to absorption of most or all light. (2) Maximum density of a photograph.

bleed (1) Photograph or element that runs off the page when printed. Photograph may bleed on any side and on one or more sides. (2) Spread of ink into fibres of support material: the effect causes dot gain.

blend Way in which the image on one layer interacts with the image below it.

blur To soften or feather details or outlines.

brightness (1) Quality of visual perception that varies with amount or intensity of light given out by an element in the visual field. (2) Brilliance of colour, related to hue or colour saturation e.g. bright pink as opposed to pale pink.

brightness range Difference between brightness of brightest part of subject and brightness of darkest part of subject. Do not confuse with contrast.

brush Image editing tool used to apply effects such as colour, blurring, burn, dodge etc. limited to areas the brush is applied to, in imitation of a real brush. User can set the size, the sharpness of cut-off between effect and no effect and amount of colour applied, and so on.

buffer Memory component in output device such as printer, CD writer, digital camera, that stores data temporarily which it then feeds to the device at a rate the data can be turned into e.g. printed page.

burning-in (1) Digital image manipulation technique that mimics darkroom burning-in. (2) Darkroom technique for altering local contrast and density of print by giving local exposure to areas of high density with rest of print masked off to prevent unwanted exposure in other areas.

byte Unit of digital information: one byte equals 8 bits. An 8-bit microprocessor handles one byte of data at a time.

C

C Cyan: the secondary colour from the combination of red and blue. Cyan separation used in four- or six-colour printing processes.

cache RAM dedicated to keeping recently read-off data.

calibration Process of matching behaviour of a device to a standard e.g. film speed or for a desired result e.g. neutral colour balance.

camera exposure Quantity of light reaching light-sensitive material or sensors in camera: determined by effective aperture of lens and duration of exposure to light.

canvas Size of virtual area in which an image is located: usually the same size as the image: it can be larger but cannot be smaller unless the image is also reduced in size.

capacity (1) Quantity of data that can be stored. NB: Actual capacity of removable media is reduced by an amount used for information needed to keep track of files. (2) Number of average pages which can be printed by e.g. ink or toner catridge.

cartridge Storage or protective device consisting of a shell e.g. plastic or metal casing enclosing delicate parts e.g. magnetic platter, magnetic tape or magneto-optical disk.

catch light Small highlight, usually reflection of light-source in eyes.

CCD Charge-Coupled Device: semiconductor device used to measure amount of light; hence used as image detector.

CD-R Compact Disc – wRite: storage device for digital files invented originally for music and now one of the most ubiquitous computer storage systems.

channel Set of information grouped in some way e.g. by lying within a band of frequencies or colour.

chroma Colour value of given light-source or patch. Approximately equivalent to perceptual hue of colour.

CIE Lab Commission Internationale de l'Éclairage La*b*: a colour model in which the colour space is spherical. The vertical axis is L for lightness i.e. achromatic colours: black at bottom ranging to white at top. The a* axis runs horizontally from red (positive values) to green (negative values). At right angles to this the b* axis runs from yellow (positive values) to blue (negative values).

clipboard Area of memory reserved for temporarily holding items during editing.

CLUT Colour Look-Up Table: the collection of hues used to define an indexed colour set: e.g. for GIF, 216 colours are chosen from 256 possible colours.

CMYK Cyan Magenta Yellow Key: the first three are the primary colours of subtractive mixing. These four inks are used mass printing: hence 'four-colour printing'.

cold colours Subjective term referring to blues and cyans.

colour picker Part of operating system or application which enables user to select a colour for use e.g. in painting, for filling a gradient etc.

colour synthesis Recreating original colour sensation by combining two or more other colours. Two methods: additive colour synthesis, subtractive colour synthesis.

colour temperature Measure of colour quality of source of light: expressed in Kelvin. Colour of light is correlated to temperature of black body radiator when colour of its light matches that of light being measured.

colourize To add colour to a greyscale image without changing the underlying, original lightness values.

ColourSync Proprietary colour management software system to help ensure that colours seen on screen match those printed or reproduced.

colour (1) Denoting quality of visual perception characterized by hue, saturation and lightness: it is perceived as attributes of things seen. (2) To add colour to an image by hand, via the computer or directly.

colour cast Tint or hint of colour evenly covering an image.

colour gamut Range of colours producible by a device or reproduction system. Colour film has the largest gamut, computer monitors have less than colour film but greater than ink-jet printers; the best ink-jet printers have a greater colour gamut than four-colour SWOP printing.

colour management Process of controlling the output of all devices in a production chain to ensure that final results are reliable and repeatable from the point of view of colour reproduction.

colour model Systematic scheme or theory for representing the visual experience of colour by defining any given perception in terms of three or more basic measures.

colour space Theoretical construct that defines range of colours that e.g. can be reproduced by a given output device or be seen by human eye.

complementary colours Pairs of colours which produce white when added together as lights e.g. secondary colours – cyan, magenta and yellow – are complementary to primary colours: respectively red, green and blue. Note: coloured filters transmit light of its colour and absorb light of complementary colour.

compliant Device or software that meets with the specifications or standards set by corresponding device or software to enable them to work together.

compositing Picture processing technique which combines one or more images with a basic image. Also montage or photomontage.

compression Process of reducing size of digital files by changing the way the data is coded. NB. It does not involve a physical change in the way the data itself is stored; there is no physical squeezing or squashing.

constrain To keep one factor while changing another e.g. keeping proportions while re-sizing image.

continuous tone image Record in dyes, pigment, silver or other metals in which relatively smooth transitions from low densities to high densities are represented by varying amounts of substance making up image. Also contone.

contrast (1) Of ambient light: brightness range in scene. Difference between highest luminance and lowest. High contrast indicates large subject brightness range. (2) Of film: rate at which density builds up with increasing exposure over mid portion of characteristic curve of film/development combination. (3) Of light-source or quality of light: directional light gives high contrast lighting with hard shadows; diffuse light gives low contrast lighting with soft shadows. (4) Of printing paper: grade of paper e.g. high contrast paper is grade 4 or 5, grade 1 is low contrast. (5) Of image quality: a high contrast lens delivers image of object with high quality. (6) Of colour: colours opposite each other on the colour wheel e.g. blue and yellow, green and red.

CPU Central Processor Unit: part of computer which receives instructions, evaluates them according to the software applications, then issues appropriate instructions to the other parts of the computer. Often referred to as the 'chip'.

crop (1) To use part of an image for purpose of: improving composition; fitting image to fit available space or format; squaring up image to correct horizon or vertical axis. (2) To scan only that part of an image that is required.

cross-platform Application software, file or file format which can be used on more than one computer platform.

custom colour A specially formulated colour used together with black ink or in addition to the separation colours. A spot colour.

custom palette Set of colours selected by user or software for specific purpose, usually to ensure satisfactory reproduction of image with minimum number of different colours, in order to minimize file size.

cut and paste To remove a selected bit of text, selection of cell contents, selected part of a graphic or image etc. from a file and store it temporarily in a clipboard to be used elsewhere, at which point the cut selection is said to be 'pasted'.

cyan Blue-green: primary colour of subtractive mixing; secondary colour of additive mixing. It is the complementary to red.

D

d-max (1) Measure of greatest or maximum density of silver or dye image attained by film or print. (2) Point at top of characteristic curve of negative film or bottom of curve for a positive.

D5000 See 5000. Also D50.

D6500 See 6500. Also D65.

daylight (1) Light that comes directly or indirectly from sun: it varies very widely in brightness, colour and quality. (2) Average mixture of sunlight and skylight with some clouds typical of temperate latitudes around midday of 5400–5900 K. (3) Film with colour balance correct for colour temperature of 5400–5600 K.

definition Subjective assessment of clarity and quality of detail visible in image or photograph. Objectively measured by combining different parameters such as resolution and contrast for image produced by optical system.

delete (1) To render a file invisible and capable of being overwritten. (2) To remove an item, such as a letter, selected part of a graphic or an image.

density (1) Measure of darkness or 'strength' of image in terms of its ability to stop light i.e. its opacity. (2) The number of dots per unit area given by a print process.

depth (1) Dimension of e.g. picture or page size measured on vertical axis, at right angles to width measurement. (2) Sharpness of image i.e. how much is sharp; loosely synonymous with depth of field.

depth of field Measure of zone or distance over which any object in front of lens will appear acceptably sharp: it lies in front of and behind the plane of best focus.

desaturate To reduce the depth or richness of colour in an image.

dialogue box Feature of interface allowing you to instruct the application – e.g. how much darker, how much larger – before carrying out the instructions.

digital image Image on computer screen or any other visible medium such as print which has been produced by transforming image of subject into a digital record, followed by reconstruction of image. or displayed according to e.g. brightness values appropriate for it.

digitization Process of translating values for brightness or colour into electrical pulses representing alphabetic or numerical code. A fundamental process that enables optical image to be converted into a form which can be handled electronically. Digital code enables record of image to be manipulated by computer programs and result can be output into visible form using printer or monitor screen.

dispersion Phenomenon of light in which degree to which beam of light is refracted or diffracted depends on its wavelength: causes splitting up of beam into spectrum.

display Device that provides temporary visual representation of data e.g. monitor screen, LCD projector, information panel on camera.

distortion, tonal Property of image in which contrast, range of brightness, or colours appear to be markedly different from that of subject.

dithering Simulating many colours or shades by using a smaller number of colours.

dodging Technique for controlling local contrast during printing by selectively reducing amount of light reaching parts of print which would otherwise print too dark. Used to 'hold back' or preserve shadow detail.

down-sampling Reduction in file size when a bit-mapped image is reduced in size: done by systematic discarding of unwanted pixels and information.

dpi dots per inch: Measure of resolution of output device as number of dots or points which can be addressed or printed by the device.

driver Software used by computer to control or drive a peripheral device such as scanner, printer, removable media drive connected to it.

drop shadow Graphic effect in which object appears to float above a surface, leaving a more or less fuzzy shadow below it and offset to one side.

drop-on-demand Type of ink-jet printer in which ink leaves the reservoir only when required. Most ink-jet printers in use are drop-on-demand.

drum scanner Type of scanner employing a tightly focused spot of light to shine on the subject that is stretched over a rotating drum: as the drum rotates, the spot of light traverses the length of the subject, so scanning the whole area. Light reflected from or transmitted through the subject is picked up by a photo-multiplier tube.

duotone (1) Photomechanical printing process using two inks to increase tonal range: two half-tone screens are made at different angles. Darker colour ink is e.g. used to print solid and near-solid areas, lighter colour ink is used to print mid and lighter tones. (2) Mode of working in image manipulation software that simulates printing of image with two inks, each with its own tone curve.

DVD-RAM A DVD, i.e. digital versatile disc, variant that carries up to 4.7GB per side that is write many times and read many times.

dye sublimation Printer technology based on rapid heating of dry colourants held in close contact with a receiving layer; it turns the colourants to gas which transfers to and solidifies on the receiving layer.

dynamic range Measure of spread of highest to lowest energy levels that can be captured by an imaging or recording or playback device e.g. a top-class scanning camera back can capture a range of 11 f/stops, a good film-scanner may be able to manage about 9 stops.

E

edge effects Local distortions of density in film due to the movement of developer and products between regions of different exposure.

edge sharpening Process of making edges more contrasty.

effects filters Digital filters giving effects similar to their lens counterparts; but can produce effects impossible with analogue filters.

electronic image Synonymous with digital image.

embed To attach data such as a colour profile to a file.

engine (1) The internal mechanisms that drive devices such as printers, scanners. (2) Software: the core parts of a software application.

enhancement Change in one or more qualities of an image in to order improve the image: e.g. increase in colour saturation, sharpness etc.

EPS Encapsulated PostScript: file format that stores an image or graphic in PostScript.

erase To remove part of an image either partially or totally: if total, result may be transparent or background colour.

EV Exposure Value. Measure of camera exposure: for a given EV, there is set of shutter and aperture settings which give the same camera exposure.

event Action or input from human or other generator (e.g. mouse clicks, input from keyboard or a triggering pulse from an infra-red detector) to a software program which initiates a response by the computer or other device.

exposure Process of allowing light to reach light-sensitive material to create latent image: by e.g. opening shutter; illuminating dark subject with flash of light or energy.

exposure index Setting used to calculate camera exposure settings. Exposure index (E.I.) is set on the exposure meter or camera in order to give exposures based not on actual film speed but on an adaptation of it for a special purpose.

F

f/number Size of lens diaphragm controlling amount of light transmitted by lens: equals focal length of lens divided by diameter of entrance pupil.

fade Gradual loss of density in silver, pigment or dye image over time.

false colour Images with arbitrary allocation of colour to wavebands. E.g. with infra-red sensitive film: green objects are shown as blue, red objects are green and infra-red light from objects is shown as red.

feathering Blurring a border or bounding line by reducing the sharpness or suddenness of the change in value of e.g. colour, brightness etc.

file format The way in which a software program stores data: determined by the structure and organisation of the data.

fill To cover a selected area with a chosen colour or pattern.

filter (1) Optical accessory used to cut out certain wavelengths of light or frequencies of data and pass others. (2) Part of image manipulation software written to produce effects simulating effects of photographic filters. (3) Part of application software that is used to convert one file format to another.

fingerprint Marking in a digital image file that is invisible and which survives all normal image manipulations but which can still be retrieved by suitable software.

FireWire Rapid serial bus technology for interconnecting devices e.g. CD writers, digital cameras, hard-disks, computers. Effectively same as IEE 1394 and iLink.

flare Non image-forming light in optical system.

flat (1) Low contrast e.g. flat negative or print is low contrast i.e. shows only grey tones. (2) Light or conditions tending to produce evenly-lit or low-contrast results.

flat-bed scanner Type of scanner employing a set of sensors arranged in a line and focused via mirrors and lenses on the subject which is placed face down on a flat glass bed facing a light-source: as the sensors traverse the length of the subject, they register the varying light levels reflected off the subject.

flatten Combination or merging of layers, masks and alpha channels into one background image in which all the effects e.g. masks, layer modes, etc. are rendered.

fog Non-image forming density in film that has effect of reducing shadow contrast.

font Set of letters, numerals, symbols related by design of their letterforms.

format (1) Structure and type of digital file as determined by software which produced it. (2) Shape and dimensions of image on a film as defined by the shape and dimensions of the film gate of the camera in use. (3) Dimensions of paper, hence also to publication size. (4) Orientation of image: landscape (if image orientated with the long axis horizontal), portrait (if image is oriented with the long axis upright).

fractal Curve or other object whose smaller parts are similar to the whole. In practice, a fractal displays increasing complexity as it is viewed more closely and where the details bear a similarity to the whole.

G

G Measure of mid-tone contrast in photograph.

gamma (1) A measure of the steepness of transfer function: high contrast results from higher gamma. (2) In monitors, the correction to the signal: a high gamma gives a darker screen image.

Gaussian blur Blurring filter in which extent of blur can be controlled.

GIF Graphic Interchange Format: a compressed file format designed to use over the Internet: comprises a standard set of 216 colours chosen from 256.

gradient Smooth transition of tone, colour or mask from a less dense or transparent zone to a more dense or less transparent zone.

grain (1) Film: the individual silver (or other metal) particles that make up the image of a fully developed film. In the case of colour, grain is the individual dye-clouds of the image. (2) Photographic print: the appearance of individual specks comprising the image. (3) Paper: the texture of the surface of a sheet.

graphics tablet Input device offering fine control of cursor or brush in graphics, painting or image manipulation program. Comprises tablet – an electrostatically charged board connected to the computer – and the pen, which interacts with the board to locate the pen and give information on the pressure, etc. at the pen-tip.

greeking Representation of text or images as grey blocks or other approximation. Strategy for avoiding lengthy screen re-draws allowing rapid scrolling through a document with many graphics or images.

greyscale Measure of number of distinct steps between black and white that can be recorded or reproduced by a system. A greyscale of two steps permits recording or reproduction of just black or white; the Zone System uses a grayscale of ten divisions; for normal reproduction a greyscale of at least 256 steps, including black and white, is required to simulate a smooth ramp of density.

half-tone cell Unit used by printing system to simulate grey-scale or continuous tone reproduction. Ink-jet printers simulate half-tone cells by collecting groups of dots to represent a cell: a white cell contains no dots, a black one is full of dots.

hardcopy Visible form of a computer file printed onto paper, film.

hardness Measure of the sharpness of edge of a brush: 100% gives the sharpest edge with no blur; 0% gives maximum blur.

height Vertical size of an image – measured along the up and down axis; also known as the depth. Together with width, defines size of rectangular image.

hide Remove from view, without removing effect e.g. Hide Edges makes marching ants defining an edge disappear, but the selection is still effective.

histogram Graphical representation of the relative population of value over a range of values: e.g. with Levels dialogue, the taller the column at a certain value, the more pixels have that value.

History Method in Photoshop for displaying different states of undo or reversing changes to image. HIstory Brush enables the partial reconstruction of a previous state of the image.

HLS Hue, Lightness, Saturation: colour model: good for representing visual response to colours but not satisfactory for other colour reproduction systems. Largely superseded by Lab mode.

HSB Hue, Saturation, Brightness: see HLS.

hue Name given by observer to their visual perception of colour.

iLink Rapid serial bus technology; an implementation of IEE 1394, effectively same as FireWire.

image aspect ratio Comparison of the depth of the image to its width e.g. the nominal 35mm format in landscape orientation is 24mm deep by 36mm so the aspect ratio works out to 1:1.5.

indexed colour Method of creating colour files or defining a colour space. The index refers to a table of e.g. 256 different colours held as normal 8-bit data (but the colours may be selected from a full range of 16 million). A given pixel's colour is then defined by its position or index in the table (also 'colour look up table').

ink-jet Printing technology based on the controlled squirting of extremely tiny drops of ink onto a receiving substrate. Most types are 'drop-on-demand' using piezo-electric or heat technology.

intensity (1) Measure of energy, usually light, radiated by a source. (2) Also loosely used to refer to apparent strength of colour as in ink, photograph, monitor colour etc. in a sense roughly equivalent to 'saturation'.

interpolation Inserting pixels into an existing digital image. Used to: (1) resize a bit-mapped image file during enlargement; (2) to give an apparent (but not real) increase in resolution; (3) rotate an image by a small amount less than 90°; (4) create an anti-aliased i.e. non-jagged edge.

inverse To reverse a selection i.e. select all the pixels that were originally not selected.

invert To reverse the colours and/or tones of an image: red becomes cyan, black becomes white or to reverse the area selected to those not first selected.

jaggies Appearance of stair-stepping artefacts.

JPEG Joint Photographic Expert Group: data compression technique that can reduce file sizes to 75% with nearly invisible loss of quality and as little as 5% of original with artefacts and other losses of quality.

JPEG 2000 New image compression standard, using advacned compression technology, with higher compression and less artefacting.

k kilo: one thousand, a round decimal thousand i.e. 1000.

K (1) Binary thousand: 1024. (2) Key colour or black: the fourth colour separation in the CMYK four-colour reproduction process.

KB Kilobyte: i.e. 1024 bits of data or 210 bytes. NB: KB May be abbreviated to K.

kelvin Unit of temperature relative to absolute zero. Temperature in kelvin is Celsius plus 273.16. Used to express colour temperature.

kernel Group of pixels, usually a square from 3 pixels to any number of pixels across (generally up to maximum of 60+), that is sampled and mathematically operated on for e.g. filtering for noise reduction, sharpening, blurring.

kerning In desk-top publishing and typesetting: the spacing between pairs of letters.

key (1) Any artwork, guide or (in printing) physical forme that establishes the relative positions of graphics elements, type or other printing element. (2) Key ink or the black separation. (3) A piece of information that unlocks an encrypted message.

key tone (1) The black component in a four-colour image. (2) The principal or most important tone in an image.

keyboard shortcut Keystrokes that execute a command.

lasso Method of selecting pixels by drawing a freehand shape which encloses group of required pixels.

layer Component of an image which 'floats' above the background image. May be called 'floater'.

layer mode Determines the way a layer interacts with the layer below.

light That part of the electromagnetic spectrum, from about 380–760 nm wavelength that can be sensed by human eyes by the stimulation of the receptors of the retina to give rise to visual sensations of brightness and chroma. It is radiant energy by which agency human vision operates. Light of different wavelengths is perceived as light of different colours.

light-box Viewer for transparencies and films consisting of translucent diffusing top that is lit from below to give daylight-equivalent light.

lightness (1) Amount of white in a colour, which affects the perceived saturation of the colour: the lighter the colour the less saturated it appears to be. (2) The opposite of 'density'.

line art Artwork consisting of black lines and areas, with no intermediate grey tones.

load (1) To copy enough of the application software into the computer's RAM to run the application. (2) To copy a file into the computer's RAM so that it can be used.

lossless compression Computing routine or algorithm that reduces the size of a digital file without reducing the information in the file.

lossy compression Computing routine or algorithm that reduces the size of a digital file but also permanently loses information or data.

lpi lines per inch: measure of resolution or fineness of photo-mechanical reproduction.

LZW compression Lempel-Ziv Welch: a compression algorithm that is widely used for lossless file compression, particularly applied to TIFF files.

Mac Apple Macintosh computer. Also the operating system used on Apple computers – now Mac OS X.

macro (1) Close-up range giving reproduction ratios within the range of about 1:10 to 1:1 (life-size). (2) Small routine within larger software program that performs a series of operations: also 'script' or 'action'.

magic wand Tool in Photoshop used to select group or groups of pixels which are alike in colour, how alike depends on the tolerance setting.

marquee Selection tool used in image manipulation and graphics software: so-called because it covers a rectangular area as it is used.

mask (1) Technique used to obscure selectively or hold back parts of an image while allowing other parts to show. (2) Array of values that are used by the computer in digital image processing to calculate digital filter effects such as unsharp masking.

master (1) Original or first, and usually unique, incarnation of a photograph, file or recording: the one from which copies will be made. (2) To make the first copy of a photograph, file or recording.

matrix The flat, two-dimensional array of CCD sensors. Also called area-sensors.

matte (1) Finish on paper that reflects light in a diffused way. (2) Box-shaped accessory placed in front of camera lens to hold accessories. (3) Mask that blanks out an area of image to allow another image to be superimposed.

megapixel Million i.e. 1,000,000 pixels. Used to describe digital camera with sensor resolutions of approximately a million pixels; hence 2-megapixel camera, etc.

mode Method, state or way of operating e.g. greyscale mode is a colourless state.

moiré Pattern of wavy light and dark bands or colours, usually of varying width and density, caused by interference between two or more superimposed arrays or patterns which differ in phase, orientation or frequency.

monochrome Photograph or image displaying neutral greys. Also applied to images with a very limited range of hues e.g. a cyanotype (blues) or consisting largely of adjacent hues e.g. reds and yellows.

N

native (1) File format belonging to an application programme, usually optimized for the programme. (2) Application program written specifically for a certain type of processor or operating system.

nearest neighbour Interpolation in which the value of the new pixel is that of the contiguous pixels. Used for line-art.

noise Unwanted signals or disturbances in a system that tend to reduce the amount of information being recorded or transmitted.

Nyquist rate Signal processing theory applied to determine quality factor relating image resolution to output resolution: pixel density should be at least 1.5 times but not more than 2 times the screen ruling e.g. for 150 screen or lpi, resolution should be at least 225, not more than 300 dpi. Higher resolutions do not increase quality.

O

off-set (1) To transfer ink or dye from one surface to another before printing on final surface e.g. off-set lithography transfers ink from the plates to a rubber mat which then transfers the ink to the paper.

opacity Degree of density of layer or lack of transparency: a less opaque layer shows more of the image below it.

open Process of loading a file into a software application i.e. translating the information into an operational form.

operating system The software program that underlies the functioning of the computer, allowing applications software to use the computer.

optical viewfinder Any type of viewfinder that shows subject directly, through an optical system, rather than via a monitor screen such as the LCD screen.

OS See operating system.

out-of-gamut Colour or colours that are visible or reproducible in one colour space but which cannot be seen or reproduced in another.

output (1) Result of any computer calculation i.e. any process or manipulation of data. (2) To print out to hard-copy a digital file e.g. as ink-jet print or separation films.

PQ

paint (1) To apply colour, texture or effect with a digital 'brush'. (2) Colour applied to image, usually by altering the underlying pixels of bit-mapped images or by filling a defined stroke in graphics objects.

palette (1) In drawing, image manipulation programmes etc., a set of tools e.g. brush shapes and their controls presented in a small window. (2) Range or selection of colours available to a colour reproduction system e.g. monitor screen, photographic film. (3) Selection of colours for painting or filling in that floats on screen in graphics and image applications ready for paint-brush to pick-up.

Pantone Proprietary name for system of colour coding, management and classification.

paste To place or add information which has previously been copied into a temporary memory or clipboard e.g. a selection from an image is first copied, then pasted into another image.

peripheral Any device connected to a computer e.g. printers, monitors, scanners.

Photo CD Proprietary system of digital image management based on a pyramid structure of image files at five different levels of resolution; maximum capacity of disk is about 100 images.

photograph (1) Record of physical objects, scenes or phenomena made with a camera or other device, through the agency of radiant energy, onto sensitive material from which a visible image may be obtained. (2) To make, create, take or arrange for the taking of a photograph.

photomontage (1) Photographic image made from the combination of several other photographic images etc. (2) The process or technique of making a photomontage.

PICT Graphic file format native to Mac OS designed for screen images.

picture element Abbreviated to pixel; see below.

piezo-electric Type of material that produces electricity when distorted e.g. by bending, squeezing or which itself is distorted when an electric field is applied to it.

pixel Picture element: the smallest, atomic, unit of digital imaging used or produced by a given device. Usually, but not always, square in shape. Device may capture image in sets of three or more contiguous pixels (one for each primary colour) but delivers image as colour-interpolated pixels.

pixelation Appearance of a digital image whose individual pixels are discernible.

platform Type of computer, defined by the operating system e.g. Mac OS, Linux, etc.

plug-in Application software that works in conjunction with a host program into which it is 'plugged' so that it appears in a menu, working as if a part of the program itself.

posterization Representation of an image using a relatively very small number of different tones or colours which results in a distinctively banded appearance and flat areas of colour instead of gradual transitions.

PostScript Language designed to specify elements that are printed on a page or other medium: it is independent of device and resolution.

ppi Points per inch: measure of input resolution e.g. of scanning device, measured as the number of points which are seen or resolved by the device per linear inch.

pre-scan In image acquisition: a quick 'snap' of the object to be scanned, taken at a low resolution for adjustment of cropping etc.

primary colour One of the colours red, green or blue. 'Primary' in the sense that the human eye has peak sensitivities to red, green and blue.

process colours Those which can be reproduced with standard web-offset press (SWOP) inks of cyan, magenta, yellow and black.

profile Description of colour characteristics of a device or working colour space.

proofing Process of checking the quality of a digital image before final output.

quality factor Multiplication factor used to ensure that amount of date is sufficient for requisite quality. Normally, image resolution should be sufficient for 1.5 to 2 times the screen frequency e.g. for a screen of 133 lpi, the image resolution should be at least 200 pixels per inch.

R

RAM Random Access Memory: component of the computer in which information can be stored or accessed directly. Most rapid form of memory, but is volatile i.e. it requires continuous power to hold information. Measured in MB or megabytes.

raster The regular arrangement of addressable points or grid.

re-sizing Changing the resolution or file size of an image. See interpolation.

refresh rate The rate at which one frame of a computer monitor screen succeeds the next. Measured in Hertz (Hz) i.e. cycles per second.

res Measure of the resolution of a digital image expressed as the number of pixels per side of a square measuring 1mm x 1mm. Largely obsolete.

resampling Addition or removal of pixels from an image by examining the existing pixels and making the necessary calculations. Part of the process of interpolation, and occurs not only in resizing operations but rotations and distorting transformations.

RGB Red Green Blue: colour model that defines colours in terms of relative amounts of red, green and blue components e.g. black is defined as zero amount of the components, white is created from equal and maximum amount of the components. May be used to refer to colour space of monitors.

RIP Raster Image Processor: software or hardware dedicated to the conversion of outline fonts and vector graphics into rasterised information i.e. to turn outline instructions like 'fill' or 'linejoin' into an array of joined-up dots. A PostScript RIP is best way to ensure accurate output and for the correct printing of complicated, vector-based graphics.

rubber stamp Photoshop name for the clone tool – replicating one part of an image onto another.

S

scanner Opto-mechanical instrument used for digitizing photographs.

scanning Process of using scanner to turn an analogue original into a digital facsimile i.e. a digital file of specified size.

scrolling Process of moving to a different portion of a file that is too large for the whole of it to fit onto a monitor screen.

SCSI Small Computers Systems Interface: family of standards for connecting devices in daisy-chain configuration.

separation Process of translating tones and colours into three or more channels of information, each representing proportions of a colour or ink. Also the channel of information itself e.g. blue separation holds the blue channel data.

snap Property of grid or guide-lines whereby an object placed nearby is pulled or snapped to the line: this makes it easy to align items with accuracy.

soft proofing Use of monitor screen to proof or check the quality of an image.

sponge tool Photoshop name for the brush which applies changes in saturation.

stair-stepping Jagged, rough or step-like reproduction of a line or boundary that was originally smooth.

swatch Set of colours gathered together ready to be selected as a colour e.g. for brush, gradient, etc. Also colour palette.

SWOP Standard Web Offset Press: a set of inks used to define the colour gamut of CMYK inks used in the print industry. To extend the gamut, one may add a fifth or sixth ink.

system requirement Specification defining the minimum configuration of equipment and version of operating system needed to open and run application software or device. Usually describes type of processor, amount of RAM, amount of free hard disk, version of operating system and, according to software, number of colours that can be displayed on monitor as well as need for a specific device.

T

thumbnail Representation of image as small, low-resolution version. Used to make it easier for computer to put image onto screen and to show many images at once. .

TIFF Tag Image File Format: format that supports up to 24-bit colour per pixel. Tags store information e.g. image dimensions.

tile (1) Sub-section or part of a larger bit-mapped image: often used for file storage purposes and for image processing. (2) To print in smaller sections a page that is larger than the printing device is able to print e.g. an A2 poster may have to be printed in tiled sections if using an A4 printer.

tint (1) Colour reproducible with process colours. (2) An overall colouring that tends to affect areas with density but not clear areas (in contrast to a colour cast).

tolerance In Photoshop, defines range of variation within which a selection is made: low tolerance settings choose pixels very similar to the selected; high tolerance allows a wider range of values to be selected.

transparency Degree to which background colour can be seen through a pixel of a different colour in the foreground. Antonym of opacity.

transparency adaptor Accessory or part of a scanner that enables scanning of transparencies: usually consists of a light-source that keeps step with the array.

trap Technique for preventing gaps or overlaps between adjacent blocks of colour in printing by introducing slight reductions or overlappings of colours.

TWAIN Toolkit Without An Important Name: driver standard used by computers to control scanners. Also a format in its own right, but rarely used as such.

U V

undo Reverse an editing action within application software to return to a previous state.

upload Transfer of data between computers or from network to computer. Usage tends to refer to act of transferring data from a local machine onto a remote site e.g. from your computer to web server for your web site.

USB Universal Serial Bus: standard port design for connecting peripheral devices e.g. digital camera, telecommunications equipment, printer etc. to computer. It is hot-pluggable i.e. equipment can be connected while the computer is still on.

USM UnSharp Mask: Image processing technique that has effect of improving apparent sharpness of image. Note it is the mask that is unsharp: the intended result is that the image is made more sharp.

vignetting (1) Defect of optical system in which light at edges of image are cut off or reduced by obstruction in construction e.g. lens tube is too narrow. (2) Visual effect of darkened corners used to help frame image or soften frame outline.

vector Type of graphics information which is resolution-independent.

VRAM Video Random Access Memory: Rapid-access memory dedicated for use by computer or graphics accelerator to control the image on a monitor. 2MB VRAM can give millions of colours up to a resolution of 832x624; 4MB VRAM can give millions of colours up to a resolution of 1024x768; 8MB VRAM is needed to give millions of colours at higher resolutions (all assuming a refresh rate of 75Hz).

W X Y

warm colours Referring to hues such as reds through oranges to yellows. A warm colour cast is generally more acceptable than a cold colour cast.

watermark Feature or data – which may be visible or invisible – in a digital image file used to identify the owner.

width The side-to-side dimension of an image; runs at right angles to the depth or height axis with which it defines the size of an image.

windows Rectangular frames on the screen of computer software that 'open' onto applications: operations take place within these frames or windows.

wysiwyg what you see is what you get: feature of computer interface that shows on the monitor screen a good (but not always very accurate) representation of what will be printed out.

x-y Design of scanner in which sensors can move across (x-axis) as well as up and down (y-axis) for high-resolution over whole platten area. Expensive.

Y Yellow: secondary colour of subtractive mixing created by the additive mix of red and green. It is very weak and needs lots of ink.

Z

Zip Proprietary name for removable storage device: each 3.5" disk holds nearly 100MB or 250MB, according to type.

zoom To change magnification of the image on the monitor screen. Zooming in increases the magnification. Zooming out shows more of the image at a smaller scale.

Web resources

www.photo.dpreview.com
Up-to-date, exhaustively detailed and informative reviews of digital cameras, also news, discussion fora and good level of information. Constantly updated.

www.what-digital-camera.com
News, information, reviews, sample image and more on a useful Web site for digital photography.

www.kenrockwell.com
Technical tips, pithy reviews and links for digital cameras, scanners, etc.

www.shutterbug.net
Wide-ranging photography resource run by the great eponymous US magazine.

www.imaging-resource.com
Frequently updated reviews of digital cameras.

www.shortcourses.com
On-line features on digital photography and instruction books for digital cameras, with links to other resources.

www.rit.edu
On the site for the great educational institution you can find long lists of discussion groups covering every angle of photography.

www.dcresource.com
Reviews, sample images and buyers' guide to digital cameras.

www.dpcorner.com
General information on digital photography and cameras, glossary and features.

www.wilhelm-research.com
Reports of tests on inks and papers to help judge quality, longevity, etc.

www.inkjetmall.com
Resources, techniques and services relating to ink-jet products.

www.wetpixel.com
Information for underwater digital photography including specialist equipment, diving up-dates and portfolios of images.

digitaljournalist.org
A first-rate site with excellent features by leading photographers and picture editors with a superb set of galleries, continually updated. Must be visited.

www.robgalbraith.com
An invaluable site by the guru of digital photojournalism, offering technical information aplenty with links to latest information and to software upgrades.

www.infoamp.net/~poynton/
More you ever wanted to know about colour – perfect for experts and geeks – with good links to other resources on colour technology and science.

www.fredmiranda.com
Miscellany of useful information and tips on digital photography.

www.photodo.com
Wide range of results of lens tests displaying MTF graphs from actual bench-tests, with some very useful articles on lenses.

www.imaginginsider.com
Some excellent features and articles with reviews and news.

www.lonestardigital.com
Helpful articles for basic understanding with reviews of cameras and links.

www.webreference.com/graphics
Covers range of relevant issues from scanning, formats to animation.

www.creativepro.com
Provides free on-line version of Extensis Intellihance Pro working through internet browser to manipulate images to improve overall quality.

www.moochers.com
General collection of freeware utilities including those suitable for viewing images, basic manipulation, format conversion, etc.

http://members.home.net/jonespm/PJDigPhot.htm
Digital Photography Reference: wide-ranging portal for anything to do with digital photography.

http://joeclark.org/access/
www.microsoft.com/enable/msaa/
www.madentec.com/
http://store.prentrom.com/
Resources for the disabled: the first two sites offer information for the disabled. The others detail and offer for sale adaptive technologies.

www.epson.com
Helpful technical guides on trouble-shooting your printer and how to get best results.

www.apple.com
A good deal of information can be found on this first-class site.

www.adobe.com
Superb site, with lots of useful material – well worth serious surfing.

www.kodak.com
A site full of resources and many free images to play with.

www.graphicconverter.net/
Excellent yet inexpensive software for image conversion and basic manipulations; some features are industry-leading.

www.bitwareoz.com
Software for calculating depth of field using different settings for focal length, apertures, circle of confusion.

Further reading

Silver Pixels
Ang, Tom; Argentum; London; 1 902538 04 8
An introduction to the digital darkroom, showing how digital techniques can mimic darkroom techniques of print-making. Companion to this book.

Dictionary of Photography & Digital Imaging
Ang, Tom; Argentum; London; 1 902538 13 7
Comprehensive listing of technical terms used in conventional and digital photography; also terms from imaging sciences, internet, publishing and computing.

Digital Photography
Ang, Tom; Mitchell Beazley; London; 1 84000 178 X
General introduction aimed at bridging traditional to digital photography, with numerous photographs and workshop examples by master image manipulators.

Digital Photographer's Handbook
Ang, Tom; Dorling Kindersley; London; 0 7894 8907 4
Mammoth coverage of the subject suitable for beginners – from choice of equipment and software, through image manipulation and projects to output options. Extensive reference section covering copyright, studying, working professionally, etc.

How to Cheat in Photoshop
Caplin, Steve; Focal Press; Oxford; 0 240 51702 4
Brilliant illustrations, step-by-step instructions and packed full of tricks from one of the finest masters of them all. Indispensable for illustrators and anyone wanting to stretch their Photoshop skills.

Digital Printmaking
Whale, Geogre & Barfield, Naren; A&C Black; London; 0 7136 5035 4
Exciting mix of first-rate work with applications of Photoshop to printmaking techniques but a bit thin on practical detail.

Photoshop Restoration & Retouching
Eismann, Katrin; QUE; Indianopolis; 0 789 72318 2
Here are 250 pages on retouching techniques: it is thorough, well-illustrated and leaves no brush unturned in its pantheon of advice. Highly recommended.

Essentials of Digital Photography
Kasai, Akiro & Sparkman, Russel; New Riders; Indianapolis, USA; 1 56205 762 6
Thorough and careful treatment, suitable for experienced and advanced worker with CD-ROM containing image files. Highly recommended though rapidly dating.

Professional Photoshop 6
Margulis, Dan; Wiley; New York; 0471403997
The best guide to colour correction and pre-press preparation of files with useful professional insights. Probably rather too much for the average photographer, but essential reading if you care a wannabe expert.

Real World Scanning and Halftones
Blatner, David & Roth, Steve; Peachpit Press; Berkeley, Calif.; 1 56609 093 8
The best available book on scanning by a long way, with excellent, down-to-earth advice on pre-press preparation. Perfect companion to Professional Photoshop. Highly recommended.

Digital Imaging for Photographers
Davies, Adrian & Fennessy, Phil; Focal Press; Oxford; 0 240 51590 0
Compact introduction, good on the science and technology, not for practical tips and software techniques.

Complete Guide to Digital Photography
Freeman, Michael; Thames & Hudson; London; 0 500 54246 5
A wide-ranging, if not quite complete, treatment with well-written text and high quality of illustration lifts this one well above its competitors.

Photoshop Channel Chops
Biedny, David & Monroy, Bert and Moody, Nathan; New Riders; Indianapolis; 1 56205 723 5
An entire book on channels is not for the faint of heart but you will never understand digital photography in depth if you are not comforable with channels.

Adobe Photoshop 6.0 for Photographers
Evening, Martin; Focal Press; Oxford; UK; 0 240 51633 8
Production-oriented approach to Photoshop benefits photographers – a very popular introduction to Photoshop.

Digital Image Creation
Kojima, Hisaka & Igarashi, Takenobu; Peachpit Press; Berkeley; 0201 88660 X
Wide-ranging survey of digital image manipulation used for illustration which by turns inspires imitation and evinces avoidance; strongly US biased.

In Our Own Image
Ritchin, Fred; Aperture; New York; 0 89381 399 0
Dated but still valuable and thought-provoking essays on changes in visual culture with advancement of digital technologies.

The Reconfigured Eye
Mitchell, William; MIT Press; Cambridge, Mass.; 0 262 63160 1
Steady, literate and clear discussion of issues in and around digital imaging and the manipulation of images. Essential reading.

The Computer in the Visual Arts
Spalter, Ann Morgan; Addison-Wesley; Reading, Mass.; 0 201 38600 3
First-rate overview of use of digital techniques in visual arts together with pertinent critical discussions and very sound on the science. Thorough and comprehensive, this is a highly recommended read.

The Photoshop User's A–Z
Cope, Peter; Thames & Hudson; London; 0 500 51061 X
The first term I looked up could not be found, but never mind, there are three thousand others, with many illustrations.

Making Digital Negatives for Contact Printing
Burckholder, Dan; Balded Iris Press; Texas, USA; 0 9649638 3 3
Step-by-step guide on the subject: essential for the advanced darkroom worker.

How this book was produced

A most important change in my work practice came from discovering that a whole day spent writing at my Apple PowerBook, with its liquid crystal display screen was less tiring than an hour writing at a cathode-ray tube monitor screen. As a result of this discovery, I now write entirely at my laptop computers.

Work-flow

The work-flow for this book is typical of all my books and it shows how the use of computers can change writing habits and work patterns. Given that the length of the book is set by the publisher, I start by sketching out a page plan or pagination. I estimate how many pages each topic will need, then allocate each page to its subject, shuffling subject-order and page allocation about while maintaining the overall length. I then break down each page into sections or paragraphs.

When I'm confident the pagination will work, I save it as a new word-processor document. There I can expand the sections for each page into fuller text or place notes and warnings to myself for additional research. I can dip into any page of the book at any time, as the pagination tells me what is needed where: it provides the framework with which to navigate the entire book.

The text therefore grows not in neat progression, but in a disorderly and lumpy way: I may write, say, pages 50–3 fully, leave the next six pages sketchy, then write the next seven pages in more depth but with several holes left because more research is needed. In time, I fill out the sketchy sections and edit down the more thickly written parts. And all the while, I keep an eye on word count so that I write no more for a page than it can hold, including pictures. And, as images are shot and collected, I insert captions into the main document where needed. All of this could, of course, be achieved with traditional writing methods but the ease and flexibility of working digitally is beyond equal.

Creating the pages is a mix of designing around a given image or sometimes locating an image to fit the feature needing illustration. The text may then have to be adapted to or rewritten for the particular image. With each step of the image manipulation, I take screen-shots of tools and settings. These have to be changed from their PICT format to TIFF. One hint for those thinking of doing the same: keep the screen-shot at 72dpi: this produces an image which needs to be reduced in size, but it retains detail in the low-resolution image used by the layout software, which means you can read it on the page.

Finally, the laid-out pages with images in place were burnt onto CD plus the hundreds of screen-shots and individual images. It was so easy to deal with all these files in Mac OS. To take delivery of the book, the publisher simply received two CDs.

Making proofs

My 22" La Cie monitor was calibrated, then characterized to a white point of D50 and a gamma of 1.8, with a check every couple of months (or when I remember). The monitor calibration proved sufficiently accurate for the book to be printed CTP or computer-to-plate, that is, without making hard-copy proof in the traditional way. It was, at any rate, hard to check an ink-jet hard-proof print as I have yet to create a fully ColorSync-compliant system.

In order to have bits of paper to hold as I progressed, I printed onto a creaking 'old' Epson Photo EX printer. This was terribly slow, but that is not always a bad thing: its noisy but leisurely plod through pages forced me to take rests. As the book's trim size is larger than A4, I had to print each spread as two pages of A3, tape them together, then cut them to size. This, too, could have been a burden but the sticking and guillotining was a pleasant change from pushing a mouse over the desk-top.

Technical resources

My main source of digital images was the Canon D30 camera – a reliable and high-quality work-horse on which I use all my EOS series lenses. All images were taken at the highest resolution with lowest compression, but not in RAW format. Images were automatically processed in the camera for improved colour, sharpness and contrast – they generally needed very little work to make presentable on the page.

The D30 was backed up by the Nikon Coolpix 990 which was particularly good for close-ups. Scans were obtained from a Microtek 4000t film-scanner for 35mm format film and transparencies and a Heidelberg Ultra Saphir II flat-bed scanner for prints and larger transparencies. Film-based cameras used included a Leica M6, Canon EOS-1n, Rolleiflex SL66 and Rollei 6008.

Image manipulation and processing was carried out on my Apple 500MHz G4 which was equipped with 1GB of RAM and two internal hard-disk drives, while viewing images and page layouts took place on the La Cie 22" monitor.

Back-up of working files was provided by FireWire hard-drives, together with a number of 2GB Jaz disks plus the burning of numerous CDs. I also sent files across my little network of three computers to a hard-disk controlled by another computer. The paranoid, which includes me, keep their CDs at a different address from the computer – so that provides abour four layers of back-up and insurance.

Software used

In addition to Microsoft Word, Quark XPress and Adobe Photoshop 6, the software constantly in use during prepartion of this book was FotoStation Pro 4.5. FotoStation is by far the fastest and easiest software to use for keeping track of images in files and for simple tasks like renaming a file while moving it from one folder to another. The basic, non-Pro, version can do everything most people need, including printing out thumbnail sets. Other invaluable software were S-Spline for enlarging files and Quantum Mechanic Pro for cleaning up pixel noise. Corel Photo-Paint 10 was used from time to time, as was the very powerful and rapidly working Equilibrium DeBabelizer 5.

Thanks

I am grateful to the generations of students who have had to suffer my speculative flights, descents into obscurity and lecturing experiments in finding smoother, clearer and cleaner ways of explaining the technical. They may not realize it, but their every question and problem presents me with parallel questions (why don't they understand this? how can I explain this more clearly? how can I make it more interesting?). The dedication of this book is therefore no mere lip-service. I only hope my students have learnt at least as much from me as I have from them.

My thanks to software houses Adobe, Corel, Fotoware, ColorPerfexion, Short-Cuts, Equilibrium and Quantum for their considerable and much appreciated technical assistance. I am also grateful to the editors of MacUser for the commissions which help me keep up with developments in digital cameras, computing and software: please keep them coming. Also, I owe many thanks to my publisher Eddie Ephraums for his patience with his irritatingly tardy author.

Finally, to my wife Wendy who is, as ever, the rock, the warm place, the big stick and source of love and strength that enable words and pictures to flow: my thanks to you for everything.

Index